Japanese Game Graphics

Behind the Scenes of Your Favorite Games

By Works Corporation

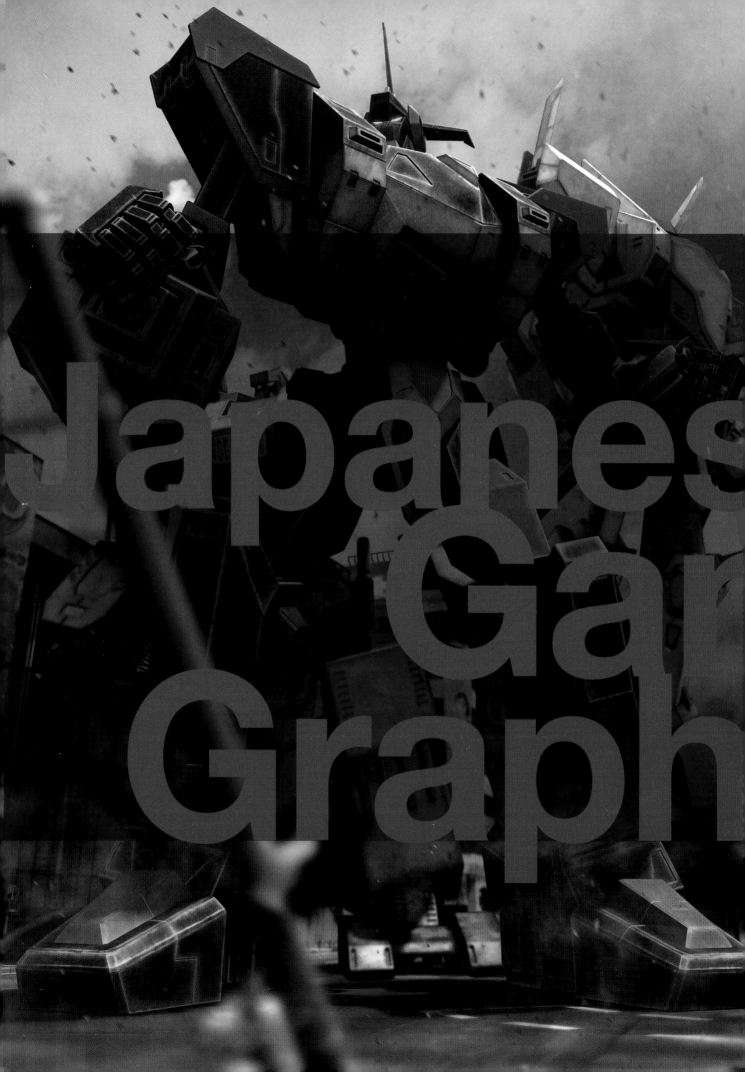

Japanese
Game
Graphics

Behind the Scenes of Your Favorite Games

by Works Corporation

HDi

HARPER
DESIGN
international

An imprint of HarperCollinsPublishers

JAPANESE GAME GRAPHICS
BEHIND THE SCENES OF YOUR FAVORITE GAMES

Copyright © 2003 by Works Corporation

First Japanese edition published in Japan in 2004 under the title of
"Making of Game Graphics 2003" by
Works Corporation
5F Hirano Building
4-12-38 Shibaura
Minato-ku Tokyo 108-0023
Japan
www.wgn.co.jp

First published in English throughout the World, excluding Japan, in 2004 by
Harper Design International
An imprint of HarperCollins*Publishers*
10 East 53rd Street
New York, NY 10022
www.harpercollins.com

Through the rights arrangement of
Rico Komanoya, Tokyo, Japan

This book was conceived and produced by
Works Corporation
5F Hirano Building
4-12-38 Shibaura
Minato-ku Tokyo 108-0023
Japan
www.wgn.co.jp

HarperCollins books may be purchased for educational, business,
or sales promotional use. For information, please write: Special Markets Department,
HarperCollins*Publishers* Inc., 10 East 53rd Street, New York, NY 10022

Printed in China by Everbest Printing Co., Ltd.

First printing, 2004

1 2 3 4 5 6 7 / 09 08 07 06 05 04

Library of Congress Cataloging-in-Publication Data

Japanese game graphics : behind the scenes of your favorite games / by
Works Corporation.
 p. cm.
 ISBN 0-06-056772-4 (pbk.)
 1. Computer graphics. 2. Video games--Japan. I. Works Corporation.
 T385.J39 2004
 794.8'166--dc22
 2003024577

At the time that this book went to press a number of the games featured in this book had not yet been commercially released in the United States. Therefore, some of the titles may change by the time American editions of these games are available. The editors regret any confusion that may arise due to this situation and will correct any errors in future editions of this book.

Staff Credits

Book Concept: Works Corporation

Production and design: Shin'Ichi & Yuko Ikuta (Far, Inc.)

Cover Design and Art Direction: Atsushi Takeda (SOUVENIR DESIGN)

English Translation: Junko Tozaki, Alma Reyes-Umemoto (ricorico)

Proofreading and Copy-Editing: Alma Reyes-Umemoto (ricorico), Alison Hagge

Interviewer on pages 8-12: Tomoya Yoshida (Far, Inc)

Chief Editor and Producer: Rico Komanoya (ricorico)

Contents

Interview:
What's Behind the Game Graphics

Toyoshi Nagata,
former Chief Editor of "Making of Game Graphics," Japanese Edition

November 7, 2003

Question

Japanese game graphics attract many people around the world. What is the reason for this?

Answer

In the United States, many valuable creators of CG movies move to the film industry, while in Japan they remain in the game industry. The reason for this is because in Japan, no other environment allows you to spend time and invest capital in making one movie quite like the game industry. Further, movie production does not handle research and development creatively, which explains why game products are in high demand.

Question

Have there been any innovations in the history of Japanese game graphics?

In recent years, do you think that Japanese game graphics have become increasingly beautiful?

Answer

Yes. Probably the first thing that stunned us was the 3D battle game called "Virtua Fighter." Before then, even though it was so intricately drawn the game graphics in general were done in the traditional 2D style. There were some games in the past that had interesting game systems and scenarios but I started to take notice of the graphics probably around the time when polygons were rendered in real time. In a 2D game, the movie uses a fixed camera angle but in a 3D game, the movie, such as "Virtua Fighter," consists of different camera angles and cinematic presentations. It was a challenge to do cinematic camera work in 3D. It brought about a great change to the field of game graphics.

Sure. CG technique has reached its mature period. On the other hand, the cost and effort to create graphics have likewise escalated, so it has been tough on the production side. As the hardware capabilities increase the range of expressions may expand, but this might be difficult to do for an innovation such as 3D representation. However, all games require detailed CG animation, so I believe that you have to overcome many hurdles through friendly competition.

Question

What do users expect from Japanese game graphics?

How do you characterize a Japanese game creator?

In the past, users were attracted to the fine quality of the opening movies. I think the time has come for CG creators to challenge themselves by expressing movie graphics in real time, which can also be viewed as a playing screen. The difference in quality between an opening movie and a playing screen needs to be decreased. In some cases, the texture of a pre-rendered opening movie is very similar to the texture of a playing screen. Recently, a comic-like 3D representation created with a shading program or a 3D representation similar to one used in an illustrated book has been frequently used in producing games instead of the so-called photorealistic 3D. We are now in the era of exploring originality and this is exemplified in this book.

Those creators who have been influenced by both Japanese cell animation and Hollywood movies possess the sense of value to treat both aspects in parallel ways. They express both a Japanese touch in the output of their work and a global viewpoint. They have a strong enthusiasm for and are excellently trained in design research, which is based on various ages and cultures. They remix the gathered data and carefully apply this information to the game setup.

Question

Is there a pressing issue in production now?

How do you envision the future of Japanese game graphics?

Answer

Like any film company in Hollywood, a setup that allows the animator who does not specialize in CG to add motions to a character generates more innovative ideas. I expect improvements in 3D CG software operations.

Japan welcomes the arrival of online games through the spread of the broadband system. The graphics in "Final Fantasy XI," for example, which became a hit in the North American market, were highly acclaimed. The PS2 platform motivates a high level of technical power of graphic expression. The original Japanese edition of this book was realized based on the creators' improved techniques in graphic expression. I believe that online games and their excellent graphics will continually be distributed to foreign countries.

Interview and Text by Tomoya Yoshida, Far Inc.

Game
Graphics
Gallery

According to CESA (Computer Entertainment Supplier's Association), annual sales of videogame hardware and software in Japan amount to about 1.45 trillion yen (12 billion U.S. dollars). Undoubtedly, Japan dominates the world market in the videogame industry. The following gallery pages feature 26 of the most-talked-about and popular titles—such as those released for PlayStation 2 and other consumer videogame hardware. Both the opening movies and actual, real-time games are highlighted, while the creators candidly discuss their image-making processes.

Unlimited Saga

The first title in the "Saga" series created for PlayStation 2, "Unlimited Saga" presents fresh, visual images with animated hand-drawn illustrations. The game uses the "Free Scenario" system—a "Saga" series trademark feature that allows scene changes during the game depending on which character the player chooses. "Unlimited Saga" features an immense variety of character animations, all of which are imbued with a personality and history and rendered in a theme color.

| platform | PS2 | made by | **SQUARESOFT®** |

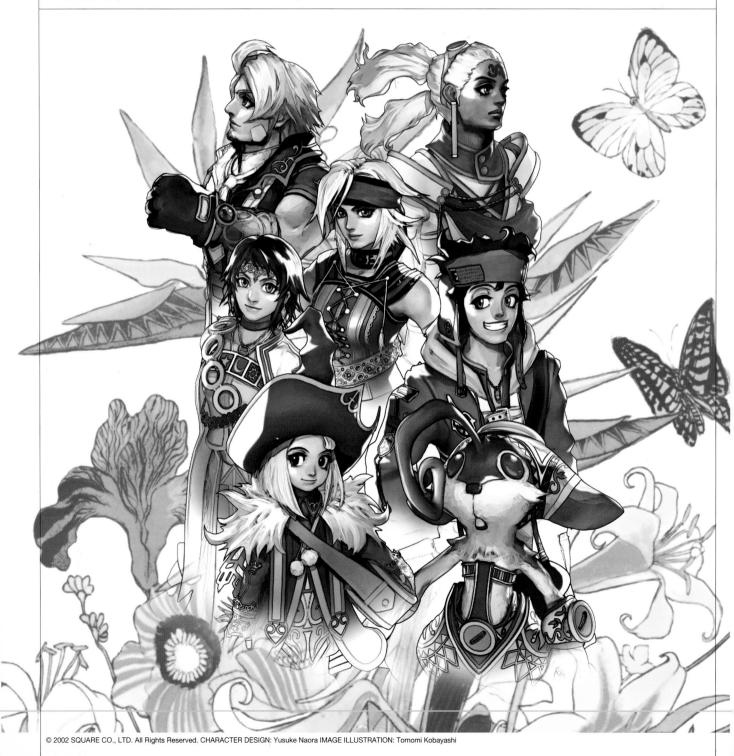

Developing the Sketch Motion technique

The character images in this title look like illustrations. The Sketch Motion technique, which was developed especially for "Unlimited Saga," allowed these illustration-like characters to be animated. Square's designer Yusuke Naora was in charge of designing these characters. He explained the reason for using the Sketch Motion technique:

"I have been the art director of the 'Final Fantasy' series for some time now. (See pages 20–25.) With 'Unlimited Saga' I took the opportunity to try a different method of expressing the characters. Previously, the 'Saga' series put much emphasis on creating an illustration-like quality for its characters. When we joined the team, we decided to make them appear more like computer-animated images."

Adobe Photoshop and After Effects were used to develop the Sketch Motion technique. Naora said that the powerful brush capabilities and filters of the latest version, Photoshop 7.0, were very useful in creating illustrations. After Effects, on the other hand, was used to make movie composites. Adobe Systems provided advice for using these tools.

Naora searched for a new and different approach—one that was even different than what was being used for movies, which have now become inseparable from videogames. He handled the production of all the movies, including the birth of an original project team, "Visual Works," found in the development division of Square (where Takeshi Tateishi, the movie director, worked). To assist with the animation of the illustrations both Naora and Tateishi decided to produce 3D models of all the main characters in the game using the software Maya. They had to go through a trial-and-error process in order to achieve the illustration-like technique that is the trademark of "Unlimited Saga."

"First, we thought about drawing outlines and painting from the inside, like you would with Celshader. However, because Naora asked us to come up with a completely novel expression, we were able to develop, by trial and error, such an expression not found in the existing version of Celshader. And this is the final result of our work," explained Tateishi.

These are the main characters of "Unlimited Saga" painted by Yusuke Naora. The Sketch Motion technique creates animations while keeping this illustration-like style.

Animating character illustrations

Movies produced by an elite staff of creators

The pre-production brainstorming was completed in two months and the movie production was completed in four months. The brevity of the production time was surprising, given the small size of the team.

Tatseishi explained how they were able to work so quickly: "One person was in charge of modeling the characters with the aid of several people. Likewise, movie composition and editing were done in the same way, with one leader-in-charge and several support personnel."

In modeling a character, Naora first created the design illustration, then the artist-in-charge turned it into a 3D model. It was amazing that the 3D artist could create a complete 3D character based only on one frontal illustration of the character.

"The person in charge of 3D modeling for this project was someone I had worked with in the past. As a result, I had no problem communicating with him, and we were able to work quite efficiently together," said Naora.

When the 3D artist had a problem, Naora would frequently sit next to him and give personal instruction. In some cases, he would draw the character or actually mold the character's head with clay to show the 3D modeler what form he envisioned.

Not much time was spent on using textures for these 3D characters. A texture that was too detailed would read as noise when the illustration outline was extracted and laid on top of it. Textures were not created by preparing separate image files, but rather by painting them directly onto each model using Maya's painting capability. The emphasis was not on creating detailed textures, but rather on developing clean images.

All of the characters in "Unlimited Saga" were animated by hand and therefore they reflect the creators' individualities. This technique was different from the titles in the "Final Fantasy" series. "Our creators are very skilled," said Naora. "Hence, the quality of our animations is very high."

Movie images that look like individual illustrations

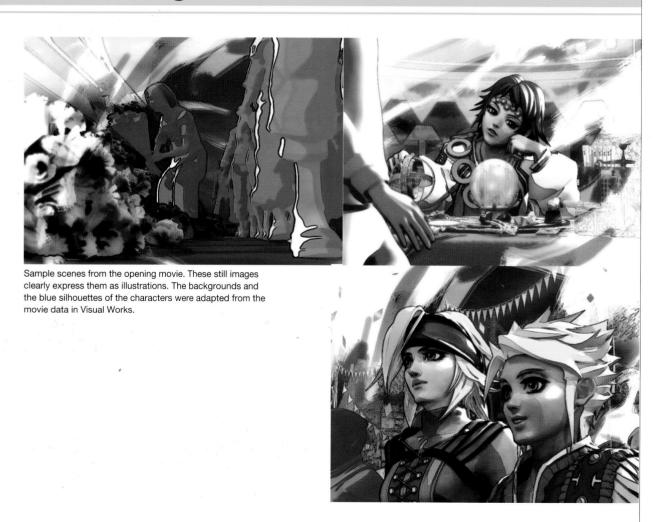

Sample scenes from the opening movie. These still images clearly express them as illustrations. The backgrounds and the blue silhouettes of the characters were adapted from the movie data in Visual Works.

Original character illustrations

Original character illustrations as they appear in the movie scenes. Their 3D models were created based on these illustrations.

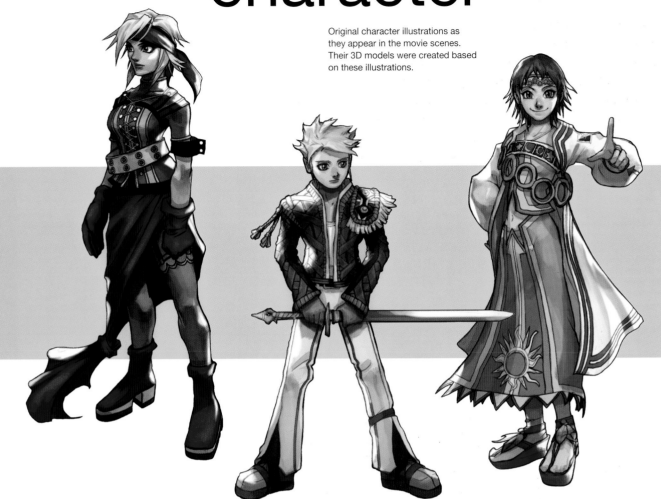

Game characters displayed as 2D illustrations

On the actual game screen the supporting characters are expressed as 2D illustrations, while the main characters are rendered as 3D models. This was done to make the users feel that they are seeing the same characters in the game as in the movies. Other 2D illustrations were created with Photoshop.

Character animations in 3D

This scene from the movie shows a man who bumps into a boy walking with a woman in a crowd. The animation was created and rendered with Maya, the composite process was achieved by After Effects, and the movie polishing was finalized by a very powerful and sophisticated video editing system. Sufficient lead time was allocated because it was expected that the composite process would be crucial to express illustrations in motion. A system was developed so that alterations could be made even after the modeling and rendering processes were completed. RPF files were enhanced with Maya, and the sense of depth was adjusted using the z-buffer algorithm. Each scene was separated into several pieces of material, then they were overlaid on top of each other.

3D CG

Final Cut

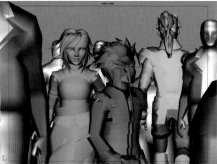

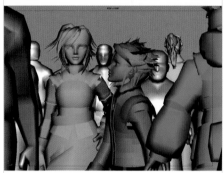
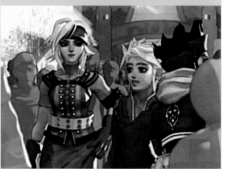

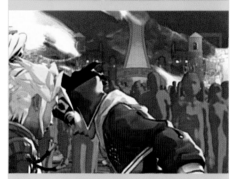

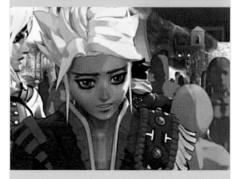

Characters' personalities and backgrounds

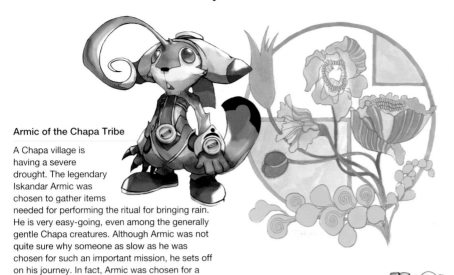

Armic of the Chapa Tribe

A Chapa village is having a severe drought. The legendary Iskandar Armic was chosen to gather items needed for performing the ritual for bringing rain. He is very easy-going, even among the generally gentle Chapa creatures. Although Armic was not quite sure why someone as slow as he was chosen for such an important mission, he sets off on his journey. In fact, Armic was chosen for a special reason—to save the Chapa village.

Square Co., Ltd.*
Development Division
Designer
Yusuke Naora

Visual Works, Square Co., Ltd.*
"Unlimited Saga"
Movie director/Designer
Takeshi Tateishi

Mythe, the inventor

Twenty-eight years old, Mythe is somewhat cool. An inventor from the Longshank Inn, he is a man who loves alcohol and women, and has a god-given talent for appraising historical relics. However, he has always had a cold heart. One day, Mythe saw a painting of a girl who had silver hair. Suddenly, lightening struck his heart and he began to ask himself, "What is this strange feeling!?" Bewildered and somehow troubled, he began to search for the origin of the painting.

Ventus, the messenger

One day a young boy shows up at Wanda, the home base of all messengers. "I want to know what happened to the last package that was taken," he says. "Get lost, kid. Besides, I can't tell someone who's not even a messenger," an old man answers. The boy replies, "Hey, old man, you're so wrong. First of all, I'm not a kid. Second, I am a messenger. My older brother's name was Briza." Upon hearing that name, all the messengers in the room turned to his direction at once. "He's Briza's little brother..." "He's just a little kid..." The boy's name is Ventus. He is nineteen years old and thinks of himself as cool, but he is more of a sidekick type, and not very popular among the girls. Ventus is searching for his brother, who disappeared while delivering a package. Understanding the situation, the guild master hands him an invoice...

*In April 2003, Square Co., Ltd. and Enix Corporation merged as SQUARE ENIX Co., Ltd.

Final Fantasy
X-2

The sequel to the title that sold more than five million copies globally, "Final Fantasy X-2" is experimental, with several changes from its successful predecessor—such as the inclusion of three heroines and the omission of the popular "summoned beasts," which was a "Final Fantasy" hallmark feature. "Final Fantasy X-2" also includes a completely revamped battle system as well as a brand-new feature, a dress-up system that showcases an abundance of costume designs by Tetsu Tsukamoto. RPG is staged in the world of "Final Fantasy X-2" with Yuna (the heroine from the previous title) and her two allies, Paine and Rikku. Yuna decides to set off on a journey into the world that was once peaceful, but that has begun to deteriorate due to clashing ideologies.

platform	PS2	made by	**SQUARESOFT®**

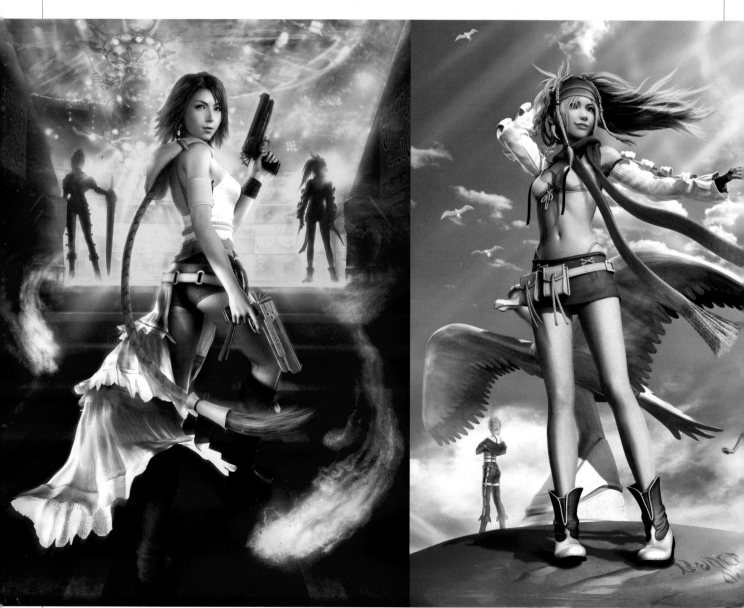

Refined quality

The production staff for this game was cut down to about one third the size that was used for the previous title. "Since this is a sequel, we gained familiarity with our work and decided that the size of the team was sufficient. This also allowed us to give a more hand-crafted feel to the outcome of the videogame," explained Yoshinori Kitase, Square's project director.

The main programs used, Maya and Softimage 3D, were the same as those used for the previous version. "We spent a lot of time creating the basic elements of the game in the previous title," said Kitase. "Once all that was done, we were able to concentrate more on the details. Also, there were a lot of real-time action scenes

where we had to apply the facial and motion-capture technology. We used this real-time action method to produce movies in the past, which allowed us to spend more time creating more elaborate scenes, such as the dancing and lip-synching, which are found only in the movies."

The opening movie, which captures the appearance of [Japanese pop star] Kumi Koda, who sings the game's theme song, is something to watch.

"Editing a movie to match a song is not very difficult," said Kitase. "However, this was our first time trying to synchronize a music scene with a theme song, and this was very tough. We pulled out the song data and captured Koda's movements, then we began the editing process while observing both sets of data. We repeatedly

played with different camera and character motions. Since Koda is human, not a robot, her song and movements did not jibe perfectly. If we hadn't edited the data, the result would not look synchronized." This took a lot of effort for our staff to achieve.

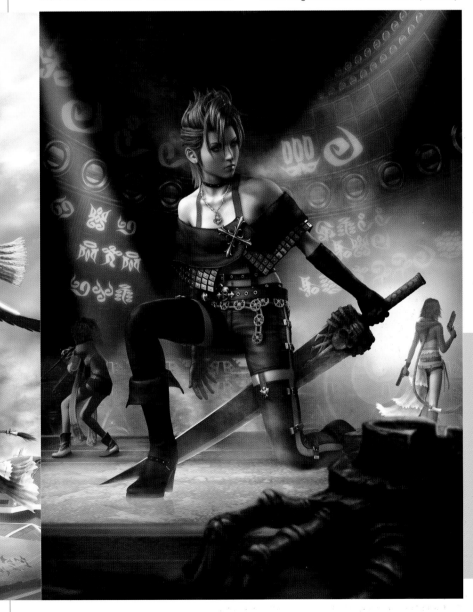

Kumi Koda's body movements and facial expressions were perfectly re-created to make this the showcase of the movie. "We proceeded with our method while convincing Koda how Yuna's movements and the song would synchronize with each other by showing her the actual movie," explained Kitase. "We began working on the song and the motion-capture process last summer (2001), but this was the last portion of the game that needed to be completed. We spent an unbelievable amount of time on every detail for this opening movie, from the camera movements to the lighting. We were placed under pressure to satisfy everyone, including Koda, her fans and the game users."

Video development behind the scenes

The story for "Final Fantasy X-2" was continued from the previous title, with one change—the "summoned beasts" were omitted from the battle scenes and a new feature, the "dress-up system," was developed to replace them.

"Even though this title is treated as a sequel, if all the features from the past were repeated, it would have ended up being quite boring," explained Kitase. "Since the theme for this title was 'changes,' we wanted to come up with something new. And this was the alteration of the characters by their change of costumes. We thought that having three heroines would brighten up the scenario."

In designing the costumes, we emphasized the personality of each character by creating one to match the other. The alternative costume designer, Tetsu Tsukamoto, patterned his designs from original illustrations created by Tetsuya Nomura, the chief character designer.

For them, designing something that is too easy to model would not be fun, but something too absurd would not be realistic. Costume design was a challenge for the model-makers.

Much effort was devoted to the transformation scenes and battle highlights, which replaced the scenes of the summoned beasts.

Each costume displays the before and after versions, totaling six different designs for three different heroines. Multiplying this by the number of costumes resulted in quite a lot of transformation scenes. Moreover, a lot of camera angles were used. Different scenes were altered depending on the costume being transformed into, amounting to an enormous number of different combinations.

Users feel like they are watching a different scene each time a transformation occurs, even when the same costume is selected. A lot of effort was put into this technique because this is the highlight of the battle. The man in charge of this job used to earn a living by creating the summoned beasts. Instead, he was asked to put all of his energy into the costume design.

A wide variety of costumes were specifically designed for each of the three heroines.

Original illustrations by Tetsuya Nomura

The "dress-up system": Adding brilliance to a **battle** scene

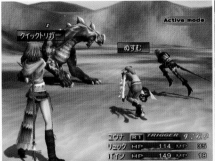
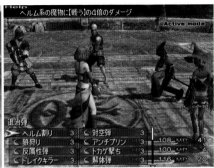

One character motion was prepared for each of the three heroines and their ten different types of costumes. In the beginning, using the same motion was considered for each type of costume for all the three heroines. However, this approach did not work because the designs and physical configurations of the characters were all different. Having varied victory poses for each character and each costume contributes a lot in providing each character with a different personality.

The team was worried about how to deal with the transformation sequences. With some elaborate programming, each character was able to transform differently. They studied the transformation scenes of many superheroes, but in the end they simply ran out of ideas. Users will be quite impressed with the outcome.

"Dress-up" of Rikku from Chief to Gambler

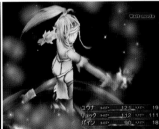
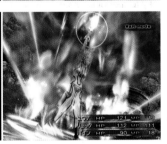

"Dress-up" of Paine from Warrior to Dark Knight

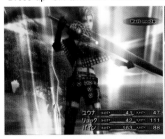

In the previous "Final Fantasy" title, when Yuna was clicked, she gave a typical manga-style expression with her eyebrows raised, but in this title, she bites her upper lip to show her emotion. This type of subtle facial expression enhanced the characters' emotions and is another improved feature craftily achieved in this title.

The heroine's facial expressions came out very well. Movies are produced with high quality, but more than that, this time the team was able to create a very natural facial look using real-time action. They videotaped the motion-capture process and used the actors' expressions as reference data. Since they used the same actors that were used for the first title, their faces, voices and acting acquired a sense of unity.

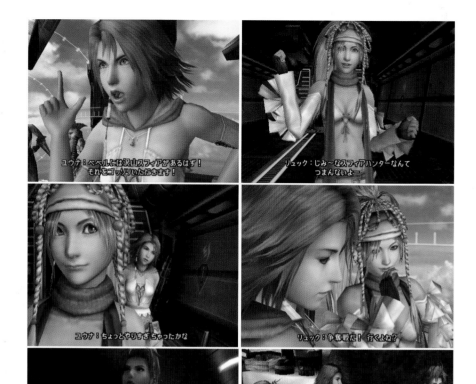

Characters with richer facial expressions

Serious male characters in contrast with the three heroines

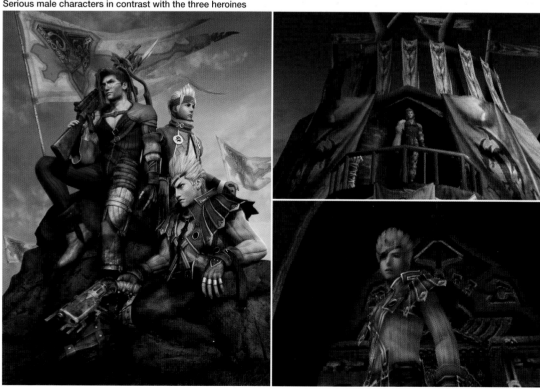

A changed world

A variety of new ideas were tested to illustrate that the world had changed from the previous title. These ideas included featuring towns that were reconstructed and new stage locations. However, the introduction of vehicle was particularly symbolic.

The team thought that it would be boring for the users to browse through the areas they have visited so many times in the previous title. Hence, they introduced the low-flying vehicle to allow players to move around more quickly and to enjoy the game more immensely.

Square Co., Ltd.*
Administrative officer
Development director
No. 1 Project development division
Project director
Yoshinori Kitase

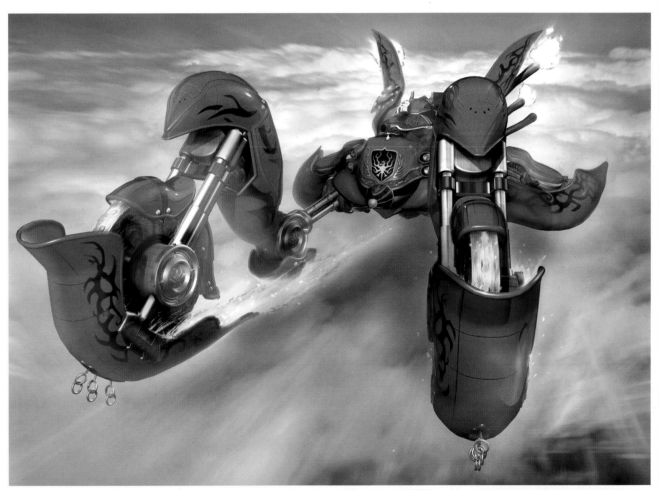

Top: A computer-drawn image of a low-flying vehicle painted to look like it is gliding through the clouds
Above Left and Center: Scenes of a reconstructed town
Above Right: A new location set and characters serve as key solutions to the story plot

*In April 2003, Square Co., Ltd. and Enix Corporation merged as SQUARE ENIX Co., Ltd.

Robot
Alchemic Drive

Huge humanoid monsters suddenly storm into a peaceful town. The town is destroyed and people try to escape the horror. Our hero is left with no choice but to use the human machines as the last line of defense. "Robot Alchemic Drive" differs from most mech games in that the user controls the ultra-heavyweight robot by remote control from the point of view of a human character who is on the scene—and very much dodging the danger of the ongoing action.

platform	PS2	made by	ENIX

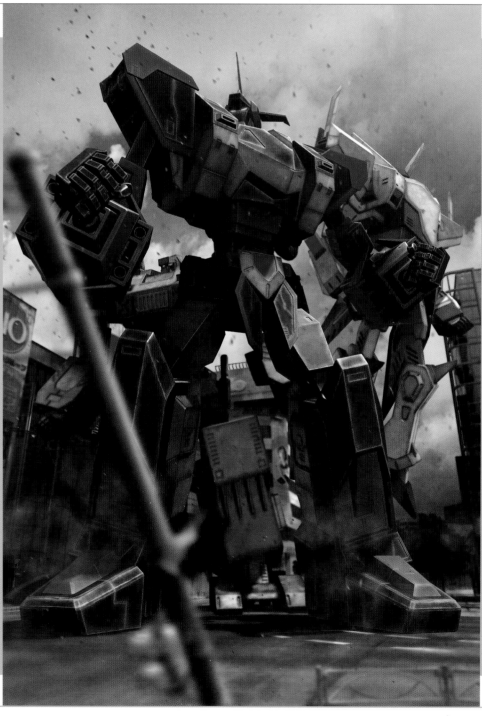

Direction based on intricate sketches

First, Keisuke Yanase, the mechanical designer, drew some sketches that emphasized the weight and presence of the robots. In order to do this, the cityscape, which was later destroyed, was heavily detailed in contrast to the human machines. Yusuke Watanuki, who was in charge of creating the backgrounds, groaned after studying the sketches for the first time, asking "Are we supposed to do all these?"

Illustrating the power of the "Super Robots"

The humanoid robots or human machines in "Robot Alchemic Drive" are not like the popular and realistic robots of today, but rather are designed after the "Super Robots" of previous years. They are huge and heavy with power-killer movements. When Wataru Higuchi, Enix's producer, took charge of the computer graphics movie for promoting this videogame title, he began recruiting creators who could design robots with weight and bulkiness. The first designer on his list was Hide Sato, who developed robots in computer graphics for the KDDI TV commercial and other media.

The production was carried out by seven freelance creators working under Sato and was completed in four months. Two and a half months were spent on preparation and

checking the preliminary drafts, such as drawing sketches and creating models. A month and a half was then devoted to finalizing the production. All of the ideas were consolidated through a series of meetings in the early production stage, after which mechanical designer Keisuke Yanase drew sketches. Meanwhile, Sato and two other designers started working on four human machine models and designers Yusuke Watanuki and Atsushi Sato began working on the backgrounds.

In the first stage, rough dummy models were made. Data was transmitted between the mechanical group and the background group in order for the camerawork to be defined.

The rough video footage was then tweeked. Cuts were added or subtracted, camera angles were adjusted, and the data for the dummy models was updated to finalize the desired images.

Hide Sato directed everything by himself—from organizing all the data to rendering and composition. Sato said, "Although I assured Higuchi, 'Sure! I can do everything on time,' it really was a bit too much." Even under such a tight schedule, he never compromised. As each scene was completed, he ordered the background team to produce more models if he felt that it was necessary. He tried to absorb density and quality. He also worked hard to reflect all of Higuchi's suggestions until the last stage.

Higuchi explained, "I made all sorts of suggestions, perhaps too many, like 'I want the buildings more detailed, the sky a little darker,' and so on." He chose compositions that emphasized grandness in size. He gave the movie a sense of speed and power by adding flashy effects like launched missiles and assault knuckles, while maintaining a realistic and natural atmosphere.

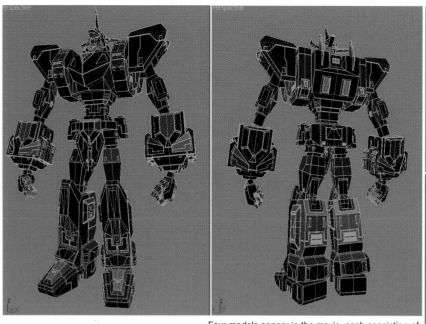

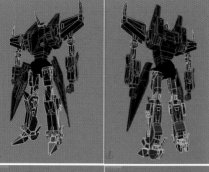

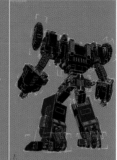

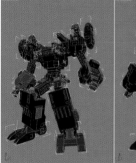

Four models appear in the movie, each consisting of a mode of about 100,000 polygons. Although each model in the game itself is heavily detailed with around 15,000 polygons, those in the movie were rebuilt with even more intricacy in order to express the necessary texture.

UV textures are positioned by repeating the following function: Polygon Select>UVWmap>unwrapUVW. Once a texture was prepared based on the UV texture, and the texture settings were done, the object itself was opened and rendered with the TLUnwrap plug-in. This completed one texture setting. The remaining task was to retouch the texture and apply it on the original model.

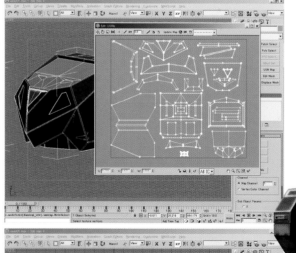

Human machine models rebuilt for the movie

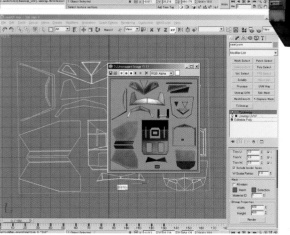

All animations were done using Key Frame Animation. Settings were simplified as much as possible by using 3ds max's IKHI Solver. The angle of the elbow joint was adjusted by selecting Chain and the setting Pick Target.

From left: body base texture, surface dirt texture, textures for chipped edges of the model

Aiming for more natural light and texture

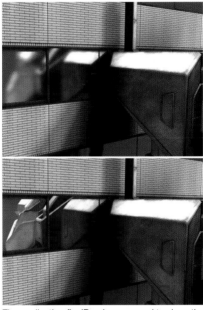

The application finalRender was used to show the reflection on a building. The top image was created by finalRender, and the bottom by standard ray tracing. One can decide which technique is more realistic.

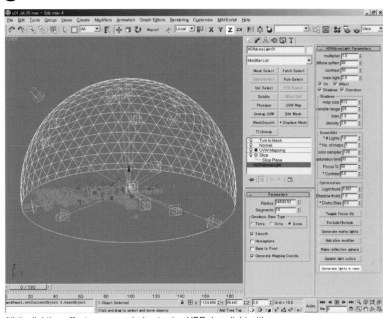

All the lighting effects were carried out using HDR domelight with just one Directlight as the main sunlight function. Several spotlights were also necessary for each cut to add specific effects. The rendering time for one human machine took about one minute for each frame, and about four minutes for each background frame.

Production incorporates various elements

Watanuki's and Atsushi Sato's primary job was the manipulation of the game itself. This was their first time producing a movie. By comparison, Hide Sato has always been a movie producer. Naturally, from the perspective of model making, the approach required to create a model in real-time action as opposed to that in pre-rendered animation is completely different.

"That worked out well for everyone," said Hide Sato. "For example, it would have been too heavy if we rendered the models

of the trees in the far background or on the sidewalk in real time. That would not have been efficient. We used the method of applying a pre-rendered image onto a model with a low-polygon count from game modeling, which uses fewer polygons. From the beginning I would have created the models using lots of polygons."

Apparently, Watanuki and Atsushi Sato struggled immensely to produce huge textures, which are normally unthinkable for any type of game. "Although it was tough, we got used to it and I am glad that I worked on it," said Watanuki. "For example, we unevenly placed many

buildings in the far background to make it look natural and so on.... We experimented with many different options."

The reciprocal relationship between game and movie production saw some textures adapted from the movie for use in the game and vice versa. Because there were two separate production teams, they developed a healthy interaction. For instance, the mat texture taken from the movies was used in the game and the bright reflection of a ship from the game was employed in the movies. Both teams cooperated effectively with each other and consequently produced high-quality work.

Developing short-range and distant backgrounds

Small objects—such as bicycles, cars and streetlights—were given a lot of detail.

Backgrounds were divided into short-range and distant, and were manipulated with Maya. The models in short-range backgrounds were built in detail, with items such as billboards and fences using 10,000 to 20,000 polygons. By contrast, those items in distant backgrounds used low polygon counts, as illustrated below. By decreasing the number of polygons, a similarly low count could also be utilized for shots taken from the air. Digital cameras were extremely handy in shooting other elements, especially items taken during overcast days, since it was easy to adjust the colors. In order to convert the images to 3ds max, only one UV texture per image was allowed.

Buildings with low-polygon count

Buildings with high-polygon count

Aerial view

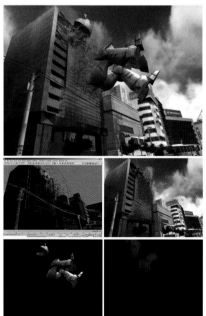

Production screen of a street scene and a row of trees. Each tree was rendered and pasted on a flat polygon object, and its shadow was manipulated as a model. The uneven street here illustrates the high level of detail.

The rendered images of buildings with a high-polygon count were applied on the models built for distant backgrounds. This allowed a natural low-polygon-model effect.

Fire, smoke and debris as carefully designed special effects

The enemy crashes into a building after being hit by the human machine, Vavel. To create the building destruction scene, broken pieces for each window were created with Particle Array, and Director was used to set the collision recognition. Because the scene is action-heavy, the elements were rendered separately, pulled out and combined using masks to create their final effects.

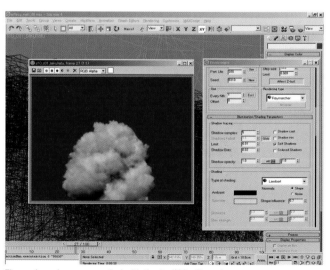

Fire and smoke were created with the tool AfterBurn. In addition to making the flashing missiles and explosions, AfterBurn was used to produce a more realistic feel, such as the cloud of dust that glides each time the Super Robot moves.

More expressive composites

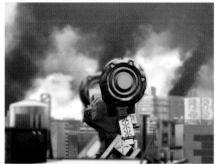

In focusing the camera, the elements of a cut were materially separated as much as possible, and composed with After Effects. These elements include Z depth and were output with the files'.ria format. During composition, fog and depth of field were adjusted. This system ensured that the composites no longer missed indispensable items in CG production.

ENIX*
Producer
Wataru Higuchi

ENIX*
CG director / CG designer
Hide Sato

ENIX*
CG designer
Yusuke Watanuki

ENIX*
Mechanical designer
Keisuke Yanase

ENIX*
CG designer
Atsushi Sato

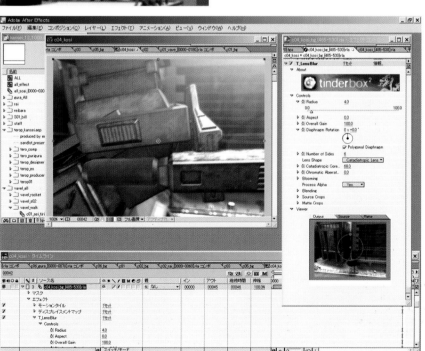

AfterEffect's T_LensBlur of the tinderbox² plug-in was applied to all scenes to simulate the actual camera focus.

Steel Battalion

This action game takes place in a make-believe city of the near future, where the player becomes a new recruit controlling the humanoid tank, Vertical Tank (VT), in order to carry out various missions for neutralizing the enemies. Its most popular feature is the custom controller unit, included in the package, which consists of 40 switches, 3 foot pedals and 2 joysticks. The player feels like he/she is controlling an actual machine.

| platform | Xbox | made by | CAPCOM® |

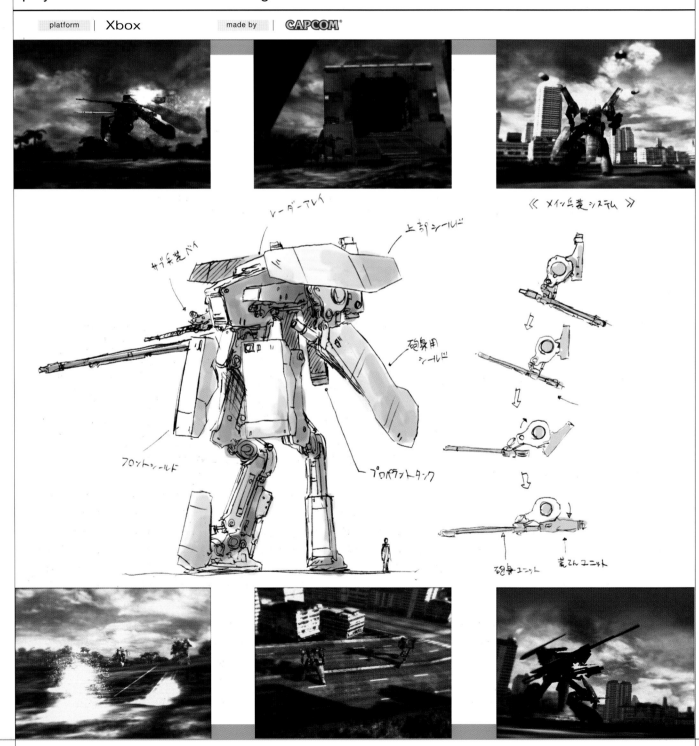

First version conceptualized as a design study

Design of the foot pedal unit in its almost final stage

One of the most distinctive features of "Steel Battalion" is its special controller, which is shown here in transition from raw to finished form. During the game's development, several standard controllers were connected and tested. The final version of the controller was completed just before the game's master disk was released.

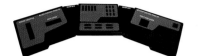

Model of various design experiments

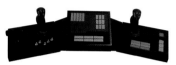

Design in its almost final stage

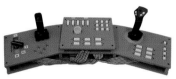

Version for testing the game during the development stage

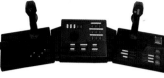

Different versions used for testing and adjusting the feel of the buttons and weight of the levers. These vary not only in visual impression but also in degree of comfort.

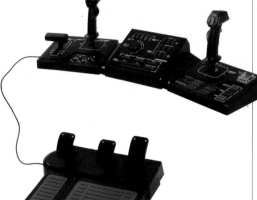

Final version of the controller with the foot pedal unit

The original plan

The most impressive element in "Steel Battalion" is the standard equipment controller. It consists of an unbelievable number of buttons and switches and is 100% compatible with the cockpit console of the robot. This controller allowed "Steel Battalion" to surpass all other fighter robot games on the market.

"The concept for this game was originally presented to us by the director of the 'Clock Tower' series," explained Atsushi Inaba, the game's producer and person who conceptualized the world of "Steel Battalion." "It began as a proposal for a robot fighting game that employed as many as fifty buttons in the first stage. When we saw this, we thought that playing such a game using a controller in a realistic environment would be fun. We knew this element did not exist. The people at Capcom also felt the same, and so they approved the project. From the start of the

The prototype images running on a PlayStation 2 (top) compared to the final images on the Xbox (below). An enormous amount of time and energy was expended to produce these differences in quality. Under close examination, one clearly sees the differences in the cockpit and the improvements in image quality on the monitor screen. This sense of craftsmanship is Capcom's noted specialty.

concept planning, they always envisioned utilizing a unique controller."

The development of this project began in the spring of 2000. Xbox did not exist at that time, as a result PlayStation 2 was the main tool.

"We had to physically produce something but the only hardware we could select at that time was either PlayStation 2 or Game Boy," said Inaba. "The problem was that the plan was so complex we did not think it would be possible to realize it

on PlayStation 2. Also, because we could not comprehend totally all of the ideas, what we came up with in the early stages of development was completely different from the final product. There is nothing from that prototype that the final version of 'Steel Battalion' inherited."

In fact, a year was spent creating and destroying numerous prototypes. Finally, the project was reorganized for Xbox and a new staff was recruited, with everyone practically starting from scratch.

One-year gap

The actual (second stage) development of the game began a year later. However, that first year was not spent in vain. In effect, during this period the staff gathered better ideas for the game, studied the capabilities of the hardware, polished up the designs and cleared up many unresolved factors.

"It is not that we did not do anything in the first year, but we found answers to many of our questions, and proceeded with the problem from there," explained Inaba. "I think the images we created during that first year of development were quite interesting."

"Design concepts—such as the instrument panel being positioned up front and the monitor screen being buried at the back—and the game philosophy in general were completed during this period," said Inaba. "From there we worked on balance fine-tuning and improving the graphics quality. However, as a videogame, quantity outweighed quality. Because we worked from the position of 'all the elements we could not do without,' we could not eliminate anything in order to improve the quality. Even if we put a lot of effort in minute details, the users would not know this. Considering that we had a limited amount of data and that we needed to choose between quality and quantity, we had to choose quantity. We placed especially enormous attention on the battlefield atmosphere and the feel of smoke."

Creative work that probed deep into the problem was required.

Realism in the cockpit

The entire production—from modeling to animation—made use of Softimage 3D. "We did not even consider using Maya,"

Game screen. "We wanted to create the impression that the game took place under unusual conditions," art director Hirokazu Yonezuka explained. "So we did not use clear images but rather those that resemble old war movie footage." This exhibits a very heavy atmosphere. "Until noise was applied to the images I was constantly complaining," added Inaba. "But once it was done I could say that 'This is the world of the Steel Battalion,' and no longer complained." The noise applied was an effect they call "battle shader." The development of this shader initially began after experimenting with a night scope mode. "We kept adding different processes to the screen image to make objects appear from the robot's camera eyes," stated programmer Masaki Higuchi. "This effect adds the grimy look as well as the noise."

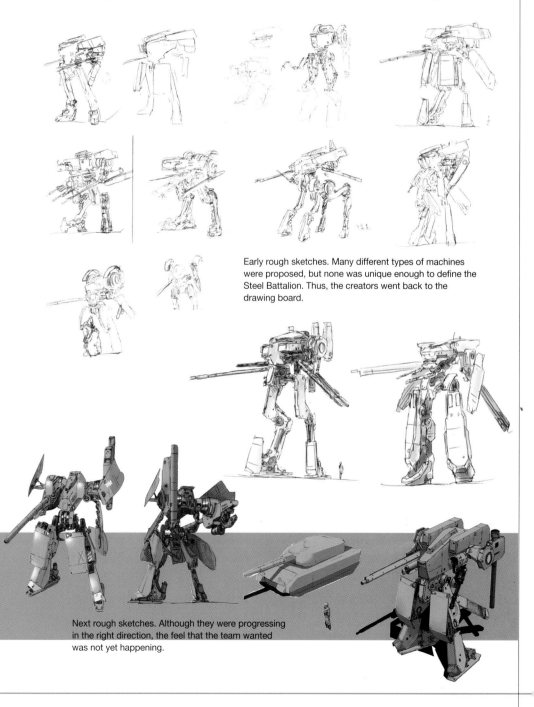

Early rough sketches. Many different types of machines were proposed, but none was unique enough to define the Steel Battalion. Thus, the creators went back to the drawing board.

Next rough sketches. Although they were progressing in the right direction, the feel that the team wanted was not yet happening.

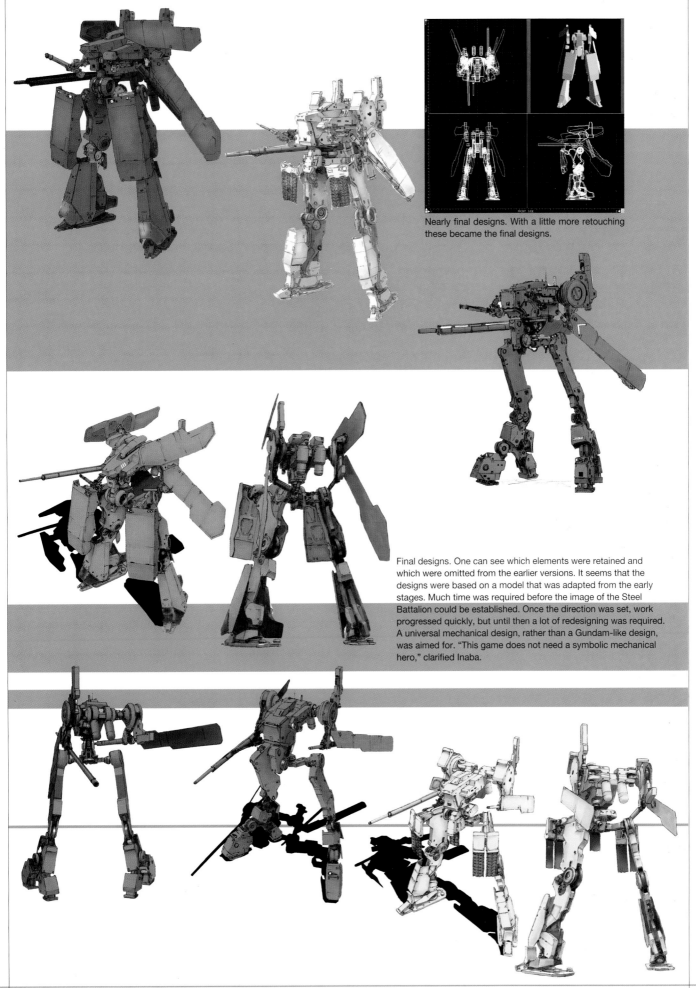

Nearly final designs. With a little more retouching these became the final designs.

Final designs. One can see which elements were retained and which were omitted from the earlier versions. It seems that the designs were based on a model that was adapted from the early stages. Much time was required before the image of the Steel Battalion could be established. Once the direction was set, work progressed quickly, but until then a lot of redesigning was required. A universal mechanical design, rather than a Gundam-like design, was aimed for. "This game does not need a symbolic mechanical hero," clarified Inaba.

Inaba stated. "The staff thought Softimage was adequate." The fact that everyone was already familiar with this almost bug-free tool made it less likely to cause problems.

Adjusting the balance between the instruments and the monitor screen took an enormous amount of time largely because the instruments were positioned in the front and the monitor screen was in the back. Simply inserting the battle scenes in the monitor in this layout would have made the game screen look flat without any feel of depth.

"Initially, both the control panel and screen texture were the same, which produced a monotonous look, like one flat image," said Higuchi (who created the unique world with the programmable shader and worked overtime to achieve 30 fps). "Thus, we worked harder on the textures themselves and the scenic atmosphere displayed on the monitor screen. One of the features we devised was an auto-focus effect for the robot's viewpoint or the actual display on the monitor screen to make the user feel as though the robot is actually seeing things. We could not have done this with other platforms, but shading off the outer edges was relatively easy with Xbox's programmable vertex shader."

Universal mechanical design

With such grand effort spent on the cockpit design, designing the robot was likewise as meticulous. This is where new designs from Izmo Juki came in.

The designs were extremely detailed and carried a lot of weight. The drawings were refined and adjusted to suit the game concept. Since all of the design work was done on PC, it was easier to retouch them than it would have been if they were done on paper. With efficiency as a crucial requirement in the game production environment, one robot was developed per week. This speed was quite incredible.

"No matter how good the designs were, the nature of polygons made them problematic," said Sawaki Takeyasu, the modeling director. Takeyasu built the models for the game based on the designs and created machines with unique techniques such as Max Painting, a method, which was developed by the renowned Max Watanabe, that allows shadows and highlights to be painted onto models. Takeyasu continued, "A robot has many square edges. We had to reserve many polygons, which were absolutely necessary for refining these edges, and we could not compromise because we could not have robots with beveled edges."

To handle this problem, a robot needed around 2,000 to 2,500 polygons. Whether

Modeling was done with Softimage 3D. 3D models were produced with computer graphics during the design process, which created an issue as to whether the 3D data could also be used. For some reason, the shapes looked different on screen than they did on paper, thus, they were retouched to match the image of the Steel Battalion. Naturally, the number of polygons was also reduced for the game.

Robot rendered in normal shading (top) and rendered in mat shading (bottom), with the shader added for the image itself. In "Steel Battalion" a custom shader was used to provide mat textures on the robots. "Because of the accumulated dust and grime, we gave them a finish without any reflections," said Yonezuka. "Brilliant machines do not suit the image of a world in the brink of war."

they were for the main or sub-monitor screens or control panel, some scenes employed more than 500,000 polygons.

"The designs were mechanically correct and consisted of many joints," explained Takeyasu. "Since we could not build models patterned exactly after the design drawings, we had to refine them, which was a dilemma for us. The configurations were also specified, in extreme detail, for all the textures and the parts, which were all taken from the real world. This, in contrast, was handy for us in calculating the later dimensions."

Furthermore, Yonezuka (who created the cockpit, monitor view and war atmosphere) and Higuchi added in unison: "We were not speaking the same language; we did a lot of bouncing back and forth."

The communication between a design director and a programmer is difficult. From the programmer's perspective quantifying a character and forming it as closely as possible to the original design is of greatest importance. However, designers are more concerned with the external visual elements, like color shades and textures. This is inevitable since one side focuses on programming, the other on graphic images.

Desired rough atmosphere

The biggest selling feature of this game is the war atmosphere. Hence, field designing was crucial for playing the game. For example, the image of the devastated town was achieved by pasting photos of buildings in Hong Kong. The textures used were all mat, without any shining effect. Also, a shader, called battle shader, was developed to make all elements displayed on the monitor screen appear like they are viewed from the robot's camera eyes.

"War movies these days come out so clearly, but the reality is different," explained Yonezuka. "They are actually more similar to what you see on the news footage of the Gulf War or old war movies. These images are coarser and more faded. I think intentionally adding noise and grime to produce the effect of a real war makes it more convincing for the users to get into the world of war games."

A realistic sense of a battlefield scene is nothing like what you see in a Pulitzer-prize-winning war photograph. That is just a shot taken by miraculous chance and does not truly depict the entire battlefield. In fact, today's Hollywood war movies stretch for two hours long and visualize these perfect "miracle shots," making one wonder how much lighting crew is needed in order to shoot them. But that is not what a war is supposed to look like. The production team knew that only a real war could accurately depict a true battlefield.

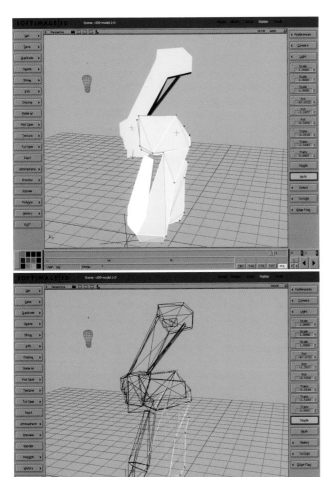

Model of a part

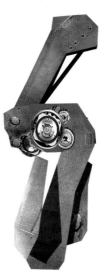

Applied textures

Alpha masks providing round surfaces

Modeling a part. Because it was built and assembled with parts like these, the robot was successfully provided the sense of being "mass-produced with standard parts." Alpha masks were also used to add round surfaces with a small number of polygons.

Due to this, they concentrated more on the creation of a general atmosphere for the entire game, rather than on details and "quality" emphasis. They believed that was the correct approach.

Moreover, Xbox's fixed shaders were not used in the production version of the game. Instead, hardware shaders were used with PlayStation 2 during the development stage and custom shaders that were specially developed for Xbox were used for the final production.

"We worked hard on expressing the depth of field and the brightness," said Higuchi. "For example, we overlaid hundreds of polygons in an explosion scene in order to express brilliance. Since it is impossible to express something like this with simple polygons, we tried to make the scene look like it was expanding. Bright areas often look exaggerated and we took advantage of that optical effect. We could not have accomplished this without using such visual tricks." He notes that instead of detailing everything, using visual tricks to decrease the amount of data plus applying blur produced more successful and efficient expressions. "Steel Battalion," with all its combined efforts, has been long anticipated by all users.

Aerial view (top). The stage data was created with Softimage 3D. The townscape as viewed from the cockpit (bottom)

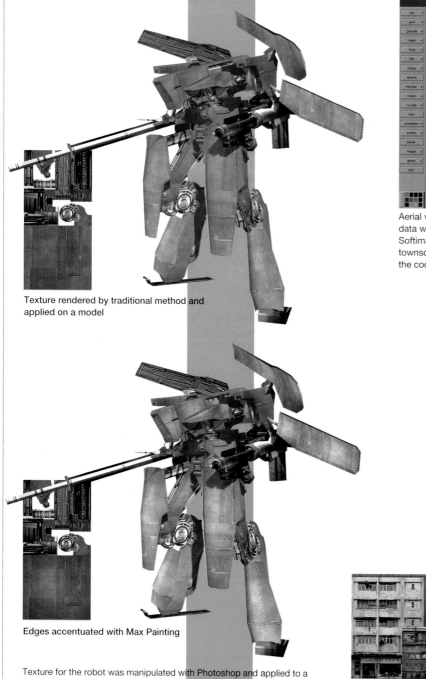

Texture rendered by traditional method and applied on a model

Edges accentuated with Max Painting

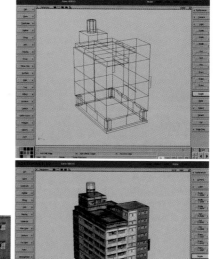

Texture for the robot was manipulated with Photoshop and applied to a model. However, the actual model with its texture displayed a lack of clear edges perhaps due to the use of the shader. To compensate, the Max Painting technique was applied. This method is often used for coloring plastic models in order to create texture to accentuate edges.

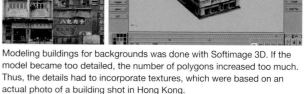

Modeling buildings for backgrounds was done with Softimage 3D. If the model became too detailed, the number of polygons increased too much. Thus, the details had to incorporate textures, which were based on an actual photo of a building shot in Hong Kong.

The auto focus effect was made possible with the use of Xbox's programmable shader. The current image on the monitor screen was used as a texture and the Z depth of the image as an alpha channel. Then they were overlayed as layers and the edges were blurred. It is amazing that all these can be processed in real time.

Capcom
Producer
Atsushi Inaba

Capcom
Art director
Hirokazu Yonezuka

Capcom
Modeling director
Sawaki Takeyasu

Capcom
Programmer
Masaki Higuchi

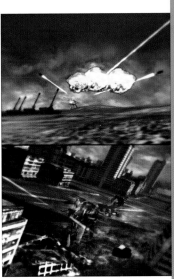

Both quality and speed were achieved by cleverly using textures instead of heavy polygons in creating such an explosions. In the earlier development stage, only three frames per second could be produced because there were many buildings and robots in one scene. However, by adjusting the amount of the data displayed on the screen 30 fps were successfully obtained.

Town rendered with (top) and without (bottom) shadows. Initially, shadows were not considered because they carried a heavy effect. But when the staff saw Higuchi experimenting with them, they decided they had to have them. Comparing the images, one sees that those with shadows look much more co-existent.

Sample texture. Xbox with an UMA structure can produce detailed texture. Each part was built to appear as though it was assembled by a fictitious manufacturer.

Resident
Evil Zero

The new edition in the "Resident Evil" series takes place in the mansion used in the first title of the series. A former second lieutenant marine officer, Billy Cowen, and a rookie member of S.T.A.R.S., Rebecca Chambers, challenge the huge darkness entity. The new Partner Zapping System—which allows two characters to work together to advance the enemy—allows users to fully experience the suspense and strategic fighting scenes.

platform | **GAMECUBE** made by | **CAPCOM**

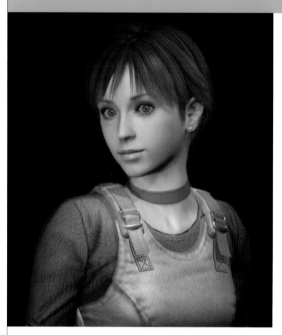
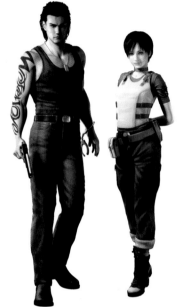

Special attention was paid to the dark areas and lighting

All of the characters and creatures in this title (including the models for the movies) were created based on Capcom's designs and image models. Some texture retouches were added for detail. There were no close-up shots of the creatures. Therefore, the details of the characters and creatures were rendered by the movie team, and then reflected for use in the game.

"We exchanged between the data and the images back and forth regarding the game world itself, image tones and settings. This helped us organize the details and eliminate inconsistencies," said Ikuo Nishii, technical director of robot production and the game's movie producer. "We also intentionally altered the lighting and ambience of the images that required real-time interactive game play and those that were used for movie visual effects only."

A variety of tools, including Maya, 3ds max, Softimage 3D and LightWave 3D, were used. In addition, Inferno, AfterEffects, Combustion and Shake were assigned for composite jobs. A motion-capturing technique was applied for the characters' movements employing the equipment Vicon8 and Motion Analysis. FiLMBOX was the main tool used for data adjustments.

Nishii said that the most important elements in producing the movies in this title were the lighting and the camera work. "In order to show the game world of 'Resident Evil Zero,' we emphasized the expression of dark areas, keeping the overall tone of the images low and creating unrevealing lighting," explained Nishii. "The camera work was designed to instigate physiological anxiety while simultaneously expressing a realistic and natural atmosphere. As result, we were able to realize lighting design composition for each scene and camerawork for each cut while maintaining a consistent concept for both. I think we managed to develop extreme movie-like images."

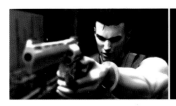

In the opening scene of the story, Rebecca, who boarded a mysterious train, is attacked by a huge number of leeches, and then rescued by Billy.

Some of the game images in the world of "Resident Evil Zero" as re-created on GAMECUBE. Unique lighting effects bring out a sense of eeriness and fear.

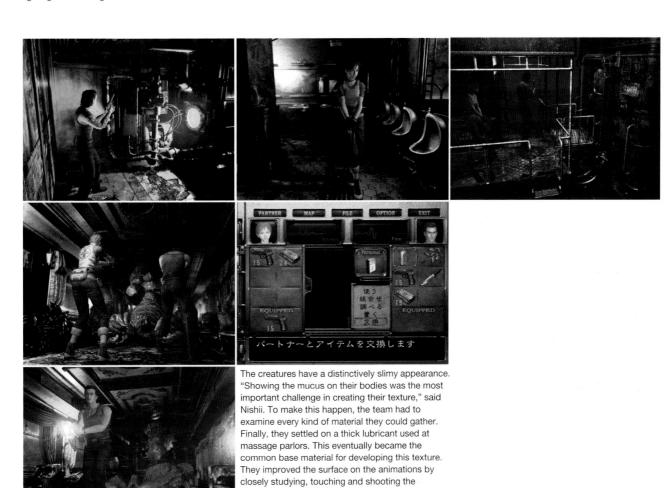

The creatures have a distinctively slimy appearance. "Showing the mucus on their bodies was the most important challenge in creating their texture," said Nishii. To make this happen, the team had to examine every kind of material they could gather. Finally, they settled on a thick lubricant used at massage parlors. This eventually became the common base material for developing this texture. They improved the surface on the animations by closely studying, touching and shooting the lubricant on video.

JoJo's Bizarre Adventure

Based on a wildly popular Japanese comic book series created by Hirohiko Araki, "JoJo's Bizarre Adventure" is an action game that features 18 unique characters. Most characters have spirits, called "Stands," that act like guardian angels and that can be used to perform special moves during this offbeat and fast-paced plot.

platform	PS2	made by	**CAPCOM**

The text balloons, sound script, paint effects and degrees of brightness of this game were all constructed with special attention. Artistoon was used to manipulate all the details but the team experienced great difficulty in optimizing the game elements. Because it is an action game, everything had to be rendered—including the characters, the stage and the effects—in 1/60 of a second. The optimization process was very tough.

Retaining the original touch

A brand-new technology called Artistoon allows the illustration-like images of "JoJo's Bizarre Adventure" to move vividly. Artistoon uses an independently developed (and confidential) algorithm that was developed by Capcom. The character director, background director and shader development director all discussed their difficulties in creating the graphics for this game.

Model rendering with the Artistoon shader is three times longer than rendering using the traditional method. Therefore, the team was required to keep the number of polygons low.

The team tried to create model motions, a method of illustrating the silhouettes and movements of the original comic book characters using a limited number of polygons, even when they move quickly. They also paid extra care to the areas around the characters' shoulders and abdomens, which were extremely

important. The number of polygons that could be used was 17,000 to 18,000 but because the silhouettes of the original comic book characters had to be retained, it took a long time to adjust them.

Textures played an important role. Since the objective was to create a comic-like rather than real atmosphere, only the images with a sharp touch (rather than those with blurred lights and shadows) were used. This meant that every line had to be clearly, painstakingly drawn in order to keep the images from looking empty.

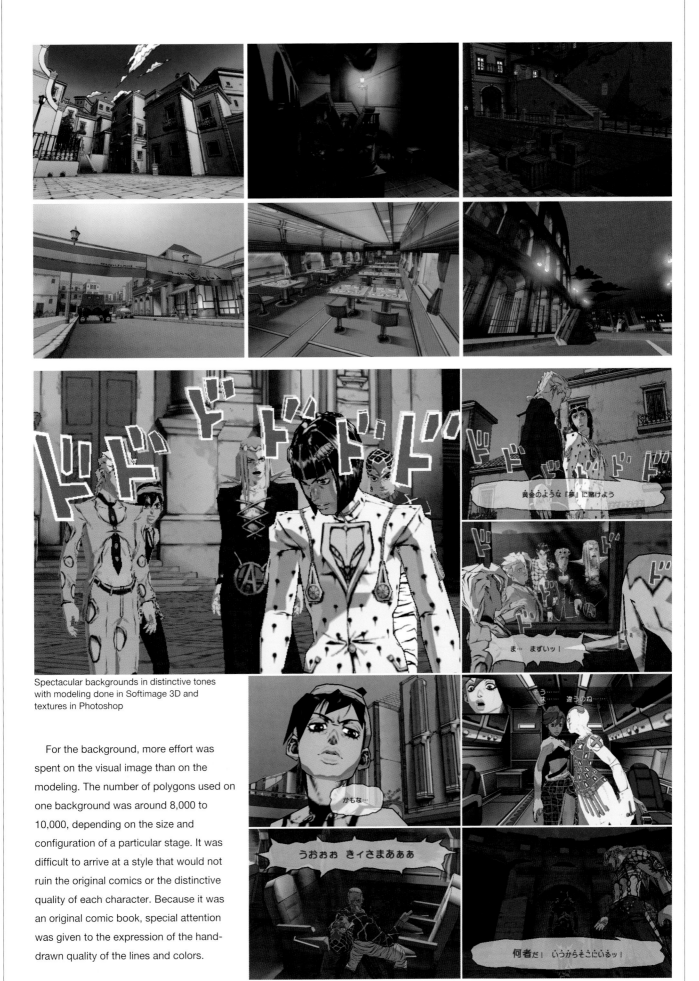

Spectacular backgrounds in distinctive tones with modeling done in Softimage 3D and textures in Photoshop

For the background, more effort was spent on the visual image than on the modeling. The number of polygons used on one background was around 8,000 to 10,000, depending on the size and configuration of a particular stage. It was difficult to arrive at a style that would not ruin the original comics or the distinctive quality of each character. Because it was an original comic book, special attention was given to the expression of the hand-drawn quality of the lines and colors.

Onimusha 2:
Samurai's Destiny

The sequel to the slashing samurai survival action game, "Onimusha 2" is set in the early summer of the first year of Taisho. The hero, Jubei Yagyu, returns to his hometown, village of Yagyu, only to find it devastated and turned into hell. He learns from a mysterious woman that the chief of phantom devils, Nobunaga Oda, was the man who destroyed the village. Yagyu sets off on a journey to destroy the Oda. "Onimusha 2" is similar to other action games in that the player eliminates enemies to clear the stages. However, the graphics quality, story depth and fun features of the game have been upgraded tremendously. The most notable feature is Yagyu, who is played by Yusaku Matsuda, and his overwhelming presence. His trademark action and distinctive voice are equally employed. Moreover, the attractive characters and their interactions with Yagyu are another one of the game's highlights. This title will undoubtedly become one of the all-time favorites on the PlayStation 2 platform.

platform	PS2	made by	CAPCOM

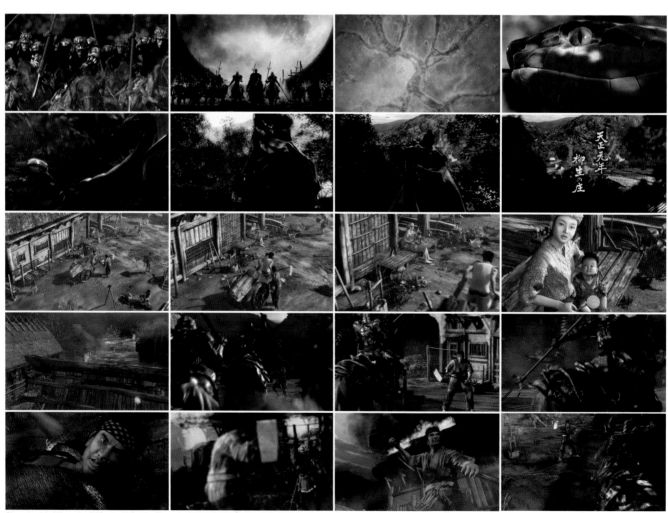

Character Jubei Yagyu by © Yusaku Matsuda office saku © 2002 CAPCOM CO., LTD. All Rights Reserved.

A production system that incorporates many ideas

Mikitaka Kurasawa—who had produced the opening pre-rendered movie of the previous title, "Onimusha" (which translates as "Devil Warrior"), at Links DigiWorks before transferring to Robot to develop commercials and movies—accepted the offer to re-produce the overall pre-rendered movie for "Onimusha 2."

The opening title is the most important element in the movie. Capcom wanted it to include both a storyteller and a character introduction. Kurasawa felt it was necessary to have movie direction to help develop the worldview and drama of "Onimusha 2" and so he asked Capcom to appoint Ryu Kaneda to direct this title.

"I had the chance to meet director Kaneda because he supervised the middle and the end during the finishing process of the first 'Onimusha,'" Kurasawa recalled. "When we talked, his movie philosophy made a deep impression on me. What I still remember is that he explained clearly,

though theoretically, about his own thoughts towards movie-making. And I've been waiting for the opportunity to work together with him."

Since then, both men have been exchanging opinions frequently (including during a drinking party) and sharing a great deal of empathy with each other due in part to their close ages. As a result, Capcom readily agreed to appoint Kaneda as the CG movie director. Although Kaneda had drawn a horror picture for the movie "Boogiepop Phantom: A Requiem (Sleep Ends Everything)" before, "Onimusha 2" was only his second time working on a historical film. (His first time was the original "Onimusha.") Furthermore, since the opening title of "Onimusha" won the prize at the SIGGRAPH Awards, he felt that he would have to take the overseas movie market into consideration.

"The Azuchi-Momoyama period is something that western people cannot emulate," Kaneda remarked. "Thus, it is a good motif for the overseas market. In that sense, it was a challenging theme."

Extremely rare storyboard hand drawn by director Ryu Kaneda

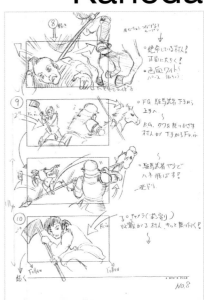

The game scenarios were used as a base for the storyboards, video script and other pre-rendered images. Interestingly, Kaneda himself drew the first half of the storyboards. Not many directors draft their own storyboards, but he used to produce independent animation films when he was younger.

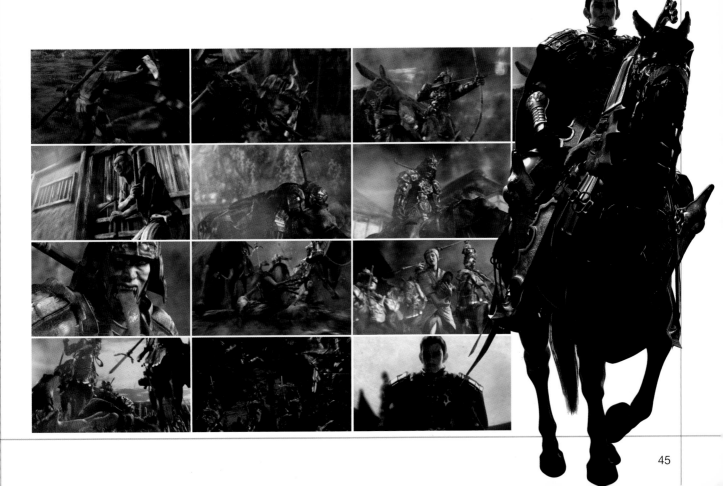

Perfecting
the details to make high-quality
characters

Even the peasant characters that appear in the first half of the opening movie were made to look awesome. Special detailed sketches were drawn for them. Then their distinctive ambience was faithfully interpreted into 3D models using 3ds max, the primary tool used for most elements in the movie.

Using bold technology to create life-like images

The first half of the opening images used in this title is quite brief for a movie. Kaneda employed a different directing style than is normally employed for a movie intro, using shorter and quicker cuts to make them function more effectively when incorporated into the game. Kaneda also exerted much effort on scenes shot with a hand-held camera.

In a live-action movie a cinematographer would usually pan the camera according to the actor's emotions, even during a still shot. By following the actor even when the image on the screen is still, the audience is led into the scene. In the case of computer-generated movies, such a scene would look like it was shot with a fixed camera, and the audience could not feel the presence of the cinematographer.

In overcoming this particular weakness of digitally created movies, camera motions were held by putting a marker on the camera during the motion capture session. Further, the camera motion was converted into motion data material using a conversion script. Concentration was focused on elements such as halation and the dust flying up in front of the camera, with an effort toward capturing what could happen in the real world.

There are many other technical elements worth paying attention to in this movie. One of these is the horse. In the previous version, only the rider's motions were captured and the horses were animated by hand. However, in "Onimusha 2" the staff decided that all of the actions—not only the running horse, but also the rider falling off the horse, and the fight between the peasants and the horsemen—must synchronize entirely.

This goal was audaciously pursued. An indoor horse racetrack in Yamanashi prefecture was rented for five days and real horses were used to capture their motions. Since sunlight interfered during the day, the shooting began around five o'clock in the afternoon and continued until two o'clock in the morning. Since the temperature was sometimes below freezing, careful attention was given to protect the horses while capturing their movements. The shooting time was scheduled to prevent the horses from getting too tired, and the ground was smoothed to protect their hooves. Each time the horses would run, the markers on their legs became dirty. Because continuously cleaning or readjusting the markers slowed down the shooting, several horses were used and switched around. Due to these combined efforts, the final action scenes are extremely powerful and make these images worth viewing.

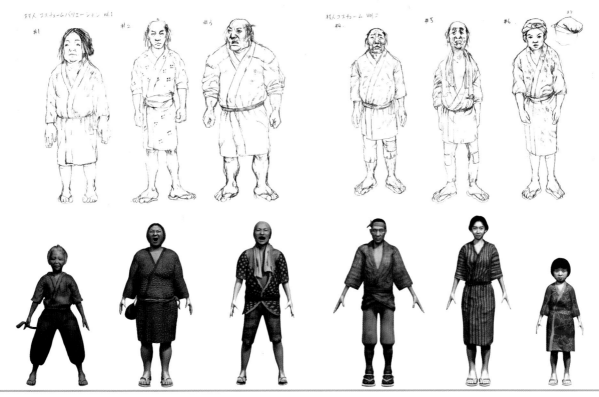

Thirteen models for the main peasant characters were created, with thirty variations. Simple and rough sketches were drawn for each of these models. Young and old, male and female, each exudes a different expression. The characters appear to be modeled after real people.

The final versions of Oda's image, the main character in the first half of the opening movie. Since only 1,600 X 1,200 pixels resolution on 3ds max were used, each window had a large margin. Both camera and track views were very important in the animation work, making this layout more efficient. Oda was built with body armor, and the cape was added as a separate part. Cloth simulation was used to render the cape.

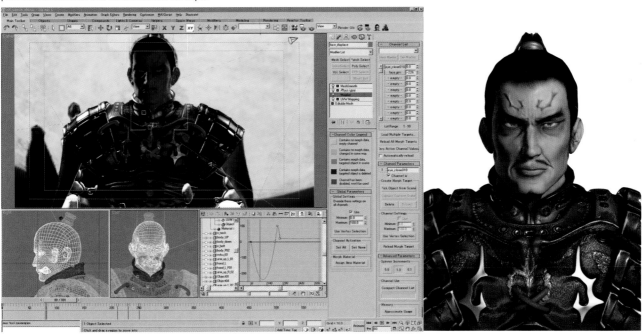

Capturing the horse and the horseman together

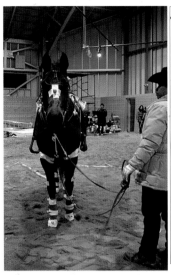

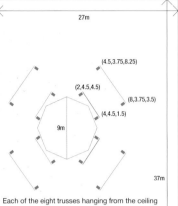

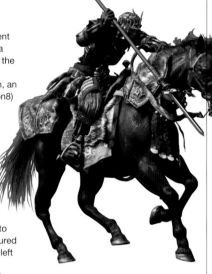

The technical accomplishment in this title is the way camera motion was used to capture the horse and the horseman together. For this production, an optical capture system (Vicon8) in a circular area 9 meters in diameter was set up in an indoor horse track in Kobuchizawa, Yamanashi prefecture. Markers were attached on both the horse and the rider. By making full use of the 37 meters by 27 meters track, every possible motion was obtained. The diagram to the left shows the area captured and the horse track. The far left photo shows the capturing process wherein around 100 different actions were shot.

Each of the eight trusses hanging from the ceiling secured two cameras, for a total of sixteen cameras. The coordinates of four of the cameras are indicated above, with the horizontal, height, and vertical distances in centimeters provided respectively. These values are measured from the center of the image capturing area.

When the staff tried to capture several motions at the same time, the relationships among the markers were often broken. To rectify this, frame-by-frame adjustments of the marker points were captured with Vicon8. This material was then compared with the actual video images. Although the system allowed for automatic adjustments, this was the most cumbersome and time-consuming stage in the process.

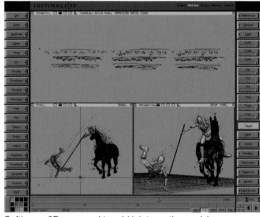

Softimage 3D was used to add joints on the models based on the captured marker point information (C3D files). Here, each of the character's joint information and marker movements were merged, outputting merely the joint motions.

Meticulous configuration of the opening images

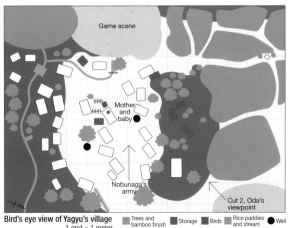

Bird's eye view of Yagyu's village
1 grid = 1 meter

Trees and bamboo brush — Storage — Birds — Rice paddies and stream — Well

Game scene

Mother and baby

Nobunaga's army

Cut 2, Oda's viewpoint

This intricately plotted map illustrates the direction of Oda's army raids, the details of the village and the position of key victims in the attack of Oda's army. However, the scene that featured an army horse dragging a villager was not shown according to this map. This was because emphasis was placed on the directorial aspect of that scenario. Also, image boards were created in advance for effects such as the fire that devastates the village.

Stage creation for the first half of the game

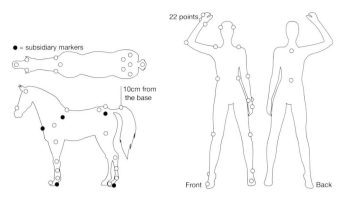

● = subsidiary markers

22 points

10cm from the base

Front Back

These four figures show the positions of all the markers attached to both a person and a horse. The five black dots indicate the subsidiary marker positions. In total 22 points were used for each person and 30 points were used for each horse. In order to maintain the accuracy of the motions, the maximum number of captures was obtained at 2 x horses + 2 x riders + 5 x fighting peasants. It was extremely difficult to attach the markers to the horses.

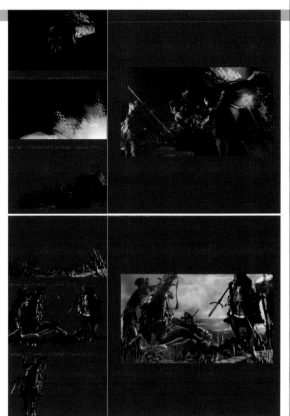

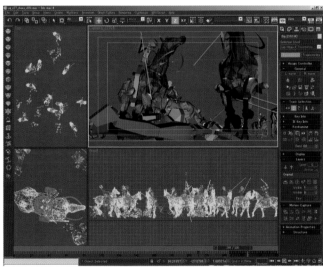

The joint motions of each man and horse were read into 3ds max as 3ds and biped files. Each group of horsemen and horses were created with low polygon data. If the camerawork had not been well manipulated, the movie would not have been successful even if it had incorporated realistic motions. Fine adjustments were made using the camera view image feature located in the upper-right-hand area of the screen.

Final editing was accomplished using Combustion. Naturally, since spontaneous rendering is time consuming, scenes were illustrated in sections and composed later with Combustion. Effects such as fog and dust were delivered in the Combustion rendering process using an RPF file that contained 3D information. This method allowed the rendering process to create more realistic effects in a shorter period of time than would have been possible with 3D software. The individual elements being combined are shown on the left; 3D processing using RPF is shown on the right.

Stage effects for simulating a live action movie

Every cut in the first half of the opening movie is packed with slow focus, out of focus, blur, flare and other effects that give the impression of a live action movie. These techniques are regularly used in movie production. For example, even if the cut was a fixed cut, the cinematographer would apply a subtle effect to add emotion to the scene. These types of techniques were aggressively used in this computer-generated pre-rendered movie. It would be interesting to see which of them was employed by viewing the movie frame by frame.

Creating the second half of the movie

An expert team—which consisted of producer Kurasawa, director Kaneda, and staff at Shirogumi and Links DigiWorks—gathered to create the opening pre-rendered movie of "Onimusha 2." The second half of the movie, which includes the highly stylized Kabuki-like images, is completely different from the first half, which incorporated a story.

The aim of the opening movie was to combine two elements: the hero's village being raided, and the introduction of all of the story's main characters. The second half of the movie was meant to showcase the beauty of the Azuchi-Momoyama culture, such as the glittering world of gold-leafed folding screens, and to introduce the characters at the same time. The questions here were first, how to attractively introduce the characters, and second, how to create a three-dimensional space on a plane. (Should it be rendered in 2D, 3D, or semi 3D?) All members of the production staff were involved in this discussion, each proposing various ideas. They ultimately decided that each character would be molded to perform Kabuki-like actions on a stage set.

Simultaneously, the staff worked on inserting the title shot between the two halves of the movie.

"In a meeting with director Kaneda, we came up with the idea to create an opening movie similar to that of the '007' series but in the Japanese style," explained Kurasawa. "The opening scenes of the '007' series always have short, introductory dramas before the title role. We wanted to create the same kind of flow. After discussing this idea with everyone, we settled on developing the movie this way."

Moreover, in the character introduction part, Kaneda wanted to illustrate something that embodied Japanese culture in the eyes of the foreigner, similar to T-shirts with kanji characters that are so attractive to foreigners. Hence, the characters' names are shown in these bold letters, even though no foreigner would be able to read them.

Balancing between live action movies and CG images

In creating "Onimusha 2" Kaneda attempted to devise a production method for creating a feature-length live action movie that was unlike any other that had been used in videogame history.

"Although this is a computer-generated animation, it was really like producing a feature-length movie," said Kaneda. Just as a director of a theatrical performance would have a staff to direct the stage actors and actresses, Kaneda employed a feature film production team to make this CG movie. There was a staff responsible for knowing the craft of creating CG movies and another that specialized in drama production. Integrating and bringing out the best of these two elements was possible because the teams worked in movies, videogames and CG images production. However, the many differences in the professional terms used by these two industries created difficulties as they worked together.

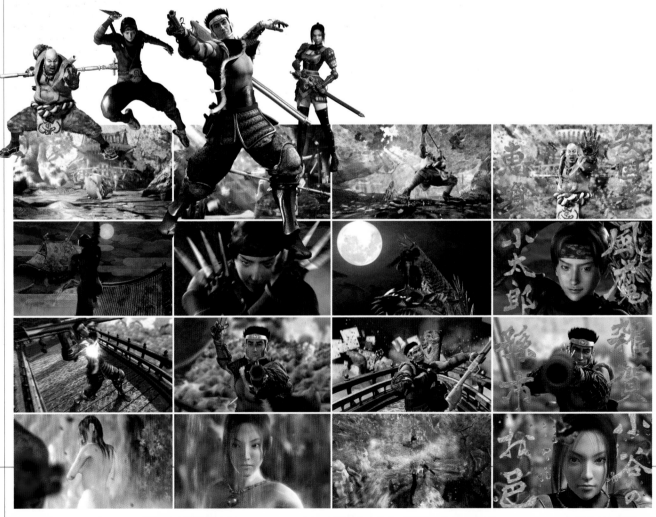

The sword on Kotaro's back is attached at two axes according to the design specification. This allows it to naturally move with the character when animated.

This is the scene where the stage of Ankokuji Ekei rotates and the character of Kotaro Fuma appears. It does not seem like the two were created separately until the scene data of 3ds max is carefully examined. The image above, right shows Kotaro climbing up a rope to the roof of a castle. A dummy object was used for this character. Design drawings of Kotaro and Ekei's temple are shown above, right. One of the castle illustrations is shown above, left.

Creating and seamlessly combining two stage sets

Viewing from the top, it is easy to see how the stage setting descriptions are converted into 3D computer graphics. The arrows show individually rendered images of the temple and a tree on the stage setting. This subtle perspective and superb camera work create an illusion, and allow smooth scene changes.

A bird's-eye view of the stage (right) and two illustrations of an animated scene (far right). "Cherry blossom stage setting" and "enclose with cherry blossoms" are some of the descriptions written on the stage set design drawing. A tough Buddhist priest, called Ankokuji Ekei, is the first character that appears in the second half of the opening movie (far right).

This scene change—from Ekei's temple to Kotaro's castle—was executed seamlessly. The image above shows the shifting stage. Because the two backgrounds were very different in scale (small temple vs. large castle) a lot of finessing was required. The scene data was executed in different scales; likewise, the camera scale was changed. The characters were also rendered in different scales with the camera. After the modeling and animation were completed, the background object was re-scaled and rendered.

With regards to some of the unique aspects of CG image production, Kaneda commented: "What is considered to be post-production work in the movie industry is the real thing in a CG image production. That is the biggest difference. We get to spend much more time in each frame in CG image production. I may try to reproduce the picture in my head. For example, on a computer I can control the weather and a cloud of dust. Of course, what I try to express is the same as in a live action movie, but I can have more fun trying to achieve perfection."

Kaneda divulged the most difficult aspect of the production of pre-rendered images: "Compared with 'Onimusha' the world of 'Onimusha 2' turned out to be much more dynamic," said Kaneda. "The job of incorporating live actors and creating storyboards, and imagining what it would actually look like if these worlds existed was the most difficult part. In the previous 'Onimusha,' we only re-created the characters we could have shot. Hence, it was easy to come up with storyboards when I tried to imagine how they would actually look when animated.

However, in 'Onimusha 2,' I gave more thought to what would happen if I were actually shooting a scene with a camera. For example, what would actually happen if a cinematographer were to shoot an unimaginably huge object? How far would he have to be to shoot it? What kind of lens would he need? I had to simulate such unrealistic shots in my mind, then create these shots. This was difficult."

One can look forward to experiencing the images that the director created with this level of intensity.

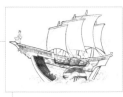
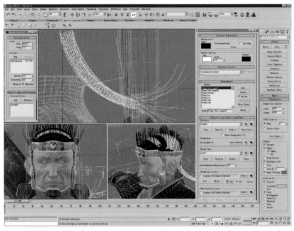

Here, the third character, Magoichi Saika, enters the stage. His character required the largest number of design drawings, including rough sketches of the ship on which he boarded. Ship designs themselves were changed from one drawing to another, some without cannons and others without sails, generating many heated discussions among the staff. Digital illustrations were adapted from the design drawings, evoking the same process that was used to create Ekei and Kotaro. These illustrations are computer-generated. Character modeling was employed at this point to create deliberate stage effects.

As was done with Kotaro's character, the spring controller was used to sway the cannon on Magoichi's back as he moves. Additionally, it was employed on the ponytail on his head for the same purpose. All the elements were studied carefully to clearly show his violent actions.

Creating the cut of Magoichi Saika with an unusually large number of design drawings

Capturing the "beauty of commercial images"

The character images that simulate Kabuki actors on a stage setting are easy to describe in words. However, it was difficult to re-create them in computer graphics, particularly since morphing was avoided as much as possible.
These images were created through much trial and error. For example, the particles and hand-painted animations were tested to create the water droplet effect in one of the scenes.

"We created a 2D anime-style movie that emulated the breaking waves in Hokusai's prints," explained Kurasawa. [Katsushika Hokusai is a famous Japanese artist of the early nineteenth century.] "However, because it did not match the style of the opening movie, it was shelved. What we wanted to do was re-create a real stage setting using computer-generated images."

In pursuit of this goal, the Shirogumi team aimed to bring out what they called the "beauty of commercial images."

"TV commercials are very short," explained animation supervisor Yoichi Ogawa. "They have to pay attention to every detail. Since the images for introducing each character are also short, I aimed at focusing on the beauty of these images—for instance, something that looks like a commercial for cosmetics. The first half of the opening movie was done uniformly in sepia tones to evoke an antique look. For contrast, we configured every element to brighten each character, and intentionally used completely different colors for each one."

Unhappy scenes were used only in the first half of the movie. In the second half, the images were made brighter and were centered around each character. The bathing scene of Kotani no Oyu exemplifies this direction. The process for this technique began by first drawing the storyboards and later creating the digital illustrations. The reason for using digital illustrations was to let each artist in charge manipulate freely the lighting and colors within the limits of the setting for each character. Each production scene was divided among different artists.

"Since each character was developed separately, we created digital illustrations for each scene in order to provide coherence. Based on these illustrations, each character was assigned to one artist, and that artist was given the task of creating the background and textures. Once all the images were completed, the lighting artist checked the overall quality of the images," explained Ogawa. The production work was divided into a tree-like structure, with specialists performing different tasks.

This production method, which makes it appear that one camera was used for continuous shots, can be seen in the entire second half of the movie. First, the character was set in a different scale on the same background. Then, a bridge was built to make it look like it was shot with only one camera. This technique was not mastered well, however, and therefore posed as one of the most difficult stages in the production, according to Akira Iwamoto, the CG director. This opening movie took fifteen staff members nine months to create. For a layman this seems like a small staff to create something with such immense detail.

"The movie is four and a half minutes long. That is to say we created thirty seconds per month. I do not think we were too few. In fact, we had to be able to create that much per month. A TV commercial crew could produce one thirty-second commercial per month with three to four people," said Ogawa. This brave statement can only come from a man who was able to accomplish such a painstaking project.

Wide variety of plants in the Jubei Yagyu scene

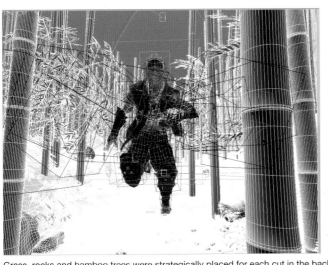

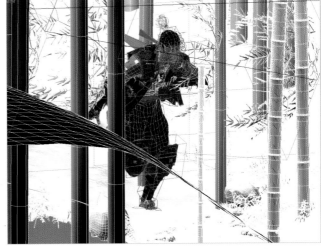

Grass, rocks and bamboo trees were strategically placed for each cut in the background of the last scene, Jubei Yagyu, in the movie opening. The wind-blown bamboo trees were created with a plug-in called Tree Storm, developed for manipulating trees. This plug-in consists of more than 330 types of trees in its library, converts a tree variety in seconds, and even allows the user to freely control the number of polygons. It also lets the user configure trees to automatically flow with the wind. However, bamboos were not included in the library. Therefore, the tree had to be covered with Tree Storm, using a separately built model. The movements of the grass were added with a free script called Blow Grass. This script automatically adds a random blowing grass animation effect.

Re-creating the beauty of cosmetics commercials

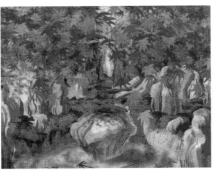

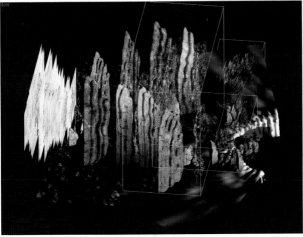

The fourth character, Kotani no Oyu, is in a sensuous waterfall bathing scene. As previously mentioned, this scene made the best use of the "beauty of commercial images" philosophy. These images include the design drawing (top left); digital illustration (top right); and the working screen on 3ds max (bottom). Although they are flat objects, the layers of stage set trees create an excellent depth of field.

CG movie director/
film director
Ryu Kaneda

ROBOT
CG movie producer
Mikitaka Kurasawa

Shirogumi
Animation supervisor
Yoichi Ogawa

Shirogumi
CG director
Akira Iwamoto

Links DigiWorks, Inc.
Motion capture supervisor
Kazuhiko Minou

Panzer Dragoon: Orta

One of the big hits for the Xbox platform is the latest sequel of the "Panzer Dragoon" series—"Panzer Dragoon: Orta." Through unbelievably beautiful graphics that are manipulated in real time and Xbox's performance, you can control the dragon to shoot the enemy. "Panzer Dragoon: Orta" was designed for HDTV output and 5.1 sound channel for maximum effect. Smilebit Corporation's other two Xbox titles—"Jet Set Radio Future" and "Gunvalkyrie"—also feature spectacular real-time 3D shooting scenes.

| platform | Xbox | made by | SEGA |

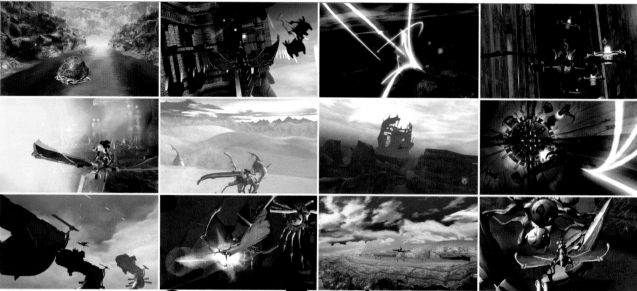

Game in Real Time

Adjusting the videogame production for Xbox

Smilebit Corporation was in the process of changing their working method, including their use of software, in order to develop a title for Xbox. So, when the team decided to develop "Panzer Dragoon: Orta" using Xbox, the first step was to find out the capability of the hardware. They soon discovered that this tool is capable of processing an increased number of polygons as well as enhancing architecture through texture treatment.

Up to this point, Softimage 3D had been their main tool. However, the team decided to use 3ds max along with Softimage 3D in order to deal with the large number of polygons and the new four-layered architecture for textures. The programmers explained the capabilities to the designers, such as the use of shaders in Xbox, and they gradually learned what was and what was not possible.

"When I said that I wanted to fly into the clouds like in the movie 'Laputa,' they told me that was not possible," laughed Kentaro Yoshida, CG designer and stage designer who directed the background graphics. Takashi Iwaide was the chief designer and character creator for the dragons and enemy characters.

Naturally, there are some functions that Xbox cannot accomplish. However, its new

Creating the hero dragon

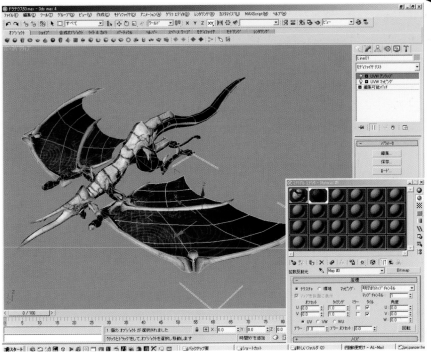

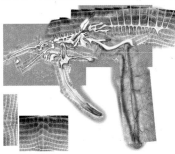

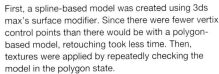

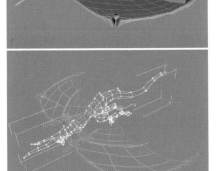

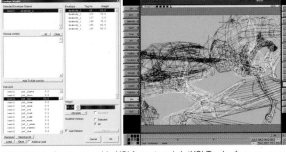

First, a spline-based model was created using 3ds max's surface modifier. Since there were fewer vertix control points than there would be with a polygon-based model, retouching took less time. Then, textures were applied by repeatedly checking the model in the polygon state.

Once spline modeling was achieved, UV editing was flawlessly completed, even with the small number of vertices. In the morphing process, Deep Paint 3D was used to avoid distortions even if the vertices were moved by the same UV values in creating a texture.

After the work was saved in XSI format and dotXSI Trader for max was applied, Softimage 3D was employed to add weight and create motions. Since the dragon morphs were made in real-time, bones and shapes were both utilized. Almost 200 bones, more than double the number used for the other characters, were used to allow detailed morphing.

feature of having four layers of texture was a huge development and allowed the creators to dramatically push for a higher quality of graphics production.

The team tried to achieve textures that were not possible with real-time rendering, by applying Radiosity rendering to one of the texture layers. Through this they had to learn high-end

pre-rendered computer graphics production methods, such as the currently popular Global Illumination. With the introduction of Xbox and its increased graphic capabilities, a new era of real-time computer graphics production for video games has arrived.

Certainly, production processes are changing. Because Xbox graphics are

based on DirectX, as long as a GeForce3 is installed on the PC, the textures and movements can be checked on the computer without using Xbox. This is a huge advantage that not only saves time and effort, but also allows for production to operate smoothly from the start when there are often not enough computers available for development.

Using a PC to check the final images: a production method made possible only with Xbox

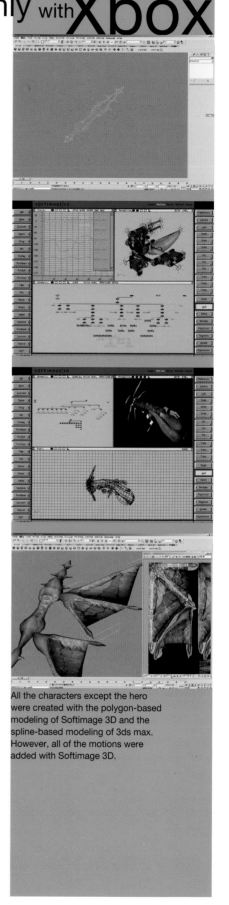

Since Xbox runs DirectX, as long as a GeForce3 graphics board is installed, the final images could be checked on a PC. The figures above show the viewer displaying the images in the same quality as on an Xbox. There was no need to output to an Xbox; therefore, this process was much more efficient.

After motions were added, materials were applied using the desired tool. From bottom to upper right: a shader was selected, then materials were applied to each texture layer.

All the characters except the hero were created with the polygon-based modeling of Softimage 3D and the spline-based modeling of 3ds max. However, all of the motions were added with Softimage 3D.

Quality to match the hardware

Iwaide explains the reason for primarily using 3ds max to configure the texture: "When we studied how to produce the quality to match the hardware, using 3ds max was the best choice. Of course, Softimage 3D is still a great tool for animation, but in managing the four-layered texture architecture, max is more flexible and easier to use. In this production we were able to organically combine these two tools together."

While making "Panzer Dragoon: Orta" the team accumulated much know-how about creating graphics for Xbox. Therefore, users can have high expectations. Before production for this title began, Sega had developed a Windows CE–based operating system for Dreamcast and two other Xbox titles. For this reason, the team consisted of highly talented programmers who understood the DirectX architecture fully and were able to create the beautiful graphics in this title. "Panzer Dragoon: Orta" is an Xbox title that only Smilebit Corporation and Sega could have produced.

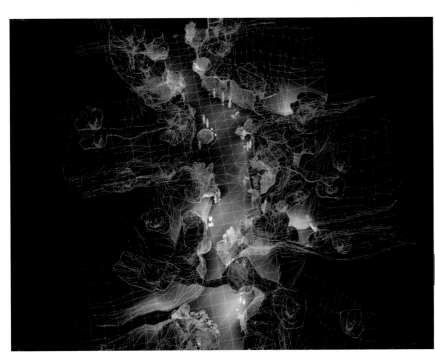

Almost all of the map backgrounds were created with 3ds max. A stage was assembled by lining up around twenty blocks for one major block. There are about 10,000 polygons in each block.

Superb stage maps

The figure above shows a file specifying shaders for multi-mapping all parameters and blending methods for models. The team made more than a hundred of these just for terrains.

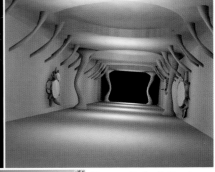

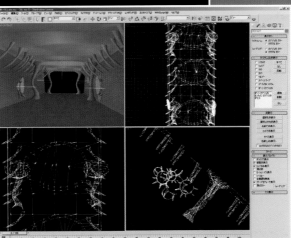

Because Radiosity Render was used to render the texture, realistic shadows were re-created even in real-time. The texture was applied using Multiply as one of the multi-maps rather than by simply pasting it for a realistic look. Images rendered with finalRender were also used for textures.

Event Editor

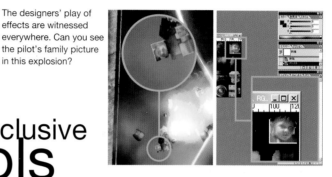

Event Editor was developed to create events and progress the story. Models were output after basic motions were added using computer graphics software. Here, the flow of events was realized. Adding fog, light and camera motions are some of Event Editor's functions that were purposely built for directing.

For shape animations, a number is designated to each of the models. These files are later called (by these numbers) and used in each frame.

Creating motions and complementing scenes between them are also possible. There are enough features to create event demonstrations.

The designers' play of effects are witnessed everywhere. Can you see the pilot's family picture in this explosion?

A rare glimpse at Smilebit Corporation's exclusive tools

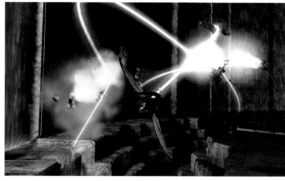

Particle Editor

Effects like explosions are very important in a shooting game. Hence, a dedicated tool called Particle Editor was used to control the particles. Materials were created with 3ds max and Photoshop, imported as sprites and applied on the particles. Generative conditions and movements were configured and physical simulations were created. With Particle Editor it was also possible to create a preview that is close to what is seen on an Xbox.

The effects created with Particle Editor were a living bullet and the lighting effect that fills up the screen. This tool has one version that allows a wide range of effects and another that contains more particles but that has certain limitations; the latter function was employed for filling up the screen.

From top left, clockwise: lighting production, wire frame display, burning effect in the light and vertices colored with 3ds max. The most notable feature is the ready light texture.

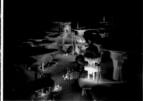

Creating motions with 3ds max

Stage 1
Enemy chase through the narrow passageways of a gorge.

Stage 4
Flying on the side of a huge battleship.

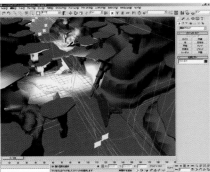

Smilebit Corporation
Design section,
development department
Senior designer
Chief designer
Character creator

Takashi Iwaide

Smilebit Corporation
Computer graphics designer
Stage designer

Kentaro Yoshida

In this production, the planners obtained the data formed by the designers, then added the enemies' motions and route on a stage using perspectives with 3ds max. Normally, a software program would be developed to perform this in-house, but it seemed that 3ds max was easy enough for the designers to understand. The perspectives were created for the game without any modifications.

Applying four-layered textures with Xbox

Because this is a flying game, much effort was placed on creating the skies. In this example, the objects are shown separately. However, in actuality, one object has four UV readings. From the top: the base sky (projected from above), a distant shot of real clouds (cylindrical), sunset glow (additional projection) and clouds lit up with a sunset glow from behind.

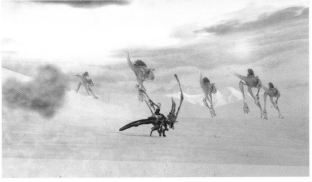

As mentioned earlier, multi-textures became available with Xbox. The figures below show the process of configuring textures to a terrain. The layer structure and the method of overlaying were configured here while the final image was being checked. At the bottom, there are four examples of textures. From left: base texture of a rock, blending texture to avoid monotony, texture showing flickering flames (color animation was configured as well), and blending texture to add fluctuation to the color animation.

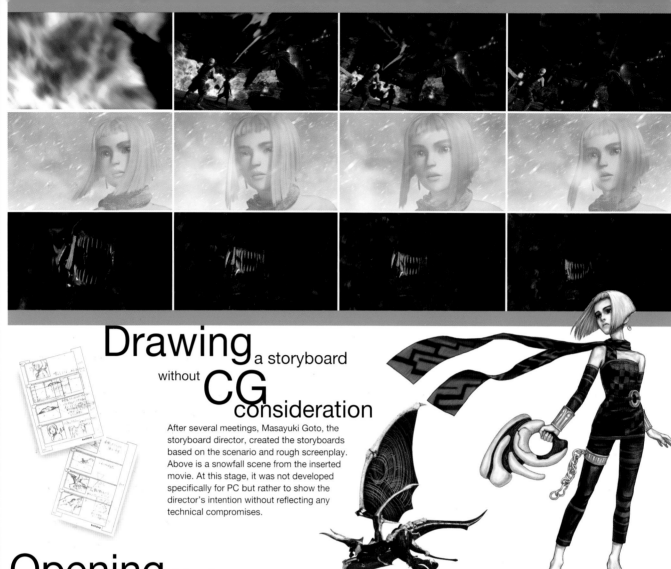

Drawing a storyboard
without CG consideration

After several meetings, Masayuki Goto, the storyboard director, created the storyboards based on the scenario and rough screenplay. Above is a snowfall scene from the inserted movie. At this stage, it was not developed specifically for PC but rather to show the director's intention without reflecting any technical compromises.

Opening Movie

External production stimulates the process

Of the six months spent producing the movie part, three months were devoted to meetings and writing the scenario. Naturally, the team had to create images that were not too different from those that users have in their minds from the previous games. Because the staff for "Panzer Dragoon: Orta" was completely different from the staff of the previous productions, it took a longer time to design the game.

To realize the directorial objectives, it was crucial to communicate everyone's intentions. The key ideas that Shigeru Kurihara, scenario and overall director, proposed in the beginning were: "a sense of speed that could only be possible with a shooting game," "an alien world where biological weapons are used" and "facial expressions of an exotic girl." From these ideas, Smilebit Corporation and buildup Inc. exchanged documents and design drawings repeatedly with each other from the pre-production stage. Meanwhile, Kurihara completed a draft of the scenario, and Masaykui Goto created the storyboards even before the final designs were done. The character designs, including Orta and the dragon, were adjusted based on the motions indicated on the storyboards.

Minoru Kusakabe, 3ds max director, managed the 3ds max team that created Orta's motions, and Akira Suzuki, LightWave 3D specialist, supervised the LightWave 3D team. LightWave was used for action scenes. Takuya Imamura, Orta model designer, modeled Orta using Metasequoia, and Kenichi Kutsugi, facial animator, added all the expressions.

Details were narrowed down while developing animations in this production. For example, ideas such as the battleship dropping the dragon or other detailed machine animations, were exchanged by chatting via Messenger software or by communicating over the phone. The essential elements were realized as production progressed.

There were many trial-and-error phases in the modeling stage, such as adding breaks to Orta's hair in order to emphasize its dryness, lowering her age to create a dream-like atmosphere and placing a lot of effort into the quickness of her expressions and motions.

Once all the characters were rendered, they were handed over to Kusakabe, who was in charge of technical direction. He composited the materials with After Effects.

One notable feature of "Panzer Dragoon: Orta" is that the texture and the atmosphere of the movie are alive in the game itself. The movie was completed first, and its atmosphere was adapted to the game part. For instance, it rains and people run around on the ground when the dragon is flying in the air in the game.

"I wanted a seamless progression," said Kurihara. "We created the actions in the game for them to look just as good as in the movie." The high power of Xbox made all these possible; at the same time it achieved a level of quality that greatly influenced later game developments.

Does calculation with physics make production easier?

The two crucial elements were how to show the powerful actions and the realistic alien world. This is where the creators best demonstrated their skills. One example is in the scene of the raiding dragon in the opening part. The high-speed flying dragon violently destroys a structure that looks like a shrine archway. This impressive scene could be directed easily with calculations using physics. However, making the collapsing wall alone would be problematic. Therefore, the shape, angle, speed and rotation of the simulated smashing dummy object were altered by trial and error.

"Achieving exactly the desired movement requires repeated fine tunings," explained Suzuki. "In some ways it is more difficult than animating each object by hand. Looking back, it was extremely difficult to create a realistic and spectacular collapse. It would have been easier to create just a simple motion. But as long as we were trying to re-create a vision, the task could never be simple—no matter what kind of simulation software was used. It would have been ideal if there was a 'looks cool' parameter."

Not a simple, but rather a "cool-looking," destruction is the key. This "cool" look was accomplished after repeated trial and error and fine tunings.

The realistic camera work also played an important role in creating the ambience. "Panzer Dragoon: Orta" does not feature impossibly smooth camera work, but rather resembles the characteristics of war photography—images that are shaken by impact or that have eye-level close-up shots (such as the dragon zooming in to make the viewer feel like he or she is actually in the scene). Incorporating camera work, direction and techniques from the real world brings a sense of reality to this computer-generated movie.

For the overall direction of the movie, Goto tried to manifest most of Kurihara's scenarios, leaving the technical aspect of the production to Suzuki and Kusakabe. For the team, it seemed better to direct freely, playing with ideas rather than worrying about technical limitations. They were concerned that, after getting adjusted to the production, one would start to see the technical difficulties, and begin to look for compromises saying, "Oh, it's too difficult to make." It seemed wasteful to throw away precious ideas right from the beginning. Instead, it was more important to say, "This is the way I want it." Once the image of the final product became clear, the ideas and ways for realizing them came naturally. After repeated trial and error, they got closer to the original idea.

In order to realize an ideal direction for this title, thorough adjustments were executed without compromises. The powerful images that make one feel as though he or she is participating in the scene are the highlight of this title.

Complex model-making

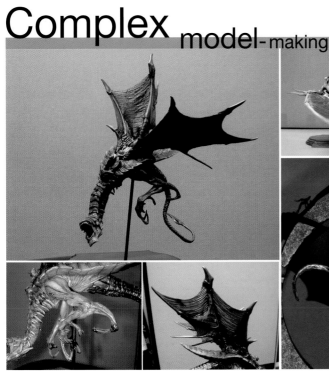

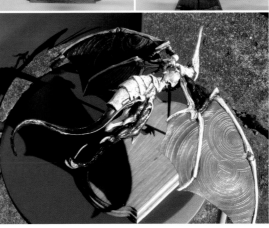

A maquette was built and used to help design the final version of the dragon in the CG production. By making a model, everyone involved in the process was able to create a concrete image," Goto explained. For buildup Inc. as well, which deals with movie and commercial production, model-making became the foundation for starting a production.

First step

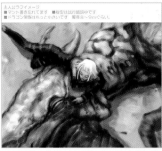

■主人公ラフイメージ　■マント着脱されてます　■試行錯誤中です
■ドラゴン実物はもうちょっとリアルです　■翼長8～9mくらい

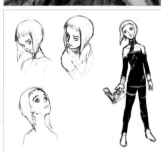

■主人公ラフイメージ　拘束されてるかんじ。
マントは腕ではなく身体の一部。フシギな質感で。

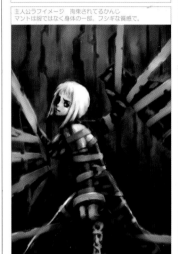

Second step

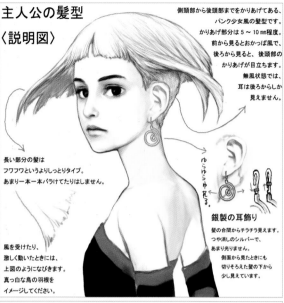

主人公の髪型
〈説明図〉

側頭部から後頭部までをかりあげてある、
パンク少女風の髪型です。
かりあげ部分は5～10mm程度。
前から見るとおかっぱ風で、
後ろから見ると、後頭部の
かりあげが目立ちます。
無風状態では、
耳は後ろからしか
見えません。

長い部分の髪は
フワフワというよりしっとりタイプ。
あまり一本一本バラけてたりはしません。

風を受けたり、
激しく動いたときには、
上図のようになびきます。
真っ白な鳥の羽根を
イメージしてください。

銀製の耳飾り
髪の合間からチラチラ見えます。
つや消しのシルバーで、
あまり光りません。
側面から見たときにも
切りそろえた髪の下から
少し見えています。

主人公の少女　表情集（1）　髪の毛を柔軟かつ自然に動かして、「ヘルメット」に見えないようにしてください。

A、Bがデフォルトの表情です。
一見クールですが、
情感の表現は豊かで、
太めの唇と少々大きめの
「へ」の字口が特徴。

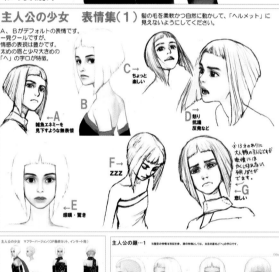

Third step

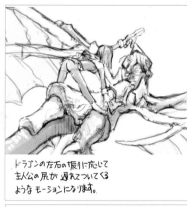

ドラゴンの左右の振りに応じて
主人公の尻が遅れてついてくる
ようなモーションになります。

主人公のドラゴンの乗り方、大きさ対比。

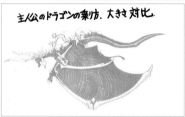

OPシーカー街
主人公の部屋のある塔
周辺の地形

First, the images were proposed by Smilebit Corporation as rough designs. These later became the foundation for modeling Orta. It is difficult to express the details without the actual CG model, so Imamura first presented it, then Smilebit Corporation requested adjustments. Imamura repeated the process several times. In the meantime, cross-reference verification and detailed setup of the design proceeded and all the texture settings, including motion, expression and costumes, were specified. The final design was completed by combining it with the maquette of the dragon.

Invaluable data-setting process leads to the final design

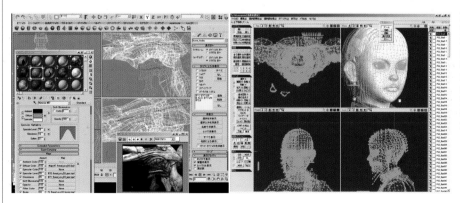

For the CG model, Orta was created in Metasequoia. The dragon was created in both LightWave 3D (regular edition) and 3ds max (detailed version). Orta was later converted to 3ds max so that her hair, expression and motion animation could set up. The dragon animation was also set up in 3ds max, except for its complex movements, which were transferred and set up in LightWave 3D using the conversion tool PolyTrans.

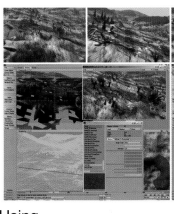
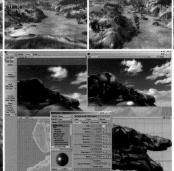

A special model was developed for each cut of the scene of the insert movie to represent the giant creature. Everything was created in LightWave 3D. The operation data for the creature was heavy, as was the data for the cloud (which used HyperVoxels), so the rendering took a lot of time.

Using LightWave 3D to create the heavy creature

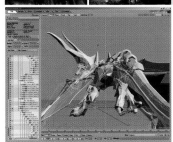

The dragon assault scene in the beginning of the movie was quite complex. Most of the scenes, except for the ones that feature Orta, were created in LightWave 3D. HyperVoxels was used for each explosion, Particle Storm 3: Napalm for particle control and Messiah (left) for the animation. Messiah was especially required for the dragon's joint control (its tail was controlled by about 50 expression points); thus, everyone in the LightWave 3D team had to learn how to use it. Also, calculation by physics through Motion Designer was applied for the scene wherein a shrine archway collapses.

Powerful assault cut actualized by Messiah and Motion Designer

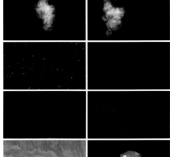
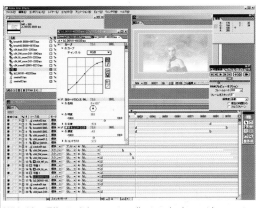

With After Effects, it is easy to adjust each element by subdividing it by type and working on the finishing touches. This becomes apparent by looking at the number of layers. It can also be used for color adjustment, error corrections and simple camera work even after the job is completed. CG production in recent years could not proceed without this composite tool.

Finishing touches by After Effects

Smilebit Productions
Designer
Scenario/overall director
Shigeru Kurihara

buildup Inc.
Designer
Storyboard director
Masayuki Goto

buildup Inc.
CG designer
3ds max director
Minoru Kusakabe

LightWave3D specialist
Akira Suzuki

Facial animator
Kenichi Kutsugi

Orta model designer
Takuya Imamura

Sakura Taisen 4:
Koi seyo Otome

Produced less than one year after the release of the previous title in the series, "Sakura Taisen 4: Koi seyo Otome" (which translates as "Sakura Wars: Maidens Fall in Love") is the finale of this highly popular drama adventure series. All of the characters from the entire series appear in this final game; altogether there are 13 heroines, including Capital and Flower Division of Paris. As with the previous title, the no-loading-time system for movie shifts is outstanding.

| platform | DreamCast | made by | SEGA |

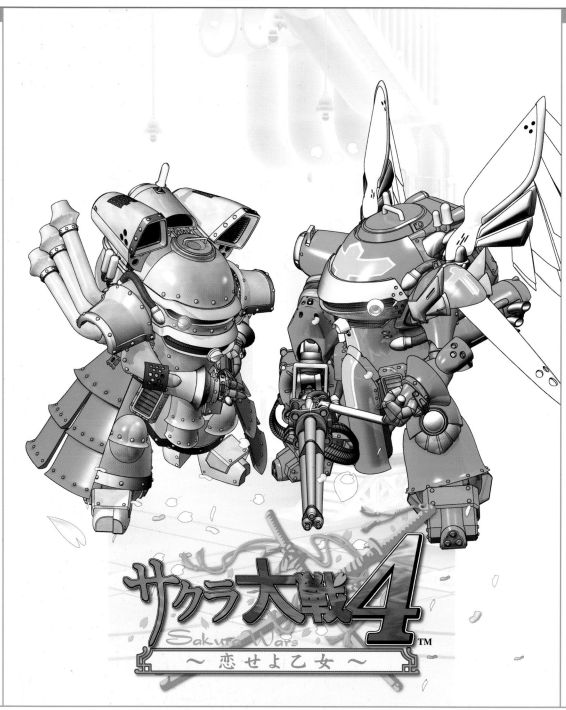

Struggling with the development period

In the production of this title, Overworks took charge of the model making, direction and insert movie making. Production I.G. and IKIF+ handled the 2D animation and OP movie. The greatest accomplishment of the creation of "Sakura Taisen 4: Koi seyo Otome" was the bond that formed among these three teams, earning this title the label "assets of the three."

Because the other teams had worked with Production I.G. in the past, the collaboration was relatively smooth. The teams developed a mutual understanding about the methodological differences between 2D and 3D. This helped reduce the risk of facing a stalemate, especially concerning the quantitative problem of 2D

drawing and retaking. This would have been a difficult situation, especially with a new partner.

The concept behind the movie part was to "create high-quality essentials" rather than to increase the quantity. Naturally, outsourcing specific components might have helped to increase the quantity. However, more importance was attached to establishing a unified quality under the editorship of Overworks. Quality control that responded to the users' expectations was also the fundamental approach for "Sakura Taisen 3: Paris wa Moeteruka" (which translates as "Is Paris Burning?"), which omitted the loading time completely. With this goal in mind, the movie team developed the video compression method professionally, based on the desire to develop a good product with the user in

mind, within all constraints. This concept contributed to the success of this title.

One of the new challenges of this title was to combine other software programs with the main software, Softimage 3D. Since Sega is a game manufacturer—and therefore the final medium is a game—a tool could not be chosen just because it could be used easily to produce a movie. Nevertheless, there were discussions about the necessity of looking ahead, not just remaining in traditional working methods. To exemplify this, the next version of Softimage, XSI, is already in version 2.0. Yet, the function of Softimage 3D compares unfavorably with other softwares in terms of movie making. It was decided, therefore, that it was more important to think ahead in all senses, and not simply upgrade a tool.

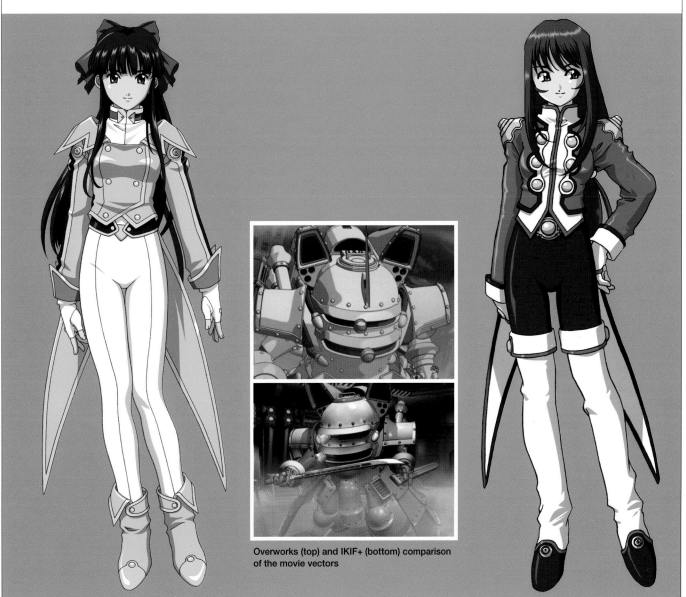

Overworks (top) and IKIF+ (bottom) comparison of the movie vectors

Detailed model expressed as a real object

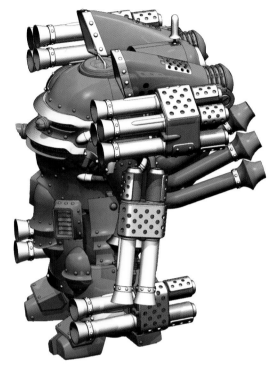

Kohran's machine

Ten of the robots' parts were newly created in a short period in accordance with the design changes. Production began by building the parts in detail, based on the lightweight object called the "unit model," which is used during the game. All of the models were created as actual objects instead of adding details with Bump Mapping. About 600,000 polygons were used to create the numerous parts of Kohran's machine. The model shown below was manipulated by Toon Rendering and required a sufficient number of partitions. Therefore, it was created using Softimage 3D's NURBS and Trim. The perforated parts such as those in Kohran's machine were difficult to develop with Trim. So Softimage XSI's subdivision surface function was applied instead.

These illustrations show the completed posing models with their finished texture settings, and all the parts that were designed to move when activated. They were saved to be readily available for promotion. The production of the 3D background was also prepared, in case it is suddenly needed for a game. It is a merit to have a movie team that cooperates smoothly and flexibly.

The model shown on the right is rendered twice: once with ordinary shading and again with only an outline to blend it. In order to avoid a jagged style, the anti-alias filter needed to be set up higher than it usually would be for outline rendering. After these two methods were combined, the work was completed.

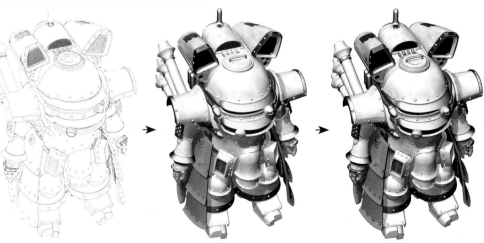

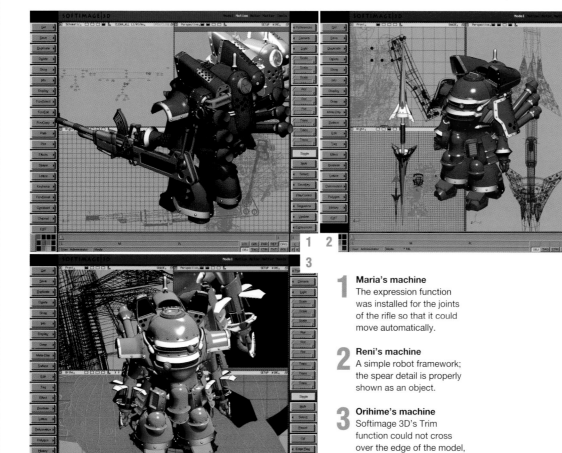

1 **Maria's machine**
The expression function was installed for the joints of the rifle so that it could move automatically.

2 **Reni's machine**
A simple robot framework; the spear detail is properly shown as an object.

3 **Orihime's machine**
Softimage 3D's Trim function could not cross over the edge of the model, so the Subdivision Surface fuction was used for the arm parts.

Resetting for the material the material Revolver Cannon for day and night scenes

The Revolver Cannon, which appeared in the last title, is seen at night this time. For the entire scene, the foreground and the cannon artillery behind were rendered separately to add depth of field. They were combined later with After Effects. Although the detailed parts are quite remarkable, the overall texture settings, including texture and lighting, are all reset in order to apply the original day scene setting (used in the last title) to the night scene. Compare the texture difference in this title from the last.

Takeoff scene from "Sakura jumps onto the model"

The movie making process began by manipulating a temporary character in Softimage 3D, and deciding on the composition, camera angle and motion. Although this stage was provisional, the motions were attached close to the final form in order to complement Production I.G.'s 2D animation director's concept (figure 1). Then, the task was transferred to Production I.G. and the 2D character's movements were developed (figure 2). The composites were brought to the background, which was created simultaneously. Finally, the job was completed (figure 3).

1
Temporary composition in Softimage 3D

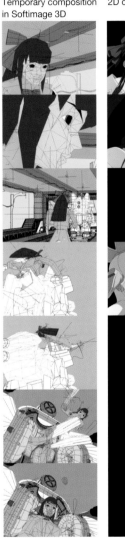

2
2D character animation

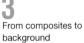

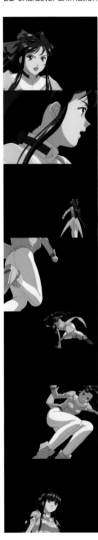

3
From composites to background

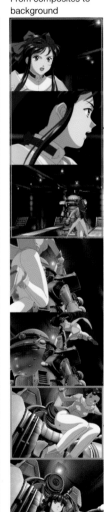

Before adjustment

After adjustment

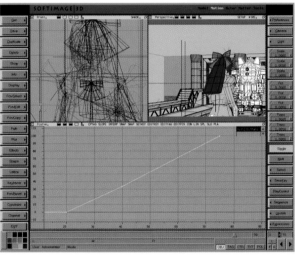

In order to allow 2D characters to blend into the 3D background and the camerawork, the key frame was created intricately in After Effects, and the process of adding color to the background was carefully done in LightWave 3D. Also, tasks like blurring only a few frames back and forth or stacking the image on the layer by transparency degree changes were professionally executed.

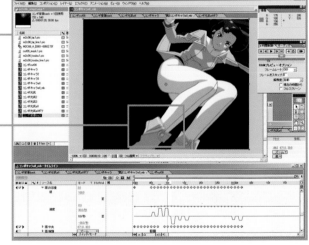

In this title, an attempt was made to allow Sakura to pass right in front of the camera. The level of difficulty of a 2D animation drawing largely depends on the camerawork, so the camera had to be manipulated several times, with Production I.G. checking each temporary animation output and providing suggestions.

Overworks Inc.
CG designer
Movie director
**Takeshi
Matsuura**

Overworks Inc.
CG designer
Storyboard, effects and
system developer
**Tamotsu
Kushibe**

Choosing an expression tool using 3ds max and Maya

3ds max was used to create the smoke in the Revolver Cannon
shooting scene and the voluminous smoke effect was expressed with
the AfterBurn plug-in. The object read the data in Softimage 3D as an
OBJ format. Although the shading information was lost, it was used
only as a mask for positioning.

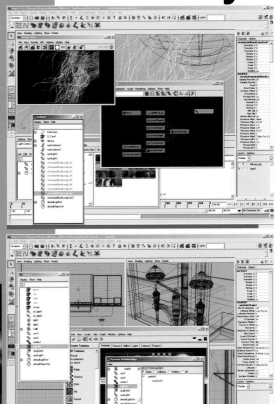

Since the Softimage 3D particle could
not be shaded when layered, it
became a solid texture for creating
smoke. In this case, Maya and 3ds
max were partly used for smoke, fire
and lightning effects. The object and
camera motion were converted and
positioned, then only the effects were
rendered and finished up in After
Effects. Maya was applied not only
for particles but also for paint effects.

Virtual-On Marz

The games in the "Virtual-On" series were initially developed by Hitmaker for video arcades. "Virtual-On Marz" is the first game in this series designed for the PlayStation 2 platform. This virtual-reality action shooting game simulates high-speed combat with gigantic robots—called "Virtuaroids"—which were conceptualized by the esteemed mechanical designer Hajime Katoki. The high-quality game approach, combined with the stylish appeal of these unique robots, have made "Virtual-On Marz" an instant success.

platform	PS2	made by	SEGA

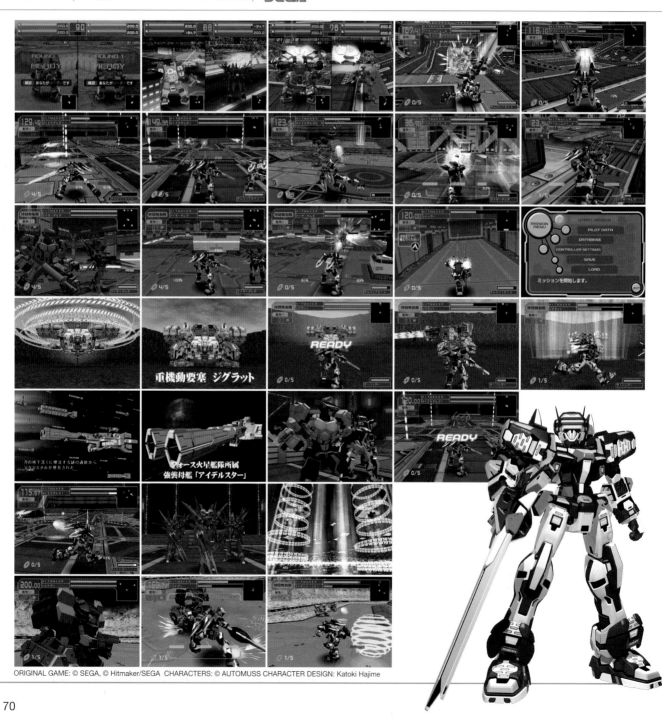

ORIGINAL GAME: © SEGA, © Hitmaker/SEGA CHARACTERS: © AUTOMUSS CHARACTER DESIGN: Katoki Hajime

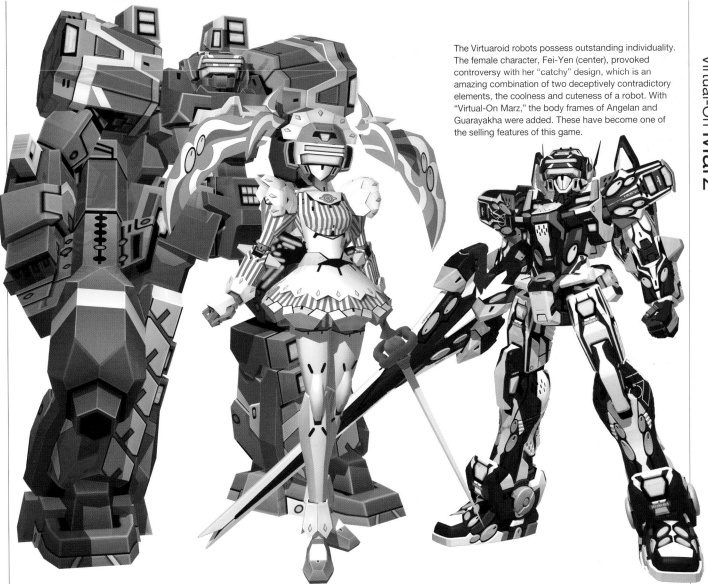

The Virtuaroid robots possess outstanding individuality. The female character, Fei-Yen (center), provoked controversy with her "catchy" design, which is an amazing combination of two deceptively contradictory elements, the coolness and cuteness of a robot. With "Virtual-On Marz," the body frames of Angelan and Guarayakha were added. These have become one of the selling features of this game.

Having robot animation as the theme

The games in the "Virtual-On" series are masterpieces painstakingly created by Hitmaker under Sega's AM3 Department. Hitmaker director, Nobuyuki Yamashita explained that "Virtual-On Marz" was planned and developed as the latest game of the series. However, it takes a slightly different course from the previous titles.

"Since the past titles were created for video arcades, we systematically had to trim down the extra fat," said Yamashita. "For this title, we tried to focus on strengthening the story and direction, while still maintaining the worldview."

The original target audience for the "Virtual-On" series was robot lovers in their early teens to thirties. However, as the series continues, the difficulty level of the games is increasing, which narrows the scope of users.

"In shifting to the new PS2 hardware, we wanted to attract more users and to experiment with this opportunity," Yamashita explained. "In doing so, we conducted a thorough review—from operations to everything."

The main character in the "Virtual-On" series is none other than a robot. "Considering the story and direction of the game, it would have been easy to feature a human character but that would have distracted from the intent," said Yamashita. "Should the main character be a robot or a human? Studying this game, we concluded that having a robot would be more appropriate. We didn't want to spoil the users' attachment towards the body frames, since we assumed they were already accustomed to which pilot supports which body frame, etc." The robots take the lead in strengthening the movie direction and demonstrate their characteristic traits in between stage demos.

"Although the users have responded to 'Virtual-On Marz' both positively and negatively, that's better than getting no response at all," said the designer, Nobukazu Naruke. "I imagine that some users were disappointed because of the reappearances of Fei-Yen and Guarayakha. But at the same time, some users have loved the amount of freedom they have with this game."

"The robot moves very much like a human being. The theme of the motion movie is 'Transformer,'" designer, Yasuhiro Mori said with a laugh. "The conventional user might be surprised by this concept."

1 The first step was basic modeling. To make the robot look good in action, the proportions were set up carefully.

Creation of Virtuaroids

2 Pasting the texture with subtractive colors supported the palette. If necessary, the model could be worked on at the same time. The texture was compiled later by pasting with UV instead of using 1 pixel dot.

3 The texture was adjusted to fit within the regulated amount.

4 The texture was collected into a certain size. "Each body frame has three textures. Compiling large textures was better than having many small ones because they required less memory and effort to manage," Mori explained.

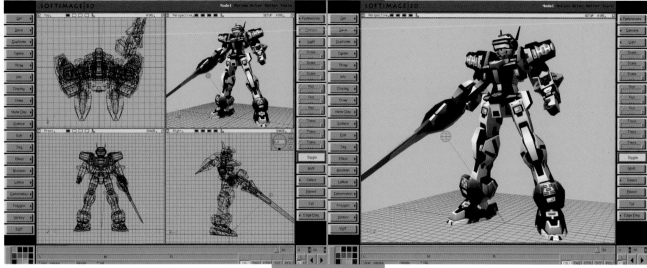

5 The palette was chosen along with the color proofs. The final check was made on the actual machine before its completion.

Simple technique for making the field

Limitations were imposed in many ways during the creation of this game, and the field was no exception. Because of the limited memory capacity, this technique was also used for smooth gradations.

1 Vertex color was applied for rough gradations.

2 The cloud that overlaps figure 1 (left) becomes half-transparent.

3 After adding all the elements, the work was completed and given an acceptable finish.

Solving problems in the series production

The development of "Virtual-On Marz" spanned a year or so, with only 17 people involved in the planning and sound production. Of course, the fundamental parts of the game—such as the models or the movie—were appropriated from the video arcade games. However, it is amazing that the team began their work only having a basic understanding of the PS2 platform.

"In a sense, it might seem crazy that we had such a small team," said Naruke. "But we didn't know how strange it was because it was our first time doing this. [Laugh] If we were working on a game that had already been designed for PS2, then we would not have had such a rough time. But since the original arcade version of the title already

existed, we had a lot of trouble retaining the characteristics of the original game and also visual quality."

This plight was overcome largely because the team was so passionate about the series that they had been working on for so many years. "We worked hard because we all love the job," Naruke said. "Even though we knew it would be difficult, we couldn't stand turning the work over to other people. Sometimes, we were directed to fix the excess parts one pixel at a time.

One of the most difficult challenges that arose during the development of "Virtual-On Marz" was having a small memory capacity. "We got floored by the memory," Mori said. "The texture was supposed to be transported directly, but mirror tiling didn't work because the memory capacity was less than half of what we had with the

previous games. We managed the small memory by using a spreadsheet. We diverted similar motifs like a puzzle in order to re-create a complicated pattern from a few textures."

Having struggled with the troubles that often occur with a one-generation-old machine, the team took extra care not to create any differences from the arcade games. "Of course, we couldn't just retain exactly the same things, so we did whatever we could," Naruke said. "It was better to focus on revealing the most important part than to try to show the whole part, because the end product would have turned out fuzzy. For the close-ups, we made detailed drawings, but for the others, we just pasted them up, and the finished work turned out to compare favorably to the arcade games."

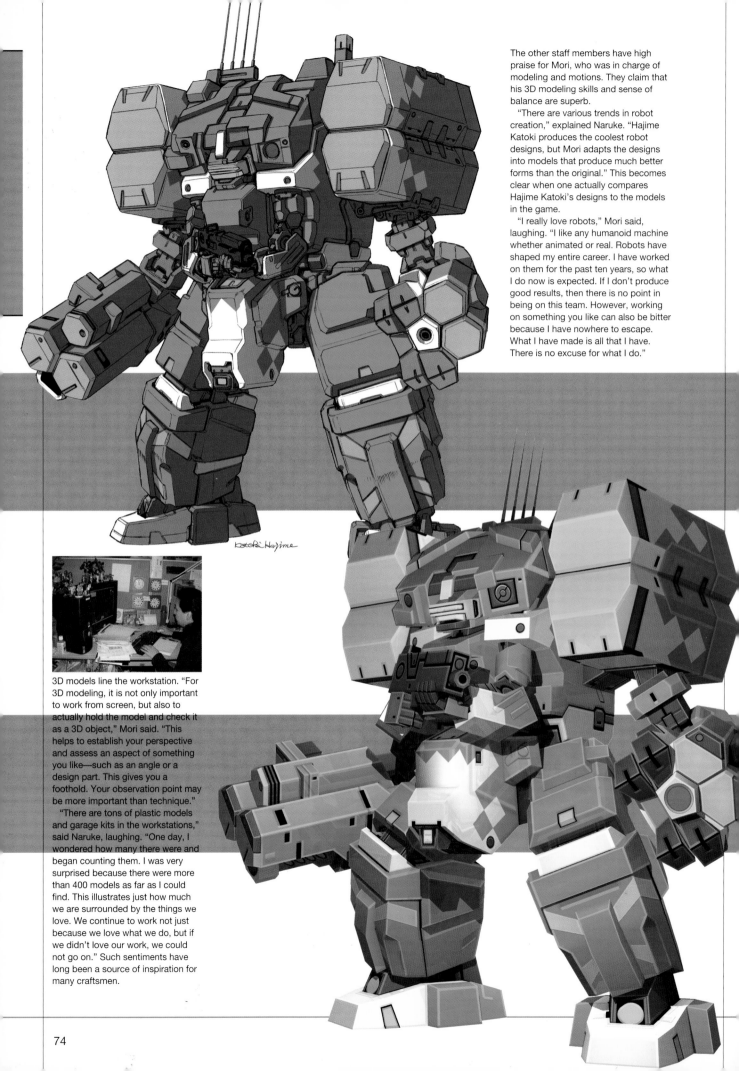

The other staff members have high praise for Mori, who was in charge of modeling and motions. They claim that his 3D modeling skills and sense of balance are superb.

"There are various trends in robot creation," explained Naruke. "Hajime Katoki produces the coolest robot designs, but Mori adapts the designs into models that produce much better forms than the original." This becomes clear when one actually compares Hajime Katoki's designs to the models in the game.

"I really love robots," Mori said, laughing. "I like any humanoid machine whether animated or real. Robots have shaped my entire career. I have worked on them for the past ten years, so what I do now is expected. If I don't produce good results, then there is no point in being on this team. However, working on something you like can also be bitter because I have nowhere to escape. What I have made is all that I have. There is no excuse for what I do."

3D models line the workstation. "For 3D modeling, it is not only important to work from screen, but also to actually hold the model and check it as a 3D object," Mori said. "This helps to establish your perspective and assess an aspect of something you like—such as an angle or a design part. This gives you a foothold. Your observation point may be more important than technique."

"There are tons of plastic models and garage kits in the workstations," said Naruke, laughing. "One day, I wondered how many there were and began counting them. I was very surprised because there were more than 400 models as far as I could find. This illustrates just how much we are surrounded by the things we love. We continue to work not just because we love what we do, but if we didn't love our work, we could not go on." Such sentiments have long been a source of inspiration for many craftsmen.

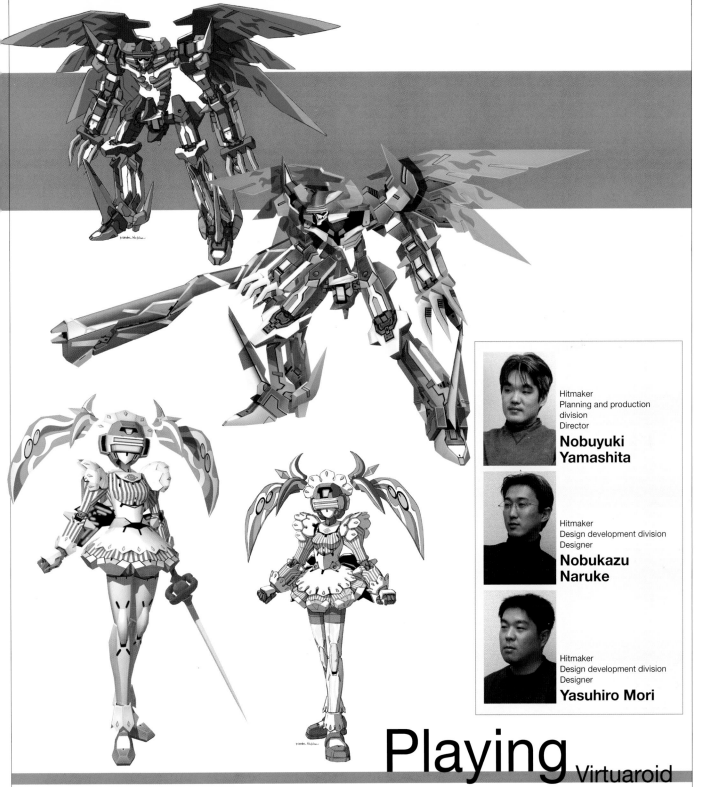

Hitmaker
Planning and production
division
Director
**Nobuyuki
Yamashita**

Hitmaker
Design development division
Designer
**Nobukazu
Naruke**

Hitmaker
Design development division
Designer
Yasuhiro Mori

Playing Virtuaroid

The performances of the Virtuaroids are often too
realistic. In some scenes, they are crucified and
face attack.

Soul Calibur II

"Soul Calibur II" is the sequel to "Soul Calibur," an enormously popular 3D fencing action game that was originally developed as an arcade game. A number of features were developed for the PS2 edition of the game. Motion Blend was added to the 8-Way Run System (which allows 8 different directional movements). This game also features more natural actions—such as simultaneous running or simultaneous walking. And finally, the vertically upright and horizontal cut and blow-off connections were improved to build a new uncomplicated system that reflects the player's intended game operation.

platform	PS2	made by	**namco**

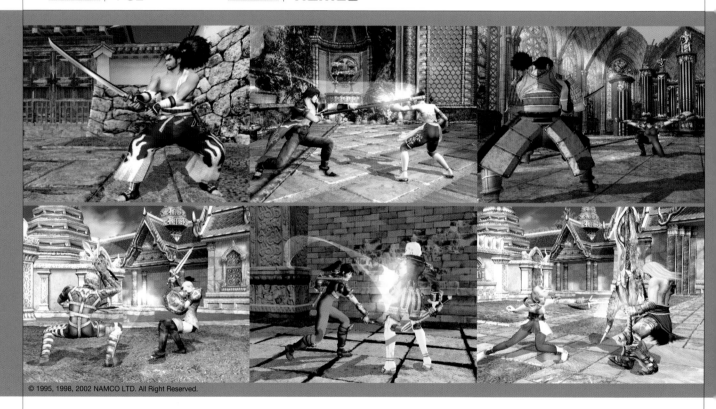

Converting an arcade game to a video game

This series was originally developed as an arcade game. Since "Soul Calibur" (the first game in the series) became popular in the arcades, this monster-themed game was converted into a video game, designed for the Dreamcast platform. This edition achieved a global sales record with millions of sets sold. The sequel to the game arcade edition was also a big hit. So it, too, was converted into a video game—this time designed for the PlayStation 2 platform (although it is also available in the United States for Xbox and GAMECUBE platforms). Because of the sequel and the multiple conversions, several projects were developed simultaneously.

It was early in 1999 when the first arcade game was converted for the Dreamcast platform. At that time, the team had already planned "Soul Calibur II." It took about a year and a half before they actually started the project—late in 2000.

All of the projects were undertaken at once. Since the production staff remained the same from the first game to the sequel, they were able to upgrade and convert the game without changing the worldview or the game image. However, with the projects proceeding simultaneously and the staff members remaining the same, the actual production involved fairly harsh conditions.

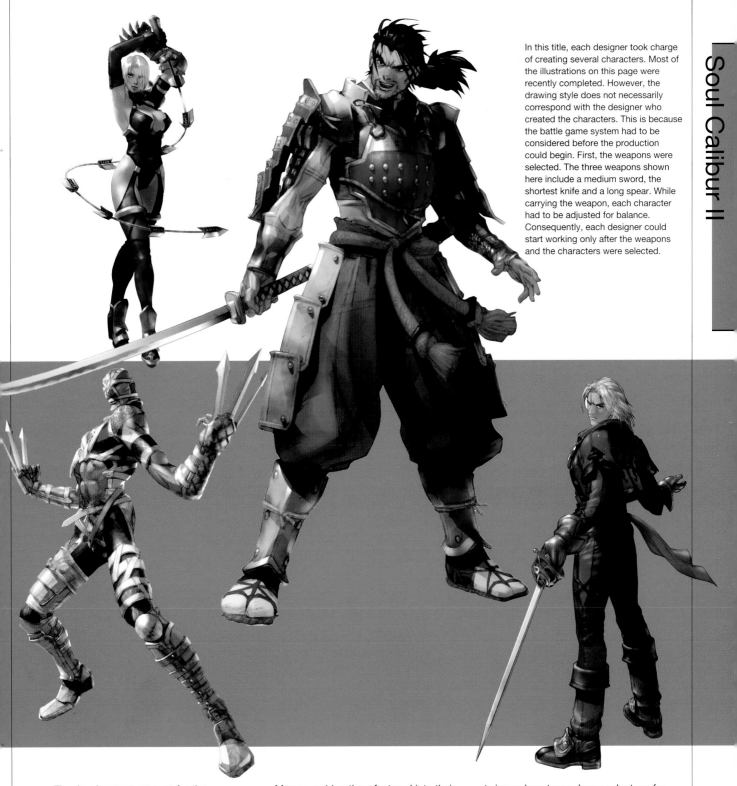

In this title, each designer took charge of creating several characters. Most of the illustrations on this page were recently completed. However, the drawing style does not necessarily correspond with the designer who created the characters. This is because the battle game system had to be considered before the production could begin. First, the weapons were selected. The three weapons shown here include a medium sword, the shortest knife and a long spear. While carrying the weapon, each character had to be adjusted for balance. Consequently, each designer could start working only after the weapons and the characters were selected.

The development process for the converted editions took a lot of time and (unlike with the game arcade editions) there were a lot of restrictions. Moreover, the converted editions were developed during the transition of hardware. Therefore, there was a time when the staff tried to figure out whether they should use Dreamcast or PlayStation 2 as the primary platform software for "Soul Calibur II."

Many considerations factored into their decision to go with PS2. Take, for example, the issue of color setting. Dreamcast is based on YUV color, while designers use full color. However, PlayStation 2 is based on index color and requires time.

Even though the increased polygon counts that are possible with PS2 software helped to enhance the picturesque quality, the workload also increased and all of that consumed considerable time. It took about

twice as long to produce each stage for PS2 platform than it did to produce the same stage for the edition created for the Dreamcast platform. In PlayStation 2 the expressions of the images change depending on the area that is focused on. Therefore, memory allocation was difficult. Because much time had to be devoted to this, the production period for "Soul Calibur II" might seem quite long.

Non-machine-dependent spirit of game creation

Maya was the main tool used in the production of "Soul Calibur II." The plug-ins, when necessary, were provided by an in-house programmer. Most movements were applied from the data of the motion capture process, and they turned out quite realistically. Movements that the actor could not perform (which were mostly physically difficult motions) were created manually. Because of this, "Soul Calibur II" is a high-quality game.

The quality of the character models for the PlayStation 2 edition is six times better than the arcade edition. Specifically, the number of polygons used for one character reached an average of 3,600 to 3,800, while the characters in the arcade edition generally had about 600. The difference is apparent. The arcade edition focussed on the ways in which the motion of a limited-polygon-count figure could be shown realistically; however, the figure is no different from that of an ordinary CG character, and is also reproducible. In addition, this title consists of different backgrounds in the battle stages.

The team did not want to experience a great burden in viewing their designs at a 360-degree angle. They preferred to design using polygons on a line. There must have been stiff competition among the background staff, since the vertex point that can be used per background stage is set to about 20,000 in Maya's data.

Compared with other battle games, the "Soul Calibur" series features special models and a theme. This speaks about the "setup." Without relying on hardware performance, the team placed a high priority on the game's setup. The key component is the characters. They are attractive, support weapons and equipment and make up the stage setting. Plus the background story serves more as reference material. Game users worldwide (who are also fans of each character) motivated the creators to produce the best game they were capable of creating.

In principle, each of the characters was assigned to one designer. This person was responsible for all aspects—from the design to the CG manipulation for the game monitor. Naturally, the person adept at creating beautifully animated girls was designated to those particular characters.

Visual designer Ryouichi Ban's favorite character is Yoshimutsu and he absolutely did not surrender him to anyone else. Ban was responsible for the overall production control. He assigned all 14 characters to 5 designers (including himself).

The number of vertex points for modeling each character was limited. The team was very careful not to extract the points from the meter that was displayed. If a designer relied on the numeric value within the CG software, this could cause the vertex points to funnel towards a part.

For the motion capture process, different actors were appointed to each weapon. It is hard to believe that someone actually performed the elastic movements such as those of the character Voldo. A lot of passion was devoted to the creation of the special weapons, such as the sword; these weapons were designed with the motions in mind.

Game designer
Hiroaki Yotoriyama

Visual designer
Ryouichi Ban

Visual designer
Hiroko Nagao

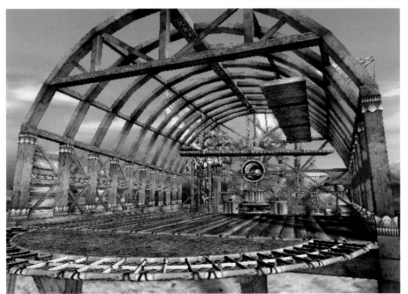

Creating the background for the PS2 platform was difficult. The scope of the production expanded dramatically due to the increase of the indicated vertex points. As a result, the quantity had to be suppressed. Visual designer Hiroko Nagao was responsible for the background design and overall production control. She was also involved in character design and production—especially for difficult and huge creations.

With the character design, extra care was given not to extract the points from the meter that was displayed. For the upper meter, the numeric value was determined by verifying the development tools and by figuring out the percentages of the background drawing capability, character design and effects. Also, the background's distant view was expressed through texture; the whole setting is not dome-shaped, it is more like an overlay of a pan that has been turned upside down on a cylinder. This technique was used—especially for the battle game with its side viewpoint.

Top: Stage closeup

Middle: View from pulling out the camera; the boundaries between the polygons and textured parts are visible.

Bottom: Stage as drawn by the computer

Soul Calibur II

Venus & Braves

To confront the fate of the prophecy granted by the goddess Ariah, the head of the Knights must continue to fight for more than a hundred years. This game—which is the second entry in Namco's Seven Project—features a variety of systems, such as a generation change in the characters who maintain comradeship throughout the passage of time. The mode support network is also available.

| platform | PS2 | made by | namco |

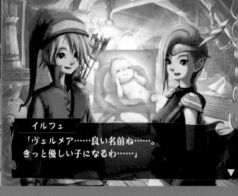

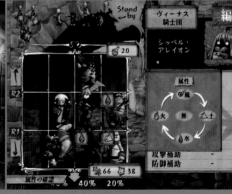

Development of the automatic retouching tool Tanabata

Since the graphics of "Venus & Braves" project a soft image that does not look like CG at first glance, many people are surprised when they learn that they were actually created by an automatic retouching tool. In the first game of this series, "Seven," the background and characters were retouched entirely by hand in order to create the look of manual application. However, the only way to check manual production is to animate it by outputting it to the computer system. So everything was done with one shot and consequently production costs were high, due to retakes or retries. Therefore, in developing "Venus & Braves" the tool called Tanabata was created for the purpose of automating the retouches that were previously done manually.

After using the tool, the staff was even more enthusiastic about the drawing style of "Venus & Braves." Another factor that contributed to the development of Tanabata was that the staff was searching for a way that a digital tool could represent the charm of analog material—such as some interesting aspect or sense of warmth that could not be expressed by calculations in manual retouching.

"We started impulsively without careful thoughts. We were just filled with rapture when the tool prototype was completed," visual designer Akinari Kaneko said, reflectively. For him, so much time and effort was devoted to the development of the tool.

The production of the first game, "Seven," required about fifteen designers. However, since this new tool was introduced, only two designers were needed for "Venus & Braves." If the retouching for "Venus & Braves" had been done by hand, along with the modeling and the motions, it would have created an incredible workload that would have taken almost two or three years to complete.

"We found it very useful for the retouching process—that is, doing the checking by actually looking at it," explained Kaneko. "I don't think we would have been able to complete our work without it."

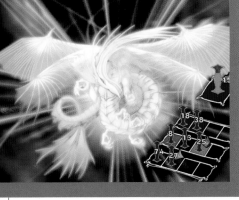

"It's important to present the character in the world," explained Kaneko. "If only either the character or the background stands out, quality may be sacrificed in the end. The background occupies a major part of the screen, so we've proceeded with our work by carefully studying the way to blend 3D characters into the background (now and before)." He further stated that the whole atmosphere must be in perfect harmony, then the character motion becomes smooth.

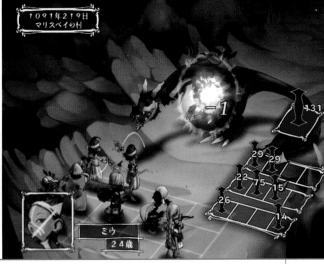

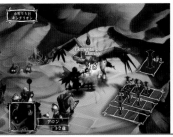
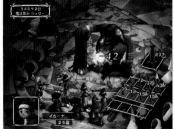

"The customized settings can be saved, but using the same setting changes the differences in model size, shade and roundness," explained Kaneko. "For this reason, it cannot be applied to other characters. So we wouldn't become confused, we created each character setting individually." Using an automatic tool, production cramming became necessary. It was difficult for one designer to take charge of about 20 character bodies, having to decide on each completed form until the very end.

Softimage 3D model

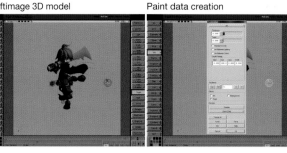

Paint data creation

Ink data creation

Brightness data creation

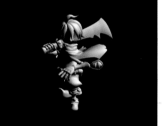

Normal data creation

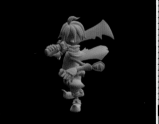

Actual retouching process by Tanabata

First, a basic model was developed using Softimage 3D. This creates four sets of data—paint, ink, brightness and normal data—which are then loaded into Tanabata. The amount to be retouched and the touch direction is supplied to the brightness and normal data in Tanabata. Retouching is applied automatically. The colors are determined by paint data at the time of the final composition, and the ink data acts as the character outline.

As an automatic tool, Tanabata is very simple to operate. However, preparing all of these different sets of data for the number of characters consumed a lot of work. For "Venus & Braves," hundreds of sets of data had to be created. This was four times the number of characters; therefore, setup was done in batches instead of by hand.

With Tanabata retouching can be implemented in the data loading process. Gradation, color and brush size can also be freely customized by using a slide bar to present various touches, and their effects can be checked in real time. The process of discovering one's preferred touch operates just like a synthesizer that is reflected rapidly in a monitor.

Eventually, since the retouching atmosphere changes drastically with a brush, more than a hundred different kinds of brush images were provided. Not only those that were built-in, but also those that were created voluntarily could be loaded for use as brush patterns.

In addition, the animation function was mounted in order to reduce costs. For example, to make the motion in 24 frames, you can check immediately from 24 pieces that the retouching has already been done in a single image of the frame before the sequence starts.

"The tool has so much flexibility yet I still don't feel like I'm handling it well," confessed Kaneko, who actually used the tool.

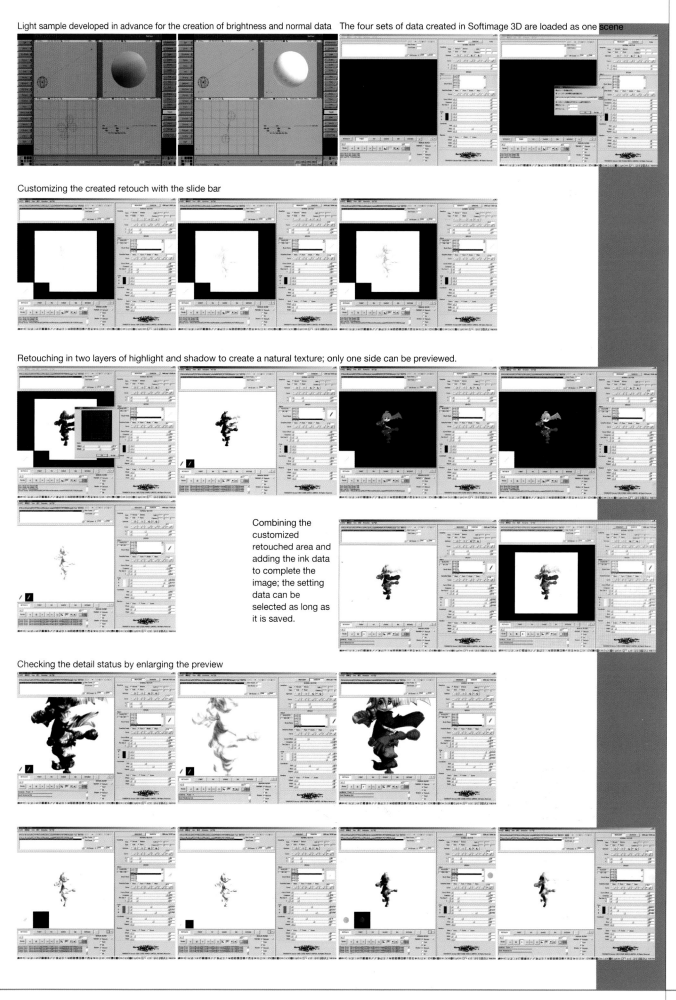

Light sample developed in advance for the creation of brightness and normal data The four sets of data created in Softimage 3D are loaded as one scene

Customizing the created retouch with the slide bar

Retouching in two layers of highlight and shadow to create a natural texture; only one side can be previewed.

Combining the customized retouched area and adding the ink data to complete the image; the setting data can be selected as long as it is saved.

Checking the detail status by enlarging the preview

Retouching
application

Tanabata's amazing versatility was used not only for the game graphics but also for the elements outside the game. "Users praise the high quality of the tool, but as the development team, we didn't expect this much," said Yasuo Ohba of the CT technology and environment group. "Probably, the power of the users made the graphics so good. The users have tried to develop an understanding of programming. Usually, they end up not knowing much about the internal process, but would understand it perfectly if we explained it to them. Because they understand logic, they can provide feedback as tips to the actual process. They are humble about it, but I believe they are handling it well."

Creating the four sets of data in the normal way

Changing a brush or setting to form completely different images, some of which look just like colored pencil drawings

Sample composition that does not seem to be created by an automatic tool

The untold story of Tanabata's development

The process of developing the tool began with the examination of hand-drawn patterns.

"There was a kind of a checklist of 'touch rules' in the production of 'Seven,' but there are countless drawing patterns for determining the rendering method," said Ohba. "Sometimes drawings are rendered with an individual touch. However, most of the patterns were not able to be developed in a certain mode. Because we couldn't make several types of patterns using the CG tool, we specially selected those with distinctive characteristics."

The creators knew that imitating the previous title would not be entertaining. In order to develop a different analog atmosphere and better quality, the team rebuilt their plan from scratch, retaining the previous process as a reference for drawing algorithms. This required a lot of labor, but Ohba, who was in charge of tool development, said that it wasn't developed only by him.

"Thanks to both designers, Kaneko and Hiroki Nagaoka, who developed an understanding of the tool and proposed various suggestions, we were able to succeed," said Ohba. "While exchanging ideas with each other, they dissolved the boundary line between the programmer and the creator. I've never had that kind of feeling before. It was like we were creating together."

They repeated the trial-and-error process and upgraded the version 178 times until the tool was finally completed. The graphics in "Venus & Braves" are the result of joint efforts by both the tool's programmer and the designers.

Namco Ltd.
CT Company Inc.
CT Technology and
environment group
Yasuo Ohba

Namco Ltd.
CT Creator group
Visual designer
Akinari Kaneko

Namco Ltd.
First development division
**Hiroki
Nagaoka**

Here is Tanabata's actual screen, which was built very strictly with a wide range of functions similar to those in a software package. The logo on the lower right side was designed for a realistic effect, and reflects the team's sentiments towards the tool. The name Tanabata came from the previous title, "Seven." It is based on the Japanese Tanabata festival of the stars Altair and Vega celebrated on July 7th.

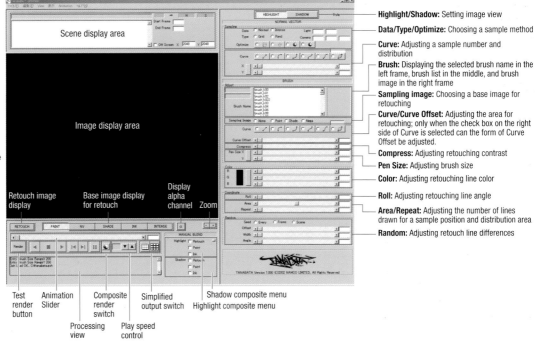

Highlight/Shadow: Setting image view

Data/Type/Optimize: Choosing a sample method

Curve: Adjusting a sample number and distribution

Brush: Displaying the selected brush name in the left frame, brush list in the middle, and brush image in the right frame

Sampling image: Choosing a base image for retouching

Curve/Curve Offset: Adjusting the area for retouching; only when the check box on the right side of Curve is selected can the form of Curve Offset be adjusted.

Compress: Adjusting retouching contrast

Pen Size: Adjusting brush size

Color: Adjusting retouching line color

Roll: Adjusting retouching line angle

Area/Repeat: Adjusting the number of lines drawn for a sample position and distribution area

Random: Adjusting retouch line differences

Test render button · Animation Slider · Composite render switch · Simplified output switch · Shadow composite menu · Highlight composite menu · Processing view · Play speed control

Coming next

Looking back at the production of this title, the team confessed that they had received a lot of attention from the previous staff regarding various aspects of the title and that this encouraged them to go on, even if it placed pressure on them in a good way. They acquired a sense of accomplishment that perhaps exceeded the previous title's.

On the other hand, they also regretted that there were still so many things that they could have done. When asked about their future plans, the development team said that since they had worked so hard on this project, they thought it would be a waste to end it now. They would rather aim for higher goals. They would like to continue to study Tanabata as a tool in an effort to create the elements that seem to have more human touch and drawing capabilities.

So, keep your eyes on the future development of "Venus & Braves" and Tanabata.

Contra:
Shattered Soldier

Since the release of the MD (Mega Drive) edition of "Contra: Hard Corps," "Contra" has been a popular series, having released nine titles in Japan in the past fifteen years. This unforgettable tenth and newest title of "Contra"—the first designed for the PS2 platform—is a brisk action game that brutally shoots the enemies who appear on the screen one after another. The speed of the shooting direction, two-player team play, mortal enemy characters and the 2D game-like presentation maintain the series' burning spirit that is still alive in this latest title.

| platform | PS2 | made by | Konami Computer Entertainment Japan |

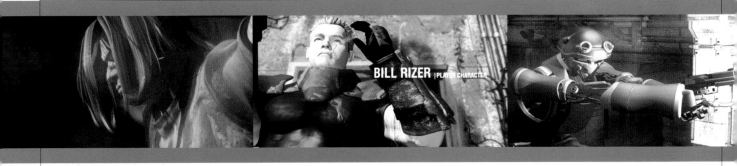

Main movie story

These days people tend to expect 3D presentations in computer games. However, with "Contra: Shattered Soldier" users maneuver within a 2D stage, though the field is in 3D. This allows them to pursue visual intelligence in enemy combat and respond to the action shooting game features like "hitting a target" or "getting attacked by an enemy."

It is difficult to manifest certain elements seriously in 3D—such as "how to avoid bullets" or "when to shoot"—because of the construction of space within a videogame. Consequently, a lot of games have automatic shooting action modes. To overcome users' concern that the excitement of the tactics may be reduced, "Contra: Shattered Soldier" separates 3D space and 2D action. This intentionally revives the thrill of the game.

"Also, the opening movie was created to represent the mood of the entire game and the story behind it," producer Shinya Nakazato explained. "The opening movie is the first scene a user views before playing the game. It's like showing a digest version of what the world would look like by selecting the game highlights. It's also meant to clarify the story plot, which is hard to understand just by playing the game. This title is a shooting game and does not focus on storytelling. However, providing explanations for the background of the battle scene can help broaden the worldview."

The movie team's design

Nakazato's instruction to the staff for developing the opening movie was to "create something hot and cool." In response to this, the preliminary designs of certain characters or mechanisms were created. Usually the design used in the game is applied to the movie, but since some of the mechanisms were modified for the movie, the design that the movie team created was fed back to the game side. Also, the character designs used in the game were prepared in a relatively rough manner so they had to be redrawn to show the movie details.

"For the movie, we designed a robot that transforms from a helicopter, and a bomber. The soldier who appears in the game was also redesigned as a robot for the movie because we didn't want a human character to be shot often," explained director Atsushi Tsujimoto.

After the characters were set up, the storyboard was created and arranged on a timeline so that the video contents could be produced. The opening song was prepared ahead of time. So the movie was made to match the timing of the song (though the song was eventually replaced). Then, the characters and the background of the video contents were transposed gradually into CG data in the order of completion. This method was useful in clarifying which part should be made next.

Storyboard as drawn by director, Atsushi Tsujimoto. Apart from producer Shinya Nakazato's suggestion to "create something cool," all elements were woven according to the desired scene and situation. As a result, the first draft was quite long. The background was designed based on the storyboard, so no image board was specifically created.

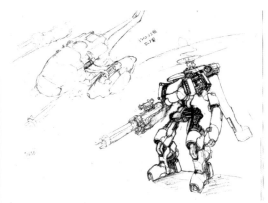

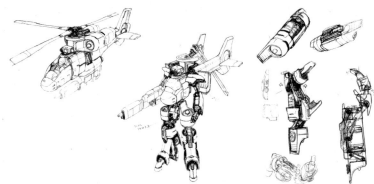

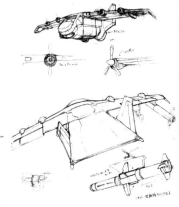

Drawings of the helicopter that transforms into a robot. The present form was established through several rounds of trial and error. The key was to show the transformation and also to design the helicopter so that it took the shape of a robot. The transformation was done by CG but in reality a truly convertible perfect model was produced. In the game, it used a low polygon count, which reduced the complete robot transformation when it was reproduced.

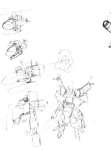

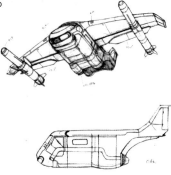

The transport plane designed for the movie also appears in the game.

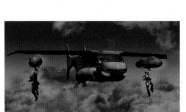

Production tools appropriately used at strategic points

Softimage 3D and Maya were used to create the CG. The reason both tools were used is that the quality of Maya was needed for a certain part but a familiar Softimage 3D feature was advantageous during the production period.

"We mainly used Softimage 3D but for background creation and the representation of smoke and explosions we employed Maya," explained Tsujimoto. "All of the character modeling was done with Softimage because we refined the model structure that was used in the other projects."

In addition, the panoramic view of the enemy's base that can be seen briefly in the opening movie, and the satellite weapon in the end were both created fully in Maya.

Sharing the camera data was managed by first creating a scene in Softimage 3D then outputting only a camera part into Maya. For some parts, after the team created a background, they attempted to reload the model data into Softimage 3D. However, because it was more efficient, most often rendering was performed by each software program then combined later.

Yet, even after they are combined, adjusting a texture (such as for colors) becomes difficult when they are rendered in different software applications. At Konami Computer Entertainment Japan, this issue is resolved by creating the final image in After Effects. Naturally, a certain degree of preparation is also executed in the software itself.

"In a scene that uses both Softimage 3D and Maya images, since priority was given to atmosphere in Maya, the settings were done in Softimage to obtain an image most similar to that which could be created in Maya, then the rendering was performed," explained graphic designer, Takashi Maruyama. "To give a simple example, all lights were set in soft shadow and as substitution for Maya's ambient light feature, the settings for infinity light and ambient color were used. During the data conversion process, we were pressed by problems such as field angle misalignment and slight blur differences, so those parts that were difficult to render in a 3D scene were done manually at the point at which the image was being composed."

Game screen. Although the background and characters were drawn in 3D, for the game, the battle takes place in a 2D scenario.

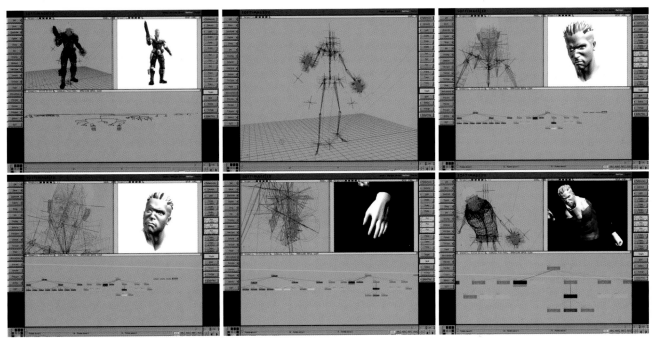

Character model data and setup all created in Softimage 3D.
Top, Left to Right:
 Entire body wire and structure; Skeleton structure;
 Skeleton settings for neck muscles
Bottom, Left to Right:
 Verification of movable range of the neck; Skeleton settings
 for fingers; Skeleton settings for waist

Despite being a human character, the enemy soldier in the game shoots madly in the opening movie, thus, he was changed into a half mechanical robot to avoid having a human character be shot at so frequently.

Illustration of Ashley Wood; character design details were also developed for the movie.

1 Creating an image to be highlighted

2 Creating an image composition for the background

3 Combining a half-sized enemy for the application of Motion Blur

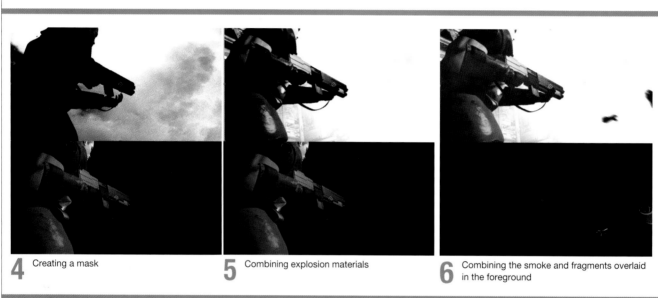

4 Creating a mask

5 Combining explosion materials

6 Combining the smoke and fragments overlaid in the foreground

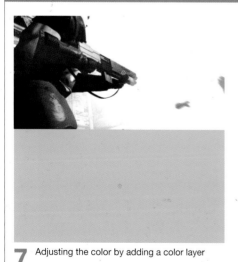

7 Adjusting the color by adding a color layer

Composition process in After Effects; what has been rendered was nothing but a textured layer and adjustments in the composition process create the target tone.

An enemy combat scene showing the production process on the right, and the final image on the left. Even the small effects on the ground required some operations such as dynamics and particle, since motion capture was applied to both the enemy and the main character. Motion capture was also implemented to adopt a natural gesture and behavior, which cannot be achieved by manual work. FiLMBOX was used for rough editing and Softimage 3D was used for detailing.

Sample image of the ground in the cut of ruins; on the left is the drawing storyboard. The storyboard was used to create the background without producing exclusive designs. The outline was illuminated in order to effectively express a building silhouette. "It's kind of a cartoonish presentation," Takashi Maruyama said.

Cut of the sky; the sky and clouds in the background were created in Maya and the airplane in front was created in Softimage 3D. These were then combined as shown.

From Top to Bottom:
Clouds created in Maya. Considering the machine load, the clouds were divided into layers and dispersed for rendering.

The background and the combat plane were combined. This scene features reflected light. Therefore, additional detailed contrast adjustments were required. The airplane trajectory and the clouds crossing over the right side of the screen were created in Softimage 3D and then combined.

Test sample of the clouds, which used Maya's particle function.

Producer
Shinya Nakazato

Director
Atsushi Tsujimoto

Graphic designer
Takashi Maruyama

Cut of the ruins. The foreground was created in Maya and the pit leading to the underground was enhanced in Softimage 3D. The camera animation was created in Softimage 3D in advance, then model making proceeded both in Softimage 3D and Maya. This made the process more efficient.

From Top to Bottom:
Outline drawn on the storyboard

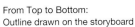

Ground modeling in Maya. In rendering, the masking part was shaded as a green background.

The pit was placed in the base and both images were adjusted. The parts shaded in green were defined for masking and composites. These were combined after adjusting the blur quality and contrast. Then, the low-quality blurred image was applied to enhance the precision of masking and composites.

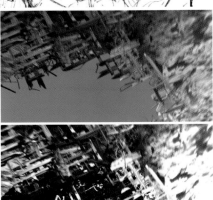

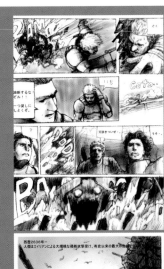

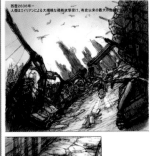

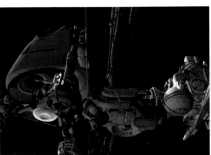 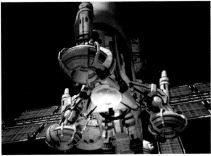

The satellite weapon that appears in the ending was modeled in Maya—as was the entire final scene.

"Contra: Shattered Solider" is the sequel to "Contra: Hard Corps," which was made for the Sega Genesis in the United States. The story that connects the two appears serially on Konami Computer Entertainment's website (http://www.konamityo.com). These pictures illustrate the first episode drawn by Atsushi Tsujimoto.

Zone of the Enders:
The 2nd Runner

By manipulating a giant humanoid weapon, users of this nimble action game beat down enemies one after another with projectile shots and blades. Based on the previous title, "Zone of the Enders," this advanced version allows users to enjoy the defeat of enemy masses through simple operation and quick response. It effectively uses toon shading and techniques taken from "Metal Gear Solid 2."

| platform | PS2 | made by | Konami Computer Entertainment Japan |

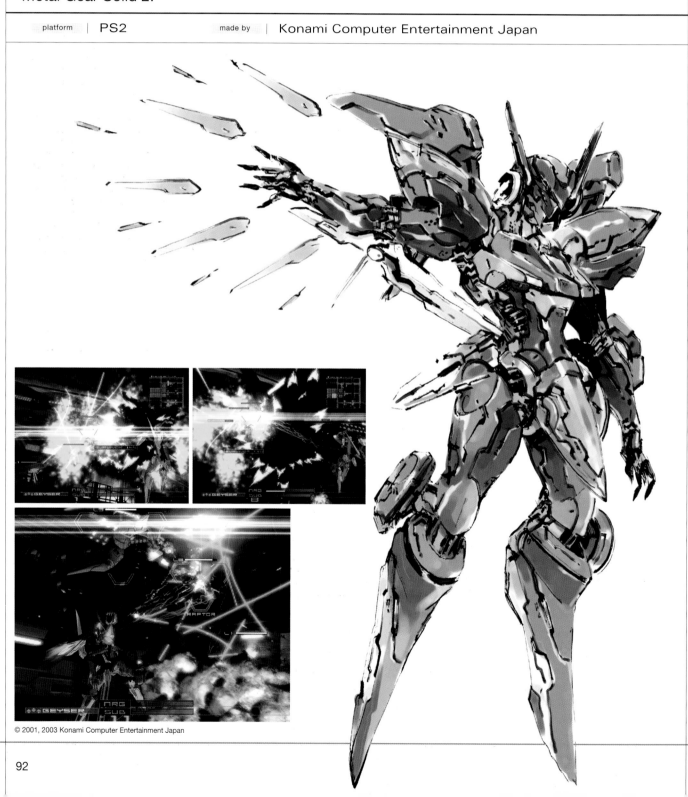

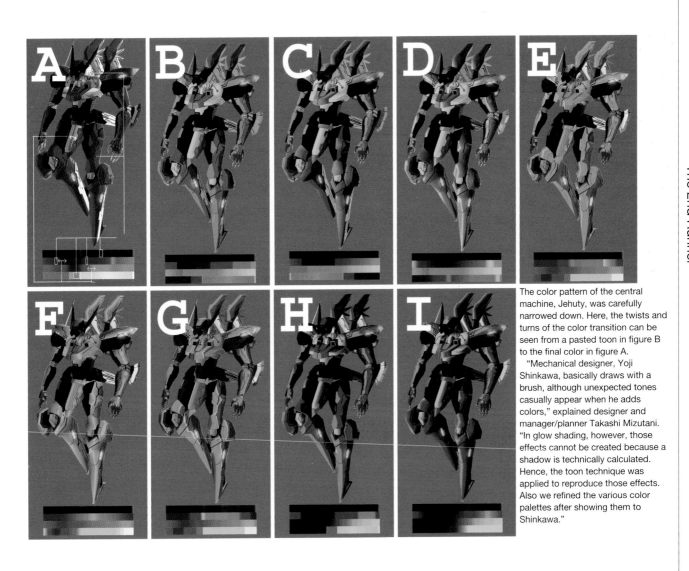

The color pattern of the central machine, Jehuty, was carefully narrowed down. Here, the twists and turns of the color transition can be seen from a pasted toon in figure B to the final color in figure A.

"Mechanical designer, Yoji Shinkawa, basically draws with a brush, although unexpected tones casually appear when he adds colors," explained designer and manager/planner Takashi Mizutani. "In glow shading, however, those effects cannot be created because a shadow is technically calculated. Hence, the toon technique was applied to reproduce those effects. Also we refined the various color palettes after showing them to Shinkawa."

New expression for using toon shading

Using a CG presentation for this title, the team implemented toon shading. This approach had been decided upon at the basic research stage in the game's development. However, some people thought that just using it would not be such a novel approach. After some examination, the team realized that many of the traditional works that used toon shading were animations for kids. Because of this, a guideline for building the so-called "Japanimation-like" worldview in the game was drafted for this title. By making the characters' physical heights and the drawing method (which was based on a comic story) real, yet consisting of an animated taste, a toon was developed that adults would enjoy. Therefore, toon shading was used to eliminate the gap between the animation and the game.

"It's a kind of line that Kadokawa animation used to strive for around the time when Rintaro was a director," designer and manager/planner Shuyo Murata said. "The work of Mamoru Oshii or Shirou Masamune is popular. It's something that the generation we are targeting would love. That's why it would have been embarrassing if we had done it straightforwardly. However, in some cases there could be similarities with our work."

So, which part in this title was created with the toon shading technique? Mizutani gave this answer:

"We used something like a color palette to brighten the areas that light hits, and to darken other areas according to the position of the light. In other words, it's just as it appears in the picture. It's not darkened by light calculation or anything, so when you add the light line only on one area using the palette, or the purple line, which has nothing to do with the model, another line will be added properly on the same area in the model. One benefit of this system is that a designer can freely control, not calculate, a color design for the model. This has helped take advantage of the mechanical designer, Yoji Shinkawa's design. Although it is possible to add a complicated line or a light line by actually hitting several lights on the model even during light source processing in normal glow shading, the calculation load increases a lot. With toon shading, the desired gradation is simply pasted on it without relying on a light source, so we can create the feeling of the model being affected by four or five lights."

Effective expression of an explosion

Widespread explosion

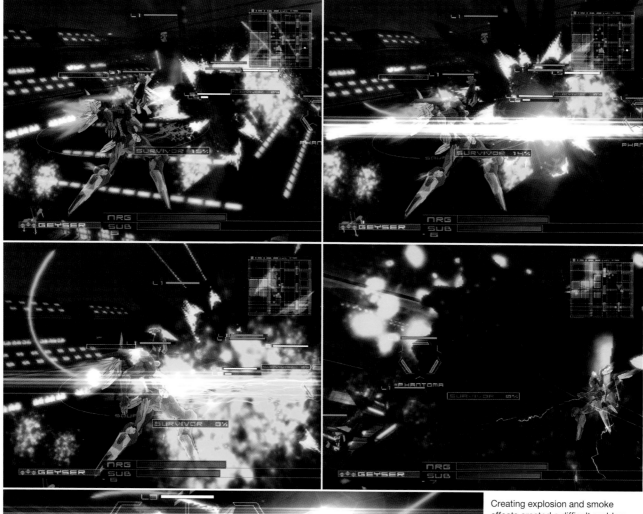

Creating explosion and smoke effects created a difficult problem, but this was resolved with an innovative idea. "The explosion as seen in the front is divided into three different color categories, which overlap in the order of brightness, such as dark, intermediate and highlight," Mizutani explained. "Making this many pieces in a group helps blend the colors in each brightness level. Therefore, its connection to the entire cloud frame can be seen in all its complexity."

Creating animation-oriented effects

As with toons, animated images utilize a light transmission processing effect.

"Because of the beauty of the light transmission, you experience the quality of theater animation," Murata said. "This looks best in a dark movie theater and we tried to adopt that quality."

If hardware with a rapid-imaging speed, such as PS2, was used for the translucent images, light expression could have been generated by layering a splite. However, that would have been completely different than light transmission.

"With regards to the screen image, certain parts were managed by light transmission processing, called 'fragmentation,' which is embedded internally," Mizutani explained. "When a certain numerical value is inserted in alpha on the model level, it allows the parts to be presented in light transmission on an actual PS2 machine. However, since the textured part embeds the fragmentation and causes the light to flash, all of these are calculated by the same single path. This allows the light to be expressed in the same amount of calculation regardless of value. After all, the process comes out the same whether a whole screen or only a part is being flashed. It's more like a 2D kind of process for light expression, but I think this is a new technique we've never used before." In addition, animated expressions are adapted when explosion effects are produced.

"In an animated explosion scene, the colors of the characters are not considered, rather several frames clearly distinguish the lit side as white and the opposite side as black," said Mizutani. "Likewise with a toon, a designer is able to apply the intended color to distinguish the areas. Let's say, if you create a two-tone black-and-white palette, and look at the light source from an explosion up close, the spot becomes white and the back surface becomes black, producing a real-time animated stage in the game. Light control depends heavily on the palette or gradation, and can be created for a rainbow color, for example. This technique can be useful depending on other ideas."

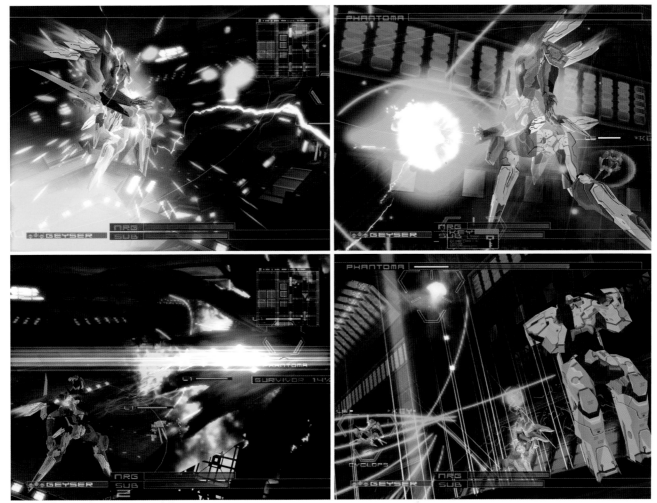

Lighting effects as they appear on a dark screen; a notable feature used not only for flame or attack effects, but also for the background window.

Toon_{detail}

As the toon process is continued, flaws appear. It may not be a problem for the game but they can be highly visible in the demo scene.

"In order to appropriately use the rough and fine perspective detail, the effects created by coloring the model with a color palette and overlapping the line drawing are displayed at the same time," Mizutani explained. "In animations, details are omitted as the picture is reduced, and are filled in as the picture is enlarged. To reproduce it virtually, we added details that fade out as the picture moves farther away."

Naked model

Detail of the naked model and the amount of tint as it changes in gradation

Combination effect with the naked model

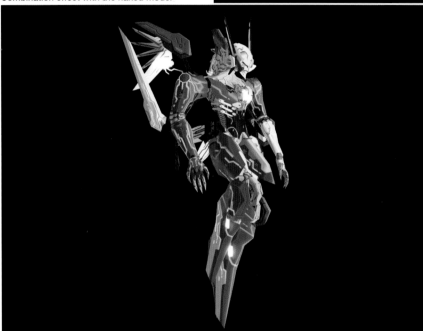

To fill in details, an unusual tool was effectively used.

"If a line is drawn at 20 or 30 degrees for the delicate X and Y axes in the texture, it becomes rough when viewed close up," Mizutani explained. "Therefore, we tried to draw it within the range of fine texture drawing, such as at 45 degrees or as a straight line, but this method proved to be quite troublesome. When we tried to increase the efficiency of the process, we needed to use the tool that pulls out the developed non-distorted UV figure. At first, we tried to develop it manually, but one day we discovered the papercraft software called Tenkai-kun (which translates as 'Mr. Evolution') and we were able to open it properly. That certainly improved our work efficiency."

1 Original polygon status

2 Opening the papercraft software Tenkai-kun; with it, polygon expansion in Softimage 3D became unnecessary and work efficiency was improved. Also, it helped to obtain a finely developed non-distorted figure.

3 Line creation based on a non-distorted developed figure

Demo production

Konami
Computer Entertainment
Japan
Planning unit
Manager/planner
Shuyo Murata

Konami
Computer Entertainment
Japan
Design unit
Designer/manager
**Takashi
Mizutani**

Konami
Computer Entertainment
Japan
Planning unit
Manager/planner
**Kensuke
Yoshitomi**

3ds max and the company's program Metal Gear Solid 2 (MGS2) were used to create the work environment for the polygon demo. 3ds max was upgraded to version 4.2 by adding a function and a plug-in that is equivalent to creating a MGS2 plus.

Making the production flow seamless was important. Both the movie and the music were used consciously to maintain the player's tension and mood.

"Actually we didn't feel the significance of the demo at all in the production," said Mizutani. "Even if we made and represented a silent interval thoroughly in the production, it's not fun until you can actually play with it. Of course, I understand the significance of building up excitement, so we tried to make the demo as short as possible."

The character motion in the demo was created entirely by hand. "We built particular motions into each character in various ways. For example, there is a character called "Nephthys" in this title who does a backflip in the demo. Being able to represent the proper motion of a robot is the advantage of using handmade creations," Mizutani said.

As a distinct feature, the camera tempo can be adjusted to either fast or slow motion by using a plug-in called Frame Rate Control. "This function had been envisaged in MGS2, but we didn't use it because we were afraid of technical difficulties. We expected problems such as sound not following in the end, however, a tool programmer had solved everything. This allowed us to extend sound and time axes. That was very helpful," Mizutani explained.

Dark Cloud 2

A boy looks for his mother, a girl arrives from the future… This is the amazing story of two people who meet beyond time. The fantastic story plot and action battle demonstrate the enjoyment of RPG, while the character and background movie's brilliant quality represents the game's worldview. Even the game system—which includes lots of high-quality, long-lasting entertainment—is endowed with passion.

| platform | PS2 | made by | Sony Computer Entertainment |

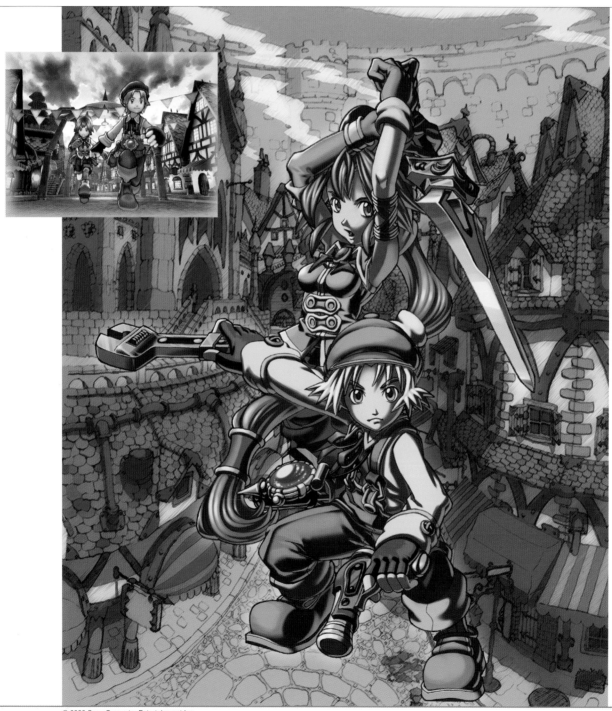

Each character was developed by a single creator

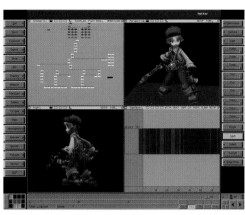

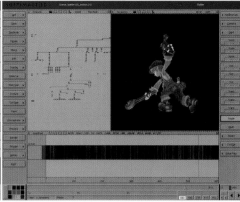

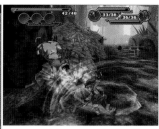

Softimage 3D was used for the 3D CG production. The modeling, texture and movements of most of the characters were developed by a single creator.

Event scene with multiple characters

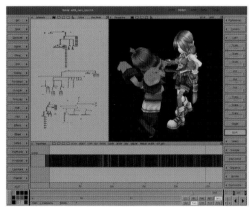

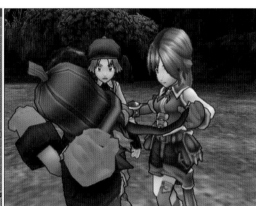

The event scene, which consists of multiple characters that appear and move automatically, was developed by another team that used the data provided by each character creator. The character motion was set manually to produce a deformed comical representation rather than a realistic human motion, which could have been created by motion capture.

Creators' passion for the characters

Level 5, based in Fukuoka, took charge of the game planning and production. The company was established in 1998 and has been getting attention for their work on "Dragon Quest VIII." Following "Dark Cloud," which was released in the U.S. in 2001, this is the second title designed for PS2 software. The production took about a year and ten months, with the CG production happening simultaneously with the development of the game.

The character and background 3D CG used throughout the title were created with Softimage 3D. This software was adopted

for the creation of "Dark Cloud 2" because Level 5 has used it for a long time.

"I personally have been using the Softimage 3D tool for six years, so it was easy to handle," commented Yoshiaki Kusuda, Level 5 chief designer. "We may have felt that it was the only option since Softimage 3D has been integrated into the company environment. However, I think we made the right choice."

Due to their experience with the first game in the series, "Dark Cloud," the staff's skills improved, and their use of Softimage 3D led to a high-quality and efficient production. Also, sharing both the previous title and the event motions provided cost savings. However, much content was added in the

process, loosened up by diverting the previous data. This resulted in a very hectic work flow, with no time to relax until the end.

Also, in this title, each creator was assigned to work on each character's motions, model and texture.

"Working in this production manner, each creator was able to develop an emotional attachment to the character he was developing," explained Akihiro Hino, Level 5 representative producer. "Even the character's facial animation was produced directly by a character designer."

A new team was set up to compose the event scene using the character data, map and accessories provided by each designer.

Event scene that does not interrupt the game sequence

"Dark Cloud 2" does not include a movie. Both the game play and the event scene (which operates automatically without a player) implement a polygon drawing in real time with the PS2 game engine. Obviously, the model data for both the game and the event scene are the same.

"I don't like it when a movie interrupts a game play because it makes me feel like I'm watching a different animation—even if the hero appears in the movie," said Hino. "If an event scene produces a smooth transition from it to the operation scene, then empathy for the game is increased."

The fact that the game and event data is successfully shared with "Dark Cloud 2" is reflected in the event scene even if the player's character costume changes for the game. This has been the major attraction of this title, which cannot be realized by replaying the rendered movie. However, creating this costume change posed production difficulties.

"The costume change caused a headache in various aspects," Kusuda said. "As the production proceeded, we felt that we needed this and that and we just kept adding and adding one element after the other. Perhaps it's our company's trademark to have many people want to make adjustments right until the end."

Quite a lot of data was produced. Also, making the CG drawings provided many creative outlets for the members of the team. The illustration-like shading was performed for CG in a fantasy atmosphere. This minimized the CG taste and realized the representation of soft texture as much as possible. A designer elaborately worked on the textures to illustrate an overall unified feeling. Exhibiting a taste for illustration, the designer also used contour lines similar to those used in cell animation on the characters.

To minimize the CG flavor in each picture, the production proceeded with the greatest care. This approach ended up reducing efficiency and often became counterproductive. Nevertheless, each creator of each part devoted a great amount of time and care to responsibly complete each segment and to bring about a high-quality and fruitful product.

Same data applied for both event and game operation

Event scene

Game play

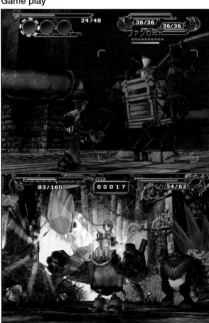

Same model data used both in the game play and event scene; obviously both exhibit the same quality.

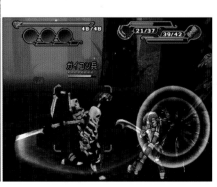

Contour lines indicated in a character model

3D CG model

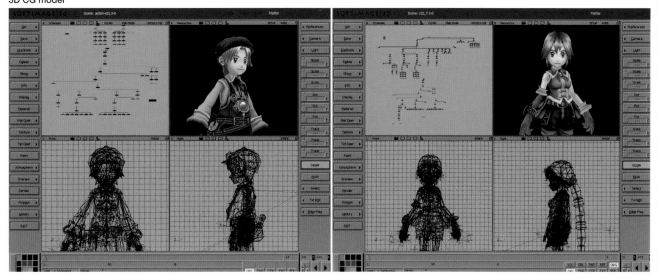

The PS2 game engine often creates a contour line drawing effect. Creating drawings for the PS2 is not very different than the traditional production process involved in making 3D CG. The product is initially drawn in 2D. In PS2 the images enlarge, the silhouetted parts expand, and the colors tone down. After the image is superimposed on the original picture, a scene is created that seems to follow the contours of the bottom image with a thick line. Since the contour line is indicated by an object, modeling needs to be performed by considering the location of the contour line. For instance, the head and neck are created separately to indicate a jaw line.

Elements showing contour lines

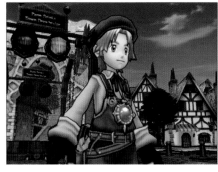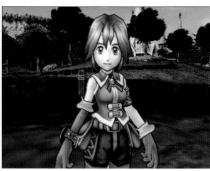

Character model

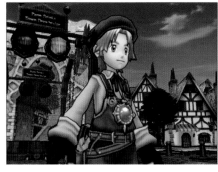

About 2,500 to 3,000 polygons were used to create the character model for the main character, and about 1,500 to 2,000 polygons were used for the secondary character. Their basic bone structures are almost the same: sidebone, backbone, neck, face, a pair of collar bones for the upper body; a pair of upper arms and forearms for hand control; then thighs, shins, legs, and feet for the lower body. The main character consists of bones for mobilizing the fingers, such as two pieces each for the thumb and index finger and another two bones for controlling other fingers altogether. In addition, there is a skeletal frame for the hair and clothes.

Making the background

Line drawing

Source image

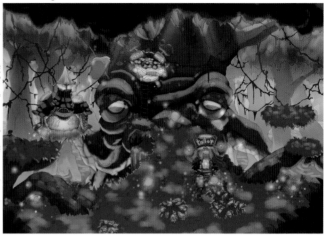

Background made into 3D CG

To create the background, first, a frame image is created in Softimage 3D, generating a picture of a building structure, road location and an overall uneven quality. Then, the contour line is drawn, producing a line drawing. This process is carried out to obtain exact perspective, etc. The elements to be colored in this line drawing become the original image source of the background. From this, the background image is made into 3D CG.

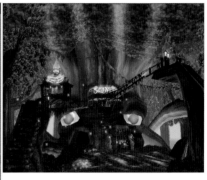

Light expression

Texture

3D CG model

Display on PlayStation 2

The light source that appears in the game is expressed with the PS2 engine. Although in some cases, those parts that become bright or dark have previously been drawn by a texture's vertex color, usually they are hand-drawn by the creator.

Monster character

The model data for some monsters requires a lot of memory.
Therefore, in order to display the image on a PS2 platform, data was carefully eliminated without destroying its appearance.

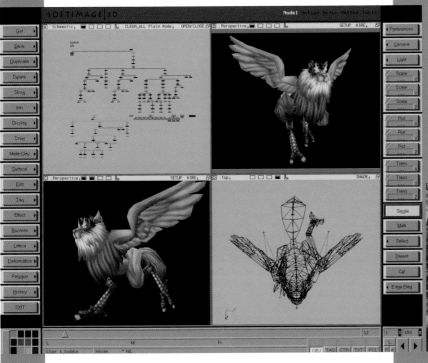

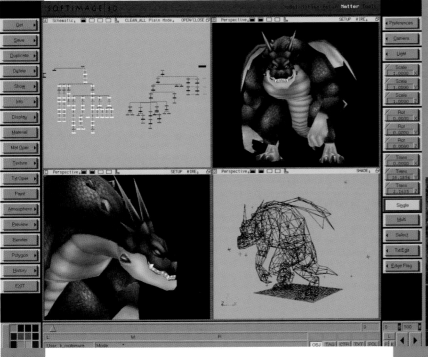

Popolocrois:
Hajimari no Bouken

The romance-animated RPG series "Popolocrois" became popular through its unique character and touching story. As the premier title in the series for PlayStation 2, "Popolocrois: Hajimari no Bouken" begins from the bedroom of Prince Pinon of the Popolocrois Kingdom, fifteen years after the final episode of the previous title. Unlike the previous two games, which featured 2D graphics, the PS2 title in the "Popolocrois" series employs 3D graphics.

platform	PS2	made by	Sony Computer Entertainment

Changing to the PS2 platform

"Popolocrois: Hajimari no Bouken" (which translates as "The Beginning Adventure") was produced over the course of about three years. As it is part of the "Popolocrois" series, the creators took great care not to make any changes in the existing warm worldview, characters and romantic story. When the project was still in the launching stage, there were many rumors in the industry that the creators might change their approach—as it was known that this would be the first title in the series made for the PlayStation 2 platform. (The previous games in the series were made for PlayStation.) The big question was whether they would decide to use toon shading, which was an amazing tool at the time, for their CG creation.

Why was "Popolocrois: Hajimari no Bouken" chosen to be the first title produced for the PS2 platform? The question about whether to switch platforms

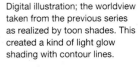
Digital illustration; the worldview taken from the previous series as realized by toon shades. This created a kind of light glow shading with contour lines.

Prototype version screen of "Popolocrois: Hajimari no Bouken," which was created around the time PlayStation 2 was released in 1999; B-spline was used for modeling then. At the game show held that year, it was a surprise to see the game working in real time with toon shading. Eventually, the creators switched to polygons because of the difficulty in model change detailing.

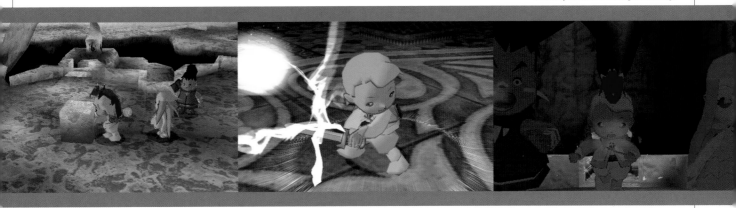

arose during the production period of the previous title, "Popolocrois II," when the producers tried to pass the baton from PlayStation to PlayStation 2. The team felt they had exhausted every means of depicting 2D on the PS, so they decided to design the next game in the series for the PS2, with the use of toon shading in mind.

The PS2 platform would facilitate a number of creative changes. Movie part details could become the mainstream of the game. The creators would not only be able to emphasize 3D, but also could use more camerawork and motion control. In short, the production staff would be able to focus on a direction that would be similar to movie making. The staff started to delve into the field of game expressions. What emerged from this process were ideas for the newest title of the "Popolocrois" series.

In the final stage of the production for "Popolocrois II," it became obvious that it would be unreasonable to continue the series in 2D. However, the project did proceed with the expectation that the next

game would be a PS2-based production, which was supposed to add some dimension to its development. The planning for "Popolocrois: Hajimari no Bouken" began during the final stage of "Popolocrois II" (at the end of 1998)—even though the PS2 board had not yet been developed and the team was not sure about the limitations of certain hardware.

Set in a world fifteen years after the final episode of the "Popolocrois II," "Popolocrois: Hajimari no Bouken" is a story about Prince Pinon, son of King Pietro, of Popolocrois who has survived many adventures, and Queen Narushia, who has a strong bond with him. Prince Pinon experiences his first adventure with friendship and an encounter.

Original software used for the editing tool

Softimage 3D was used to create "Popolocrois: Hajimari no Bouken." Textures were only used for certain parts of

the background and most of them were created with colored polygons. However, sometimes textures were used for the main character so that they can be reflected in the appearance when the outfit is changed. Also, the shadows and the wrinkles of the polygons in some of the event scenes were covered up by texture makeup. The process was sped up as much as possible.

There were a maximum of 10 programmers and 25 designers in the production team. During the production process, first, each character and background was created using Softimage 3D and then integrated with the in-house editing tool. Although the procedure was the same as in making a movie, once the in-house tool was used for integration some elements could be edited without going back to the Softimage 3D. With this tool, the on/off effects and light location could be adjusted in real time. This method has also been used for other SCE game software, with the tool especially customized depending on the title.

"Popolocrois II" was released for PlayStation and was developed with a combination of 2D expression and bitmap animation (left, top). In "Popolocrois: Hajimari no Bouken," toon shading was selected to realize Popolocrois in a worldview using camerawork and detailed movements, and also to continue the worldview established in the previous game. A consistent tone from the field to the battle and events was well achieved (left, bottom).

The background is indispensable to create the worldview. A trial-and-error process helped determine what kind of background matched with toon shading. In the end, a tone similar to an animated background was decided on since the character was a cell animation type. The background was created from a design drawing.

Battle mode as created by toon shading; this was indispensable for unifying the expressions. In fact, a model equivalent to the event scene was used, which was more refined than the field mode.

Effects were written by a program, and on/off settings were controlled on the original tool.

Not all elements were created by toon shading. Some characters, such as the enemy character, needed translucent processing. Toon shading could not achieve this because of hidden surface removal, so hardware shading was carried out especially for that part.

Challenge of toon shading

The character design for "Popolocrois: Hajimari no Bouken" was handed to an animator who had been in charge throughout the series. Initially, there were some doubts about making the characters into 3D. However, creating different 3D models helped to reduce the doubts and increase the work demand naturally.

"With so many possibilities, more things were experimented on," said director Syunji Suzuki, who was in charge of overall progress management and production. "The production team worked hard to meet the demands."

However, perfect drawings were not created right away. CG and the overall

design were both created by mutually adjusting the forms. Of course, during the presentation stage, the motions were considered and the model was shown. The model that consisted of visual motions was exhibited and the technically difficult parts were described.

Further, one of the objectives of this title was to focus mainly on stage direction. Instead of eliminating technique, efforts were placed on the amount that could be reproduced technically in terms of stage direction and there were no compromises. Moreover, while assessing the machine limitations, the staff was immeasurably challenged to produce a movie that livened up the stage direction.

There are various views on toon shading. It was clear from the beginning of the

game's development that "Popolocrois" was not the same as other games. A certain number of polygons were required to use toon shading; otherwise it became rough around the edges. But then, in RPG, many characters occasionally appear all at once on the screen. Since there is a limit to the number of polygons that can be used at the same time, the number of polygons had to be minimized in order to include all the important characters in the game. As roughness in the characters would result in distancing the player from the game's worldview representation, the creators were faced with a dilemma.

So in the end, instead of using toon shading, a shading with a slight glow was implemented to minimize the roughness. The models were divided between those

Character designs developed in parallel with 3D modeling; the lack of coordination in the CG models, the trouble caused by the movements and the appearance developed by toon shading became visible in the CG and the overall design. Above from left: Pinon, Marco and Luna; top far right: a character setup; right center: collection of expressions and right bottom: the actual screen display

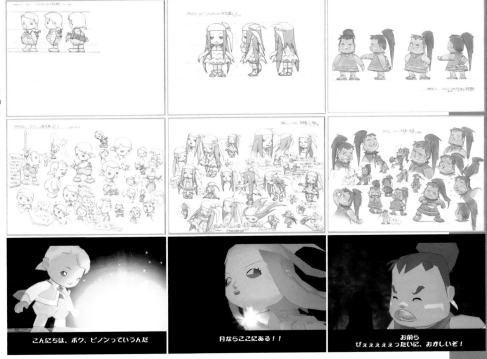

for the event and the battle and those for the field, so a brilliant model was used for the highlights and an ordinary model was used appropriately to maintain the tone.

Discerning hardware limitations

As a new approach, which had never been tried before, the sound was inserted in the bitmap event scene in "Popolocrois II." However, the creators faced a dilemma at this point. Even though a professional was used for the voices to produce the best movie representation, the essential part of the movie turned out unexpectedly: the phonetic expansion was established but there was a problem with the worldview, which remained like a miniature

garden on the screen. In addition, the creators devoted much time to handling the hardware problem. Many days were spent determining, through trial and error, the capabilities of the PS2 platform. Consequently it took a long time to get to the final stage.

"PlayStation is a hardware with a definite limit," explained director Shiro Umezaki, who was in charge of movie direction and progress management. "Maybe it's because we tried everything we could, but the possibilities are limited because of the number of polygons and motions. In that respect, PlayStation 2 allowed us to try as many different things as we wanted to. But we couldn't do everything perfectly, so we tried to maintain a balance for the production. That's why the process took so

long. And the staff in the production team was used to creating 2D games, so this was another reason for the slow work. Speaking of the overall project, one's willingness to be challenged by the work without making compromises was the driving force of this production, and I was glad to see everyone work so hard to create a good product in the truest sense. Going through the trial-and-error process helped us have high aspirations, I think."

In recent years, hardware has advanced and game production has changed. "Popolocrois: Hajimari no Bouken" developed in that transitional process, which makes it contain an epoch-making quality.

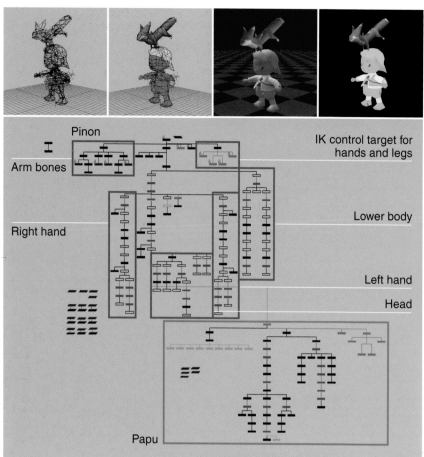

Pinon

Arm bones

IK control target for
hands and legs

Right hand

Lower body

Left hand

Head

Papu

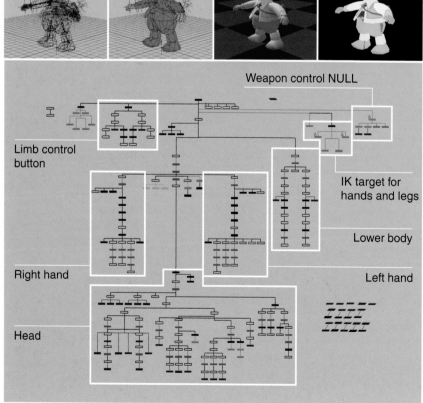

Weapon control NULL

Limb control
button

IK target for
hands and legs

Lower body

Right hand

Left hand

Head

Generally, character shading was performed using a polygon color, except for Pinon, the main character, which needed to have an image with texture hybrid to show the changes in his outfit. Also, lighting and texture were used to cover unnecessary shadows and strange expressions.

"This is a kind of Sonoko Suzuki light," Umezaki said laughing. The structures and models for the characters were slightly different from those for the field, battle and event. The basic bone structure was the same, but the number of bones, IK controls and details were different because of the polygon numbers that were displayed. The pictures on the left show this difference. The upper stage was for the field and the lower stage was for the battle and event.

Left images, from Left to Right, Top to Bottom:
 Wire-frame; differences in the fineness of the model and bone structure can be seen.
 Shading in Softimage 3D
 Normal shading
 Result after toon shading
 Schematic view of the character structure

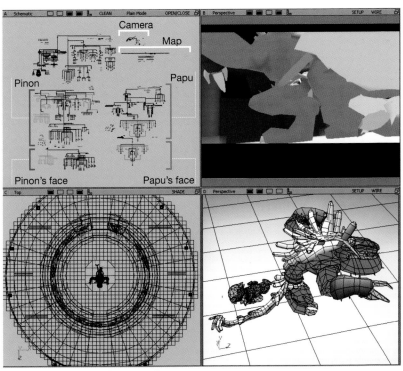

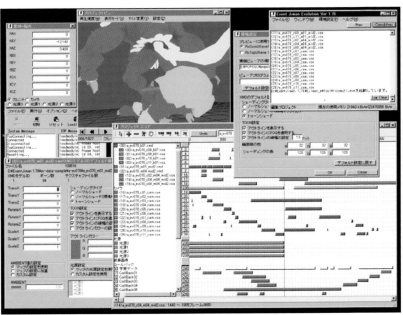

Creating a basic scene in Softimage 3D

Scene created in Softimage 3D; the visual effects in the actual machine were adjusted with the original tool. This is how it worked with Windows; all the settings were transmitted to the development tool T10000 for preview. Visual effects for the characters created by lighting and texture, animation timing and effects and motions editing could all be controlled, as could the contour and method of shading.

All kinds of settings carried out with the original tool

Director
Syunji Suzuki

Director
Shiro Umezaki

あぶないっ！！！

Normal shading

あぶないっ！！！

Creating the worldview of "Popolocrois" with toon shading

Energy Airforce

The unique feature of "Energy Airforce" is that a player is not a combat plane but a pilot. Realism in the plane behavior, cockpit detail and gravity expression were pursued to the extreme—giving the user the feeling of being in control. Intended to be more genuine than has ever before been possible, the game also has an ease of play that is comparable to the best contemporary flight simulation. One feels maximum presence by wearing the head mount display that is included as an option. If you have never been satisfied with air combat before, "Energy Airforce" provides the best "pilot feel" experience.

platform	PS2		made by	TAITO

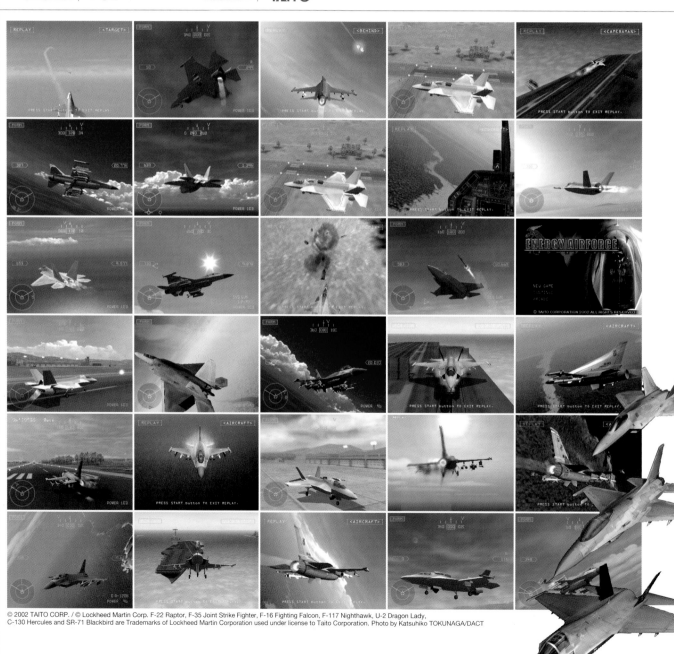

No other real game quite like this

Since the the PS2 platform handles 3D effects, many flight simulations have been released that claim they are real. However, game designer Yosuke Tsuda, who was in charge of direction for "Energy Airforce," said, "Actually, none of these games reproduce various elements that surround the combat plane in the true sense."

What about a PC game? Surely, it is more intense, using a special controller, manipulating the airframe with a foot pedal and playing with multiple displays.

This kind of "flight simulator" pursues a type of reality that has already existed, however. Tsuda explained, "Often these games are difficult to operate and even to fly. The graphics are not very good because the machine power is eaten up by aeronautical calculations."

As a result, the creators of "Energy Airforce" were motivated to fill this void in the marketplace and create realism that could be enjoyed as a game.

Needless to say, PS2 is a high specification tool that has various means of expressions, but it is not enough to represent a vast space such as the one used with flight simulation. The operation is especially difficult with only 4MB VRAM. The challenge is how to maintain quality within that limit.

The solution that the creators of "Energy Airforce" developed was to narrow down the list of elements needed to obtain a realistic representation. "For example, night stage and weather change were not included on purpose, because to make this look good the burden on the graphics would have increased," explained Tsuda. "We drew a clear line on what needed to be created in order to develop a comfortable game."

For a night stage, it is necessary to show a shadow's reflection and light expression, but these carry a heavy burden. The game itself already has trouble processing elements other than graphics in which the behavior of a place was created based on aeronautics. Therefore, such parts were excluded purposely and realism under limited conditions was pursued. One can say this approach has been successful— particularly as it concerns realistic targeted parts and good game response.

Another important factor was added from the middle stage of the game's production. This was the adoption of a function called Head-Action Tracker (HT), which offers a virtual space experience in all directions.

"HT creates a unique representation of reality," Tsuda said. The Sony Head Mount Display (HMD) equipped with the HT function was released simultaneously. The HMD helps players enjoy the vast sky in front of the cockpit, allowing them to experience the virtual cockpit situation. The complete game lets users enjoy the experience just as though they were pilots.

Feeling a sense of atmosphere

One can play the game both from the viewpoint of the cockpit and from behind the plane, but the former is a more spectacular sight. It really gives one the feeling of riding in a combat plane. Even the needle movement of the meters is realistic. For instance, the decreasing level in the fuel display panel accelerates when using After Burner. When using this feature, the camera field angle is different inside and outside the plane. When the field angle is set outside, the meter disappears and when the meter is brought into view, the spatial effect of the external is lost. Therefore, the cockpit interior was drawn first, then the external view was drawn from a different field angle.

Head Mount Display as the major point for increasing a sense of presence

The HMD is the highlight feature of "Energy Airforce." If a player uses the HMD, which features a built-in directional sensor, the viewpoint automatically moves when he turns his head to the desired direction. It is just like sitting in a cockpit. As actually experienced, looking down through the window during takeoff and following the buildings as they pass over one's shoulder is a sensation one has never experienced with a monitor. As the body movement directly reflects right in front of the player's eyes, he can feel a sense of presence for the first time. The attached HT cable connects it with the PS2. The degree of the head rotation is input as a direction button in the controller. Initially, there were some troubles in misalignment and proper view operation, but these turned out to be almost perfect in the end. Moving the view too far causes misalignment but this can be fixed by pressing one button and is not a crucial problem.

Experiencing the Head Mount Display (HMD); TV monitor is set in front for preview.

The view as seen from the left wing by turning the head backwards to the left

[PUD-J5A]
- LCD: 0.44 inch 180,000 pixels with twin LCD
- Virtual screen size 42 inch and virtual distance from eye to screen about 2m
- Input surface S-video with special stereo mini-cable
- Weight: 340g (main device only)
- Contact: Sony Corporation, Inc.
- URL: http://www.playstation.com/

Even with low polygons, Lockheed Martin combat planes remain consistent with the actual plane

F-16 Fighting Falcon

X-35 Joint Strike Fighter

F-22 Raptor

A small gimmick can be used to simulate the actual plane structure. In order to create a huge world through real-time rendering, the maximum number of polygon points that could be applied for a single plane was 2,000; however, the details were successfully expressed within this limit. "Energy Airforce" was made using LightWave 3D and Photoshop (for texture creation). Although most of the textures were developed in a modeler, effects such as burnia for the X-35 vertical takeoff was created with a different object, then built into the layout. These sets of data were output in a special format by using the self-developed PS2 data conversion tool, which combined the texture and the object.

The photograph data was provided directly through the cooperation of air photographer, Katsuhiko Tokunaga, and the aircraft manufacturer, Lockheed Martin.

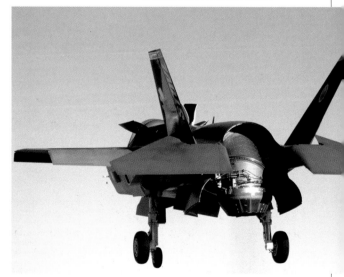

Even the pattern percentage used in the actual plane was completely re-created for the texture. The percentage is generally based on a 4-bit color setting (16 colors) and tones down the color as much as possible. A maximum of 256 colors is used. The color saturation is low, just as in the actual plane. Mapping is applied with UV in the LightWave 3D modeler.

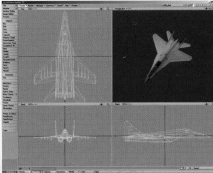

Low polygon (100 polygons) Middle polygon (800 polygons) High polygon (1,500 polygons)

The number of polygons used for the combat plane and map 3D display is not constant. Rather, the LOD (Level of Detail) of the object can be changed depending on various conditions, such as the object's distance and the number of enemy planes appearing in one screen. The burden of processing data in the display monitor decreases when the small airframe is kept far from the camera and when low polygons are used in real time. The pictures above show the model of an F-22 airframe in three stages. Instead of being displayed only by VRAM, sets of data are constantly transferred from the main memory to VRAM and the data of the previous drawings is deleted. This system maintains the best quality of the graphics. Technique and a proper device are required to express the large world through real-time rendering.

Controlling the LOD (Level of Detail) of the displayed polygon

Balancing between game quality and graphics

LightWave 3D and Photoshop were the only graphics software used in the production. Otherwise, the company tool was used for the map layout. Often much of the production work was done with a specially made company tool, but the production work for "Energy Airforce" was very simple.

"We had various options—such as developing a special tool or using a high-end existing software such as Maya—but we didn't try that this time," explained graphic designer, Masato Shinchi, who was in charge of direction, combat plane settings and design. "It's because we had to make the production process simple. Of course, a complex special tool that can do anything may be useful, but then it does not respond well to the problem of individual parts or irregular additional elements. Considering graphics, airframe behavior, game response and limitations of PS2 as a hardware, we just had to simplify the production process so that the

conditions could be easily maintained in order to preserve the quality."

The same principle can be said for high-end software such as Maya and Softimage 3D. An all-around tool cannot help but make data management complicated and add one more step. For graphics creation in real-time rendering, it is better to have fewer processing steps up to the operation verification stage for an actual machine. In this sense, LightWave 3D was a handy format that could be customized easily—even outside of a tool.

"The modeler was better than anything else," said Shinchi. "Since we tried enhancing realism in the first place, creating the combat plane was more like doing CAD. The good thing about it was you could manage it clearly with coordinates and numerical values. We actually made it possible for the PS2 coordinates to fit in LightWave 3D instead of a basic format. It was that simple." It seems that LightWave 3D has a high affinity for PS2 game production.

By narrowing down the production tools and environment, the creators were able to achieve thorough realism.

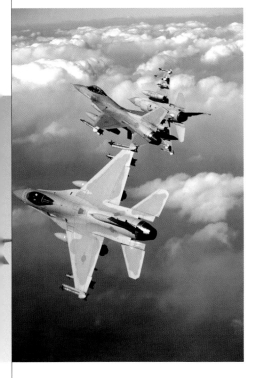

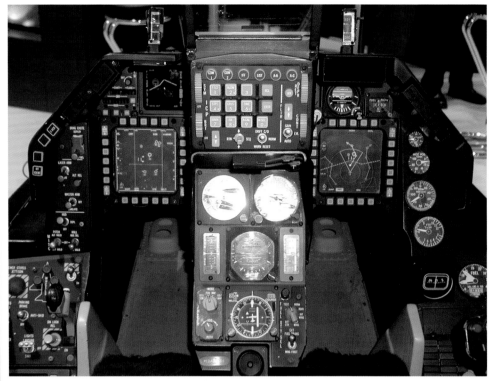

The professionally developed cockpit; comparing it to a photograph, one can see that it has been reproduced faithfully within the limited number of polygons. The term "realism," perfectly fits this image. For the detailed creation, Masato Shinchi worked on collecting the actual plane data that could be obtained from a photograph by boarding a training simulator and actually touching a real plane. The numeric value of the meter, radar and needle movements were created by the program in the actual plane and displayed.

F-16 Fighting Falcon cockpit

X-35 Joint Strike Fighter cockpit

F-22 Raptor cockpit

Hats off to the extremely detailed cockpit creation

Mountain stage map

Ocean stage map

City stage map

Reality and deformation: creating an incredibly balanced flight stage

The most difficult part of making the stages for "Energy Airforce" was that the stage would be just too small and unclear in the actual game if it was created on the same scale as the satellite photograph. Until what point needs to be real? Deformed? That adjustment was a major concern and the production proceeded by creating and displaying it in the actual system several times. First, parts were created in LightWave 3D within a radius of 10 kilometers. These were then laid out using a map-making tool that the programmer developed. The texture based on the satellite photo was processed seamlessly by adjusting the color scheme and reducing it to a 16-color base. The process was just like forming a puzzle. The pictures above show the production scene of each different surface. Map-making is well represented by decreasing the number of polygons.

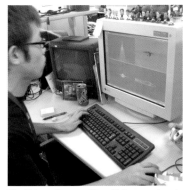
The TV monitor used to edit the map is set up on the desk of the map designer, Yoshihiko Yamaguchi.

Taito
Game designer
Yosuke Tsuda

Taito
Graphic designer
Masato Shinchi

Taito
Graphic designer
Yoshihiko Yamagichi

Space Raiders

This action shooting game focuses on a battle against invaders who have suddenly attacked the earth. The game's objective is to shoot the enemies by selecting one of the three main heroes (each of whom possesses different skills) and by making full use of various gadgets and techniques. "Space Raiders" has two types of game modes—story and survival. The game proceeds along the plot within the story mode; this mode also contains a beautiful CG movie, in which the user witnesses the end of the heroes' battle. The survival mode includes the "score attack" feature, where players can achieve an ultimate score by bonus points from a direct hit.

platform | PS2, GAMECUBE made by | TAITO

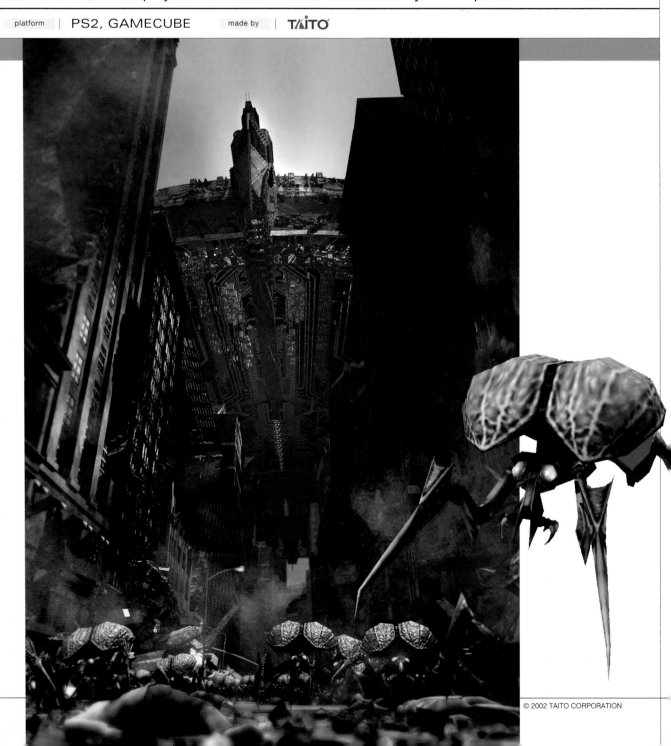

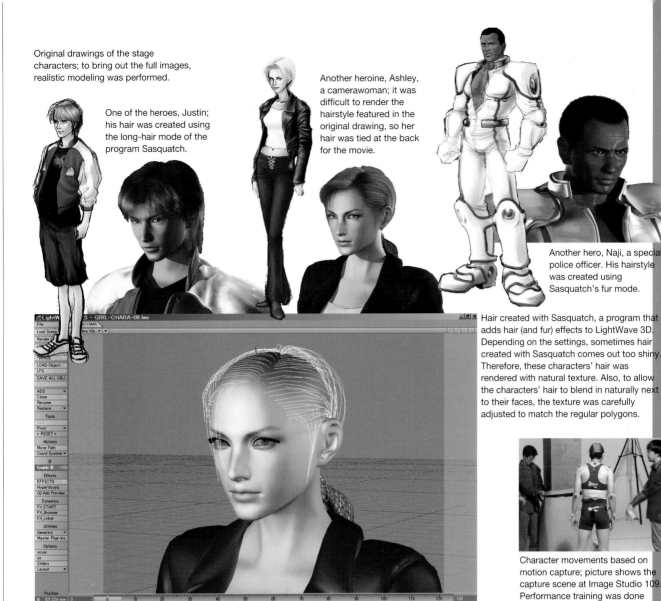

Original drawings of the stage characters; to bring out the full images, realistic modeling was performed.

One of the heroes, Justin; his hair was created using the long-hair mode of the program Sasquatch.

Another heroine, Ashley, a camerawoman; it was difficult to render the hairstyle featured in the original drawing, so her hair was tied at the back for the movie.

Another hero, Naji, a special police officer. His hairstyle was created using Sasquatch's fur mode.

Hair created with Sasquatch, a program that adds hair (and fur) effects to LightWave 3D. Depending on the settings, sometimes hair created with Sasquatch comes out too shiny. Therefore, these characters' hair was rendered with natural texture. Also, to allow the characters' hair to blend in naturally next to their faces, the texture was carefully adjusted to match the regular polygons.

Character movements based on motion capture; picture shows the capture scene at Image Studio 109. Performance training was done personally by movie director, Toshiyuki Aoyama.

Creating emotional expression and a sense of presence

"Space Raiders" is a fighting game where users battle against invaders from outer space who have attacked the earth. It is reminiscent of the classic Taito game "Space Invaders."

In order to heighten the players' empathy towards the game, a high-quality, Hollywood-style film was created. Masaaki Taira from Trilogy Feature Studio took charge of producing this movie.

After consulting with producer Kojiro Modeki of Taito, who planned this project, Taira searched for staff members that could create a high-quality, emotionally

expressive movie and be able to realize a Hollywood-like presentation within a tight production schedule.

Taira remembered Toshiyuki Aoyama, with whom he had worked before, and who is good at expressing emotions with eyes and the use of effects. Taira asked him to direct the movie. Since Aoyama uses LightWave 3D, it was not difficult for him to work with the game staff (who also used this production tool).

After Aoyama accepted the offer to direct the movie, he gathered eight freelance CG creators. The total length of the movie—including the opening, middle and ending portions—is about eight minutes, and the production period covered only four months.

The Internet was used to increase the efficiency of the staff, since they worked in different locations. The storyboard, design drawings and model data were exchanged over the Internet. Despite these circumstances, the production proceeded as if the staff was working together in a virtual studio.

Aoyama attached great importance to facial animation in this movie. He felt that emotional facial expression was still behind what the technology was capable of achieving, even though the quality of modeling and image detail in movies has recently improved. Therefore, the technical challenges that he set for the team involved creating natural faces and enhancing the characters' emotional expressions.

Developing
a realistic expressions

Endmorph Mixer applied for expressions; instead of creating each expression, a morph target separately created the parts such as the mouth and eyes and animated expressions by delaying the timing.

In the cut where Justin bumps into a wall and endures the pain, his hairstyle was made messier than usual to exude a suffering image.

Scene of Justin trying to bear the sadness of a friend's death; this scene, which includes music, was directed as the most emotional scene in the opening portion.

Naji, injured by explosion, approaches desperately; his expression exudes revenge.

Naji, holding an MP5 machine gun; his determination can be seen in his face.

Ashley, smiling and jumping with a bike; after she jumped over the invader, her pleased facial expression changed into a worrisome look as she headed to her apartment and her awaiting sweetheart.

Seemingly half-desperate expression; wrinkled expressions are very difficult to create on a female face and tend to be avoided, but neverthless these were attempted in this title.

Pursuing a sense of realism that evokes Hollywod films

When the movie production began, the staff had only one 2D design drawing (which had been created by the Taito staff) for each of the three game players who act as the main characters. The staff gathered by Aoyama was responsible for making these drawings into realistic 3D characters through modeling.

Each character's face, body and clothes were created separately by different staff members. Modeling was performed efficiently within a short time period. Since the models served as a low-polygon templates for the game section, their creation was driven by the needs of the movie.

On the other hand, the insect-shaped invaders that appear in the movie were modeled for the game part by the CG staff at Taito. With minor adjustments, the model quality was good enough to be used for the film. Although the pre-rendered movie seems to have received special attention, factors that contributed to a heightened sense of reality—such as the stage background—were also used for the game section.

After the modeling was completed, the emotional expression required attention. The creators wanted viewers to recognize the characters' inner emotion just by watching the movie.

Concerning the technical details, morph target was broken down into parts like eyes and mouth, so that the timing of each motion would be delayed and, therefore, more natural. Characters were carefully prevented from moving without changing their expression, and looking unnatural (such as with a closed mouth).

The results of this process were presented to several staff members and involved parties, so they could evaluate whether the desired expressions were delivered well or not. If they were not, modifications were made carefully.

Digital Fusion was used for the finishing touches of the rendered movie, such as composition, color collection and adding glow. Also the After Effects plug-in called Iris Filter helped express the blurred image of a camera. This image looks very real. Therefore, After Effects was used in the scenes that needed to be blurred.

The scenes with fine details were rendered at double resolution, and reduced to create a sense of density.

Such intense dedication to reality helped the staff complete the movie in a style that is reminiscent of scenes from Hollywood films.

Creating a sense of reality in the crowd scene and background

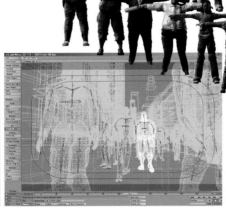

City scene in the beginning of the movie; the city crowd was achieved by having about fifty people walking. Even a computer with 1.5GB of memory was not powerful enough to execute the rendering, so several rendering parts had to be divided. The cut of extras walking in the distance was made possible by putting the image loop sequence of a walk on a polygon board.

About forty different kinds of people of various races and body shapes were cast for the crowd of extras.

Wire-frame for the crowd scene; the man with bones is manually placed in position.

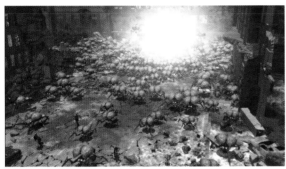

Crowd scene of about 300 invaders; three kinds of walking movements were randomly mixed in the motion.

Crowd of invaders created by a function of particleFX; since each of them has a "collision," they can walk without tripping. The type of walking motion also changes automatically based on the walking speed.

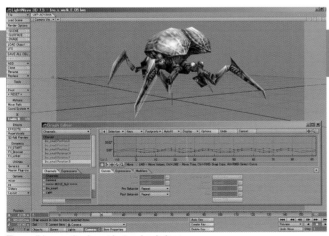

The walking motion is not just a simple loop. A loop that pauses for a few seconds was also added to the motion, so that each of the invaders has an individual character when gathered in the crowd.

The setting for the background was made to look like New York. The number of polygons was reduced to represent the buildings in the distance by their texture.

Apartment where Ashley and her boyfriend live after being attacked by the invaders; the interior and accessories were nicely designed based on the basic setting called "cameraman."

Ashley lamenting with the jacket, a memento of her boyfriend; the light shining through the window is used effectively.

Naji leaving the graveyard where his friend is buried; a tree with leaves modeled in high-polygons is close to the camera. By contrast, the trees far from the camera were enhanced by putting the photographic material on a polygon board.

Polished finish for the photo realistic quality

UFO attacking the city with lasers; the laser light is a composite.

City collapsing from the attack; the smoke moves by using particleFX (PFX) and is rendered with HyperVoxels3 (HV3).

People running to escape from the collapsing city

Crowd of invaders being attacked by a machine gun; the spattered body fluids as well as the smoke were possible with both PFX and HV3.

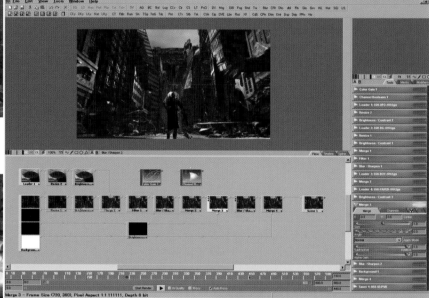

Digital Fusion was used for composites; the staff worked directly on a NTSC monitor.

Ashley putting on her jacket; this complicated cut was created by using morphing, bone and physical calculations provided by a motion designer. The hand motion was made by erasing the motion capture key and refixing it with Inverse Kinematics (IK).

Depth of field provided by Iris Filter; since it emulates the lens and film properly, it can create a blurred image that looks like a live picture.

Original image before applying Iris Filter

Depth map output from LightWave 3D, which was used for applying Iris Filter

Using Iris Filter less can give a natural look.

Movie in the game part; this realistic street scene was created by using mapping effectively.

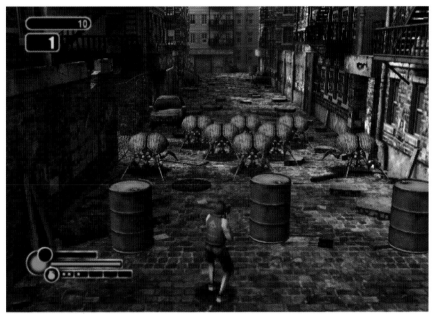

Finely created detailed parts including the street scene and fragments; sunlight reflection was represented by textures.

Taito Corporation
Producer
Kojiro Modeki

Taito Corporation
Game CG designer
Toru Kawaishi

Taito Corporation
Game CG designer
Makoto Fujita

Trilogy Feature Studio, Inc.
Movie producer
Masaaki Taira

Movie director
Toshiyuki Aoyama

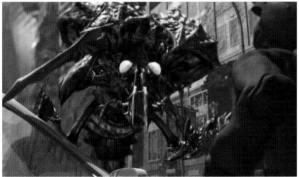

Insect-shaped invader as it appears in the movie; although it has been touched up slightly, it is almost the same as what is used in the game.

Game part's realistic CG in parallel with the movie

Insect-shaped invader modeled by the CG staff of Taito; the polygon number was reduced for real-time rendering in the game.

Armored Core 3:
Silent Line

The seventh title in the "Armored Core" series, "Armored Core 3: Silent Line" took over the worldview of the previous title. It features various companies, agencies and Ravens (armored bounty hunters). Other elements—such as Real Time Equipment Cancellation, Consort System and Machine Weight Free—were applied from the previous title. A new system consisting of a highly requested cockpit view has also been added. This chapter is divided into two sections: Visual Preview Disk and TVCM.

| platform | PS2 | made by | **FROM SOFTWARE** |

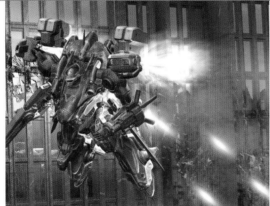

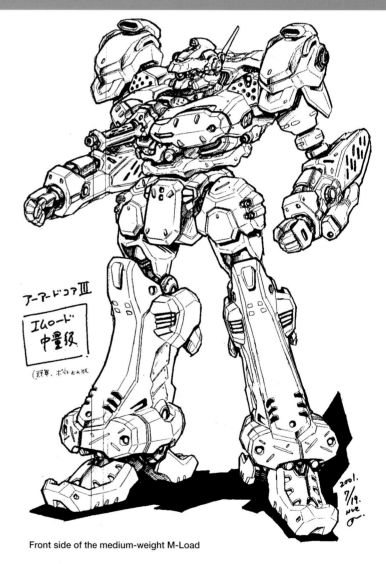

アーマードコア III

IムＬＯ－ド
中量級

(装甲, ボルト止め版)

Front side of the medium-weight M-Load

Design drawing by Masaharu Kawamori; sometimes a final drawing can be generated from a couple of high-quality rough sketches, but some of the M-Load Armored Core required more than thirty sketches. The perspective drawings here show the front and rear sections of the medium-weight machine, which took time to design. The inner parts, such as the joint junctions, were created by the CG team.

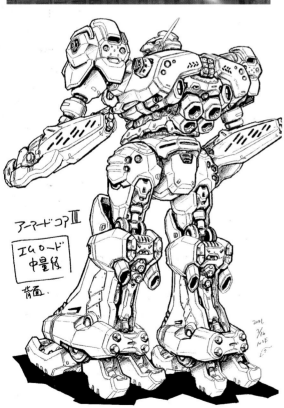

アーマードコア III

IムＬＯ－ド
中量級

背面.

Rear side of the medium-weight M-Load

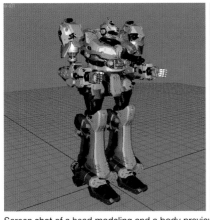

Screen shot of the head model and close up of the enemy joint part creation; since no additional rendering was required for the still image of the enemy, fewer details were produced compared to the medium-weight AC. This can be seen in the wire-frame part of its head. However, the joint structures of the enemy were as complex as they were for a medium-weight AC. The two suspensions located at the shoulder can be stretched in conjunction with it.

Screen shot of a head modeling and a body preview; the medium-weight AC of a pre-rendered model comprises about 250,000 polygons. Compared with the previous model, which consisted of about 300,000 polygons, it purposely posed a lesser burden and was not too heavy. The staff did not simply cut corners, rather they excluded those parts that were invisible in the movie. Perhaps more parts could have been excluded, but the modeling was performed before the storyboard was created.

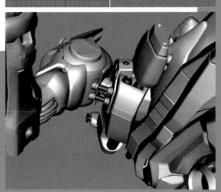

Visual Preview Disk

The DVD created to promote "Armored Core 3: Silent Line" kicked off the game's sales distribution in Japan in March 2002. The DVD, which they call a "Visual Preview Disk," features a one-minute-and-thirty-second" movie that combined highlights from the opening title of PS2's "Armored Core 3" (which was two minutes and forty-five seconds) and the original movie of the game section. The PR department was responsible for the movie editing for the DVD.

Back when they were making "Armored Core 3: Silent Line," the team planned to produce the opening movie in two minutes thirty seconds, but it eventually stretched fifteen seconds longer because they wanted to feature the heavy-weight armored cores (AC) more. The movie concept was about destruction.

The destroyed building elements are embedded in the game system. As a major premise for the movie, the team tried to

share features with the game system as much as possible. The unplayable parts in real time on the actual machine are represented on the pre-rendered movie. Since the opening movie represents the beginning of the film, its content had to be promising—something that makes the users delve into the game. This situation is typical for a game company.

This concern for working with the unplayable parts in real time is applicable to the displayed M-Load AC, but generally it refers to the representation of elements such as smoke, the desert and the breaking of one character's arm.

"A blurry image can be expressed above a certain level in real time. However, because the polygon board and texture are combined, at a certain point the image becomes 'solid' and cannot go any further, so we decided to use a pre-rendered movie for that part," Tsukuda explained.

"Armored Core 3" was the sixth title in the series. Because the CG section was involved with creating several other pre-rendered movies at that time, the movie-making was quite hectic—particularly due to things such as unscheduled movie lengths. However, the core of the structure was established by pre-screening the video content and allocating parts to the staff members. In the actual production, the team realized that they had gained enough experience from making the transition to 3ds max that they developed the original script to improve operation efficiency and explored new techniques for movie expressions, such applying Final Render for certain cuts. Apart from the opening movie, the pre-rendered movie was provided for the ending, so one can witness the evolution of FromSoftware's CG section by playing the game.

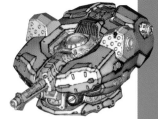

The material ID made for the chest part called "core" is indicated on the tree display shown on the left. In the previous title, there were more than one hundred IDs provided for only the core, but this time the number was curbed to around fifty, because that and the model polygon in the previous title were just too elaborate. These two pictures show how each material ID was applied to the core.

Tarnished mapping

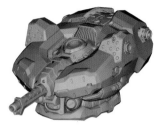

Without mapping

Surface texture mapping

Storyboard; each M-Load AC motion was specified by an arrow to show the mechanical object that moves in a straight line. The detailed specifications for each motion are indicated in the captions.

Although the movie for this title was excerpted from the opening title of PS2's "Armored Core 3," the DVD also included the movie introduced at the game show. These pictures show the screen shots from that movie.

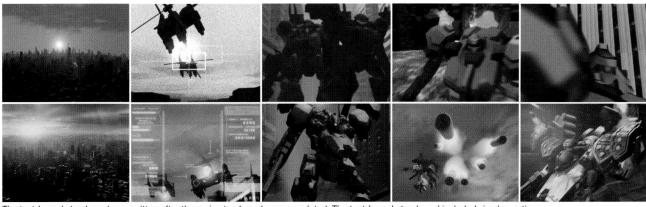

The text-based storyboard was written after the main storyboard was completed. The text-based storyboard included simple captions—such as "Enemy, pull out the missile" and "Enemy, run away"—to make each cut easy to understand. Then the image-based storyboard was developed using the game's low-polygon models and live action, which the CG team managed based on the script. The screen shots of the completed cuts (shown on the bottom row) are linked to the image-based storyboard (shown on the top row).

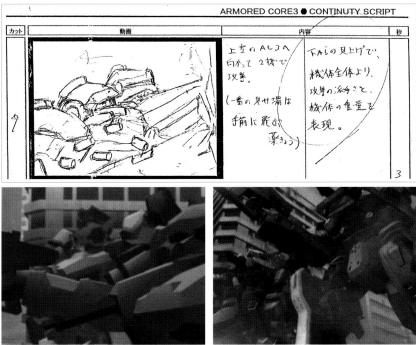

FromSoftware, Inc.
Development division 1
Planning section
Assistant manager
**Ken-ichirou
Tsukuda**

FromSoftware, Inc.
Production department
CG Section
Senior staff
**Toshiyuki
Suzuki**

FromSoftware, Inc.
Production department
CG Section
**Takashi
Shinozuka**

FromSoftware is unique in that it does an in-house review of its image-based storyboards. Sometimes, after reviewers voice various opinions, a completely different cut may be adopted. This is a cut that was changed in the end because it looked too similar to the movie from the former title—even though main storyboard and image-based storyboards had already been created. Top: main storyboard; bottom left: image-based storyboard; bottom right: completed screen shot.

Original scripts used in this title

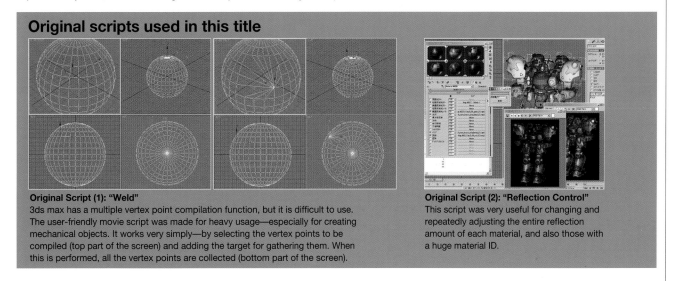

Original Script (1): "Weld"
3ds max has a multiple vertex point compilation function, but it is difficult to use. The user-friendly movie script was made for heavy usage—especially for creating mechanical objects. It works very simply—by selecting the vertex points to be compiled (top part of the screen) and adding the target for gathering them. When this is performed, all the vertex points are collected (bottom part of the screen).

Original Script (2): "Reflection Control"
This script was very useful for changing and repeatedly adjusting the entire reflection amount of each material, and also those with a huge material ID.

TVCM
ARMORED CORE 3

Storyboard provided by Shinji Higuchi for the commercial production; it outlines the live-action material requirements

Two movie directors, Shinji Higuchi and Makoto Kamiya, assumed the leadership for creating this title's TV commercial, while Digital Frontier took charge of the production. Here is the behind-the-scenes story of the making of this movie, lavished with live-action material and engineered by an excellent staff.

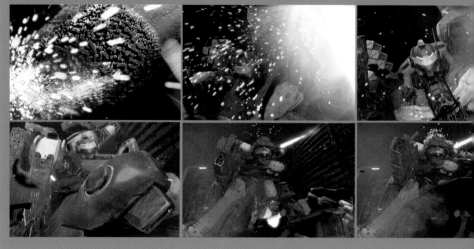

Filmed live-action material and photo of the film making; except for the stock material that was already provided by Higuchi, the cut resembling an explosion was filmed with a high-speed camera using 16mm film. It was zoomed in at three to ten times, depending on the requested material.

Since a high-quality pre-rendered movie was already included in "Armored Core 3: Silent Line," it made sense to develop a different type of TV commercial (TVCM). Special effects director, Shinji Higuchi, took charge of the overall direction and the storyboard through the Toei Agency. Because of time constraints, another special effects director, Makoto Kamiya, handled the stage direction, and Digital Frontier managed the commercial production based on special effects.

"The TV commercial theme was explosion and the sizzling sensation of melting armor," producer Suguru Matsumura said. "Based on Higuchi's idea, we decided to produce that expression using live-action shots and CG, because sometimes the motion of an unexpected element can be caught when filming an explosion or spark live. We could have made everything with CG, but Higuchi wanted to incorporate the unpredictable

charm of live images. On the other hand, we considered shooting the film from scratch and converting it to M-Load AC, but schedule conflicts made this approach impossible. M-Load AC's existing model was converted into Softimage 3D and combined with Softimage DS in the end."

There were a wide variety of live-action materials, which included not only explosions and sparks but also a part that heats up an armor, smoke and fragments called "Gara." Since the staff that shot the movie also shot the film for the TVCM, it could not have gotten any better.

"With this movie, we had a difficult time converting the model, which had huge polygons and lots of material, and dividing the movie into the first and last half," said director, Yasuhiro Otsuka. "The smoke motion was especially difficult." One can check out the powerful movie on Japanese TV; it certainly does not seem like it was created in a week.

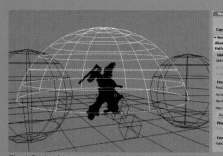

Final Gathering was applied to the commercial rendering. Pictures above show the screen of the Final Gathering settings as well as the main machine and the light object. Picture below shows the rendered image before composition.

Test image for Final Gathering

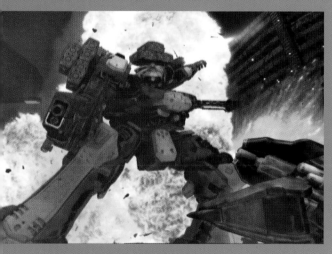

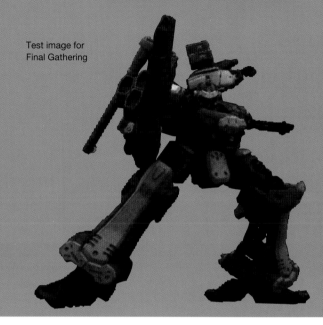

For the CG material, FromSoftware's data was converted into Softimage XSI using a 3dx max free plug-in called dot XSI for 3d Studio MAX. But since each part was well created and equipped with quite a number of added textures, it was first arranged in the render map as a specular, color and bump. The convertion process was a difficult task.

Digital Frontier, Inc.
Producer
Suguru Matsumura

Digital Frontier, Inc.
Director
Yasuhiro Otsuka

The screen shot for creating the spark composition by Softimage DS was rarely featured. Digital Frontier fully utilized Softimage DS for the commercial production.

Disaster Report

A huge earthquake suddenly strikes an enormous city built on a man-made island. The player controls the main character to overcome the subsequent disasters—such as buildings collapsing or fires erupting—and to escape eventually from the island. The user must find a way out of this devastation by meeting a friend and making full use of available tools. A detailed map of the island is provided, which can be utilized and enjoyed. Using it to escape is a good strategy, of course, but it may be wiser to explore the demolished town.

| platform | PS2 | made by | **irem** |

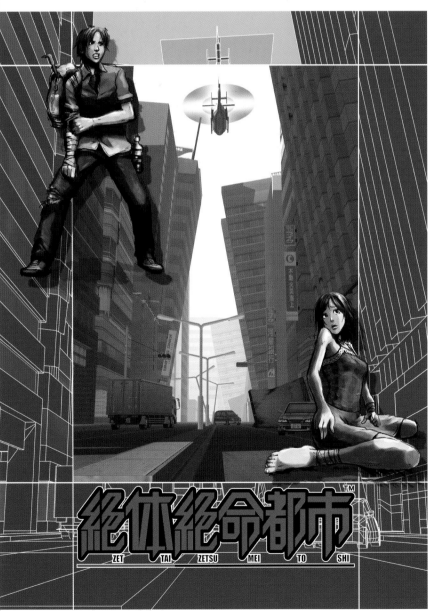

Reproducing a highly detailed city

Irem Software Engineering (which was formerly called Irem) is a veteran game developer that has been producing arcade games such as "Spelunker" and "R-Type" for a long time; it is a subsidiary company of Nanao, which is famous for their computer monitors.

"We have enough monitors to buy a new PC," joked Kazuma Kujo, the producer and director of "Disaster Report."

Kujo and chief designer, Kouichi Kita, discussed the difficulties they experienced during the development process. It is not the game's use of realistic pre-rendered CG or the remarkable visual representation that makes this title special, but rather the actualization of the city (called "Capital Island") itself, which was built with real-time rendering in the game. A similar city and well-created buildings appeared in a previously released game, but it was just a reproduction of the limited space within a small scale. This city in "Disaster Report" was the first bold attempt to reproduce a vast townscape.

"I wanted to create something that would make the player feel like he/she is really there, rather than rely on what a player does or what will occur," Kujo said. With that intention, the buildings and their

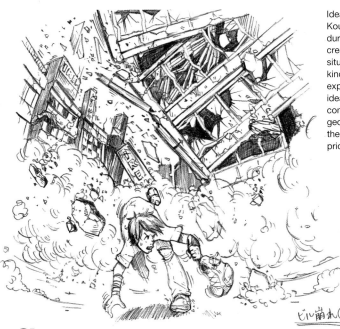

Idea sketches by chief designer, Kouichi Kita, and other designers; during the project's early stage the creators discussed what kind of situation would be exciting, what kind of place a user would want to explore, and how to bring these ideas to life. The visual components—such as the island's geography and the appearance of the disaster—were determined prior to the creation of the script.

The first step in developing an idea

elevations that were supposed to be reused in the first stage were mostly changed to consist of new material.

"Many destroyed buildings appear on this stage setting. If they collapsed in a similar way, users' excitement would be diminished, even if the buildings were made to look real, because they would get bored by seeing something that they've seen before," Kita explained.

Naturally, this led to a lot of modeling and the difficult task of dealing with the limited number of displayed polygons. Approximately 100,000 polygons are simultaneously displayed on the PS2 in its basic state. After adding various effects, such as fog, the number is reduced to

about 50,000 or 60,000. Much effort was poured into developing a realistic cityscape within this limit. This was complicated by the fact that laying out different things does not always help make a scene look right.

"Let's say you create the interior of a convenience store," Kujo cited as an example. "First you go to a store, and list the things you see. Well, it doesn't really work that way. You have to think first about what would make a set look like a convenience store. Whatever comes to your mind will be the thing that would make people recognize its existence."

It is impossible to visualize everything. Therefore, choosing which information to present becomes very important.

Creating the virtual city with LightWave 3D and a company tool

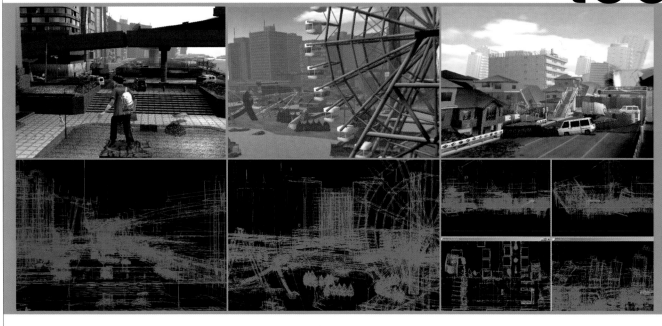

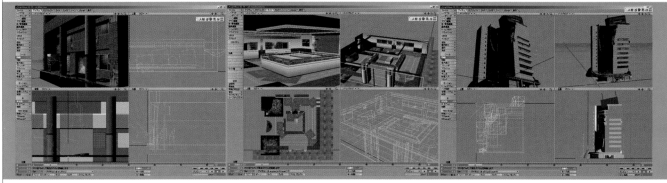

Development starts with a hybrid unit

The development period of this title spanned three years and began with a group of several people. At that time PS2 hardware was not yet available, so the team developed an original tool called Tedorigawa Ver.1.51 that could convert the data from LightWave 3D and output rough polygons into PS2 in order to implement game rules such as "collision detection." A year later, the staff was increased and the production commenced in full swing, yet it was interesting that none of the new people had experience creating games in a 3D field.

"It was a hybrid unit, consisting of a 2D designer who had never done 3D before, a designer who only had a little experience in 3D, new graduates and mid-career workers," Kujo said. He had decided that experience with 3D was not crucial, and that it was more important for the staff members to get used to the company tool.

"There was a guy who earned his living by making dot animations, and I asked him to try adding motion," said Kujo. "He did it so quickly. He has a knack for motion."

Knowing how to use a tool was not as important as having basic knowledge; in this case, having an aptitude for the flow of motion. "If a person has basic knowledge, he can easily handle things in different

fields," explained Kujo. This is probably true about creating all things.

The team was asked if they had any geographical problems, since Irem is a game company based in Ishikawa prefecture located in the middle of Honshu Island, which is miles from Tokyo. They responded that, although they had a few difficulties dealing with the external sound-production company, their location was not that inconvenient because the network environment is very efficient; one can always keep in touch by e-mail and send packages by express delivery. On the other hand, their location had some unique benefits: The company has a huge parking lot, so the staff could drive to work and not have to worry about catching the last train.

The team tried to plot a visible location on the map for each island that could represent "a city of famous sights." The pictures to the right show screen shots of the game and the company tool for Windows. One can see from this wire frame how well the set was developed. In the process of creating the city, the team identified buildings and used the tool to lay out simple models of these buildings along the road. Then, a designer substituted more complex models and gradually improved the overall quality. The team tried to make the overall cityscape look good, rather than make single objects look good. Displaying all the objects in the tool was too heavy, so the team used a non-display setting for distant objects.

The company tool, Tedorigawa Ver.1.51 was used not only to draft the city map but also to position the character and its "collision detection" and to set the camera motion in the polygon demo scene. Many game visuals were built with this tool.

LightWave 3D was used to create the objects. Not many buildings were repeated; using low-count polygons, the team made various changes to the original building shape itself as well as to its collapse. The team recognized that if the buildings and their way of cracking and collapsing looked similar, the effect of the cityscape would be diminished. It took thousands of hours to create the building door that a player walks in and out. Meanwhile, the overall cityscape can be checked in the computer so it does not need to be confirmed by laying out the object in LightWave 3D.

To the left is a screen during the development stage that shows a condition without fog setting or any other feature. Every time the cityscape was updated, it was output into the computer in this manner and then confirmed. Incidentally, in the game itself, the city cannot be seen from this camera angle.

Texture
production
technique
for
real-time
operation

Textures were manipulated with Photoshop. Most textures were based on 256 colors; however, the parts that were hard to fit within the memory capacity were dealt with in 16 colors. The difference between this approach and the pre-rendered CG production is the competition for memory allocation. Producing the texture material required the lowest possible resolution, yet a fine and seamless texture needed to be used repeatedly. Even if only one texture was applied on an object, two textures were overlaid to change the appearance. Through trial and error, the team fit the data within the memory capacity.

Wall surface texture 1

Wall surface texture 2

Road texture

Character retakes
development
until the end

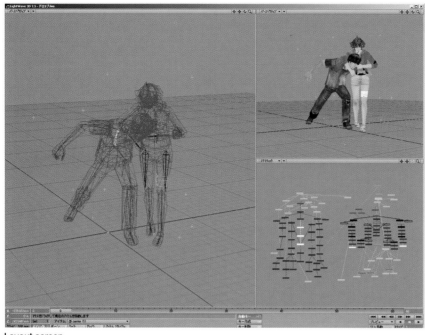

Screen shot showing the addition of character expressions with LightWave 3D; preparing wide variations was difficult because the data increased as the morph map increased.

Character modeling was done in LightWave 3D, then the bones were set in the layout. Each body has about 3,000 polygons. Neglecting the number of polygons would not have been good, but on the other hand, insisting on making the polygon count small would have been going too far. Therefore, extra polygons were allocated to the characters. Fine adjustments were required especially for the female character's face, which was a wise measure. The character was repeatedly fine-tuned based on the preview image. The pre-rendered movie cannot be changed once the character is determined, but the game can. This could be one feature of a real-time rendered production.

Layout screen

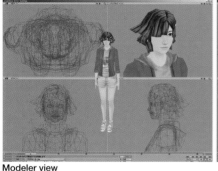

Modeler view

The character model with high polygons was created as an experiment. The team discussed using this for publicity, but since the character's clothes and facial lines for real time were updated day by day, they decided not to use it.

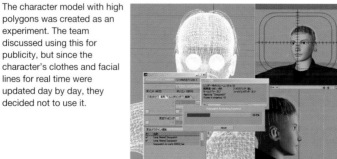

As the game progresses, the main character becomes sun burned and his clothes wear out. This picture shows the transition process of the heroine's clothes. Since transparency mapping is not reflected in the preview with LightWave 3D, the left image looks like the skirt is shortened, but the right image illustrates the skirt as it wears down and becomes tattered.

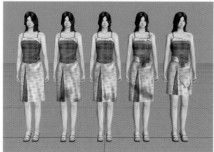

The character was exported as an object. The motion data was applied separately in the computer after programing a loop. In the production, a sound effect was performed in LightWave 3D and the motion was added while the image was visualized.

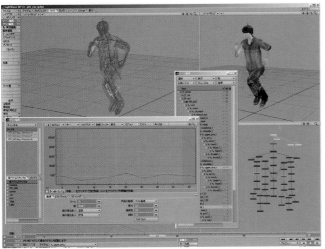

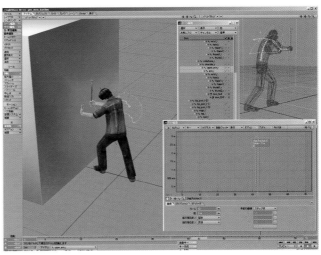

Server built for communal function

The development data was managed in the server like a book is tracked in a library. For example, if someone pulled out the object data to edit it, another person would not be able to pull it out. This helped avoid having two people working on the same data simultaneously. It was possible to see who pulled out which data, so other team members' work situation was easy to comprehend. Because they tended to work independently, the members of the development team used a bulletin board system (BBS) to facilitate communication. The BBS was actively utilized to make requests and exchange opinions, and even to make suggestions about the design for the title screen.

Irem Software Engineering, Inc.
Producer and director
Kazuma Kujo

Irem Software Engineering, Inc.
Chief designer
Kouichi Kita

Kamaitachi no Yoru 2

The heroes, Toru and Mari, received a letter about a year and a half after an incident in the pension called Spur. It was an invitation to the solitary Crescent Island, beautifully located offshore. With wonderful background graphics blending CG and live-action scenes, this title was upgraded to feature an intricately intact story. The characters appear in silhouettes, which stimulates one's imagination and the attraction to this game.

platform	PS2	made by	CHUN SOFT

Exploring a suitable expression regardless of production method

"Kamaitachi no Yoru 2" is one of CHUNSOFT's most famous titles. A classic video game from Super Famicon, it features realistic background graphics and the character stage direction using silhouettes that a user can imagine. This title was released as the long-awaited sequel to "Kamaitachi no Yoru," and has succeeded in creating more real and fantastically beautiful visuals while taking over the basic stage direction from the previous title.

This amazing world was realized through CG expression, illustrating the possibilities of retouching and modifying photographs and animated live-action material. The technique of developing scenes through photo retouching first became available when the software The City was created for Sega Saturn. Based on their experiences, the team was convinced that this software could create unique expressions, which allowed the production to operate smoothly. In addition, the production period, including the scenario development, spanned a total of four years, two and a half of which were devoted to only graphics creation.

The objective of the production for this title was progress regardless of its process—giving the highest priority to the final image became a purpose rather than a method for the CG creation.

The team extracted the real parts from the movie that could not be obtained from a live-action scene and excluded the rest. They filled in the parts that used CG and excluded the ones that seemed too computer graphical by retouching. They carried out the process by utilizing only the best aspects of each of the two methods.

In order to do that, they needed to depart from "the syndrome of wanting to realize everything in 3D," which every CG designer tends to aim for, and instead had to have flexible minds to arrive at an objective decision as to which part was better to use. When they could not make a decision, the team would realize both parts and compare them; this chapter illustrates how much energy was exerted for the visual production.

The team claimed that they had a difficult time looking for the right person who could adopt both approaches of handling a live-action scene and using CG when it was needed to designate jobs not only internally but also externally. So, Haruhiko Syono, who is known as the producer of "Gadget," was chosen to supervise the numerous graphics in the scenario called "Sokomushi Village Edition."

Image board drawn by Yohei Taneda

© Yohei Taneda

Storyboard

Careful
planning

After the scenes were completed, Yohei Taneda, art director of the movie "Swallowtail Butterfly," drew the image board. It was used to figure out how to use the live-action material and what to represent with CG. At the same time, the scenario was divided into individual scenes to create the storyboard, then the movie-making structure was determined. All of the elements were written down in detail—such as whether a cut should be a still image or an animation, how scenes would switch from one to another and what kind of character would appear—to devise the flow of the entire game.

A total of 6,000 pictures photographed in various locations

Almost all of the live objects were photographed by the development staff. After gathering information for the scenes through the Internet and a map, the team headed out to various locations, for example, the Shizuoka sea, Tochigi lake and a deserted village in Nagano. It took about two months to collate about 6,000 pictures, which were archived as preparation material for the production.

Making backgrounds to determine the worldview

Original photo

↓

Combining the photo with a shrine

→ → →

Blending color and adding light

Final image

For the visual production of the background, the unique worldview was represented by effectively using both live-action material and CG. Basically, natural objects (such as plants and the sea) were obtained from live-action scenes and retouched, while artificial objects that required angles (such as buildings) used CG. However, this method was not used exclusively. In the scene shown here, the details were adjusted after the CG image of the shrine was combined with the original live-action photo.

Blending color and light additions

Since the building interior is viewed from various angles, it was completely reproduced by CG using Maya 3.0. Instead of retaining the image as rendered, the details were adjusted in Photoshop to shape it into a more atmospheric image. The animation was adjusted in After Effects.

The animation sequence that allows players to look around took quite an effort to make. Live-action material was first collaged in Photoshop and then roughly assembled. Then, the details were drawn by hand and the color was adjusted. This process is similar to drawing light and shadow. Next, the completed panoramic image was pasted to a cylindrical object as a texture using Maya, and the camera was set to pan inside it. In addition, the sea part was masked with an alpha channel in order to combine it with the loop animation of the waves.

Using 3ds max to create a crowd of spiders

To create the CG, both Maya and (for certain parts) 3ds max were used. This scene was created by Kaihei Hayano, who is known for creating texture illusion. From model making to texture and loop animation settings, everything was created by 3ds max and the texture was adjusted and completed with After Effects. In addition to Hayano, many other individual creators were involved in this production.

Texture adjustment with After Effects

Screen shot of 3ds max

Watching out for various visual expressions

In the beginning, the production proceeded by adding motion only to waves, fog and characters in the camera's fixed position. However, one big picture was not strong enough to create a feeling of width and space. First, the team explored the possibilities of motion making and gradually, through trial and error, manipulated the camera work. They learned that just because a motion had been developed did not mean the end product would be effective.

The game is played by reading captions. Therefore, when a motion was added to a part that included a caption, it could not block it out. This was the fundamental principle for the stage direction. As a result, it was necessary to evaluate the visual approach after considering the overall view of the game.

Regular DV and digital cameras were utilized to shoot the material for this production. The materials were often obtained from daily scenes. For example, the loop movie of the water surface was created from DV material filmed at a pond in a local park.

"We never imagined it could be so easy to digitize a photograph and animation," Syono said. The merit of this system will be effective especially when creating material with an analogue technique. "CG expression arises from building skill and fixing on a parameter. Any dramatically interesting object will not pop out. In that

respect, when one creates a spider web by applying an adhesive bond to a nylon string and taking a photo of it, it will become something very interesting," Syono remarked.

Since it was easy to manage the data, it was not so difficult to combine analogue and digital production. One should adopt whatever looks interesting without adhering only to CG technique. This philosophy will be necessary in the future.

This title contains a wealth of remarkable visuals. One should also see the live-action-oriented opening title produced by Shinji Muto who is well known as the music video director for Ayumi Hamasaki and Namie Amuro.

Character animation expanded by a silhouette

In this title, the characters were created by CG in such a way so that they could move around. This is a silhouette display but the modeling is performed until each character's particular features appear. In addition, gradation is applied from head to toe using the texture settings in Maya.

Kayama/wire-frame display

Kiyo/solid display

Mari/shading display

Toru/rendering screen

Image as loaded into the background for operation

Positioning an object to add a motion

Even though the rendering was only performed on the characters, the background objects and the images were transferred to Maya because a guide needed to be positioned when a motion was added. In order to improve data management, the basic bone structure was applied to all of the characters.

Applying the filter after fine adjustments

Original texture after rendering

Turning the silhouette into a gray scale

The background color was selected when the silhouettes were combined directly

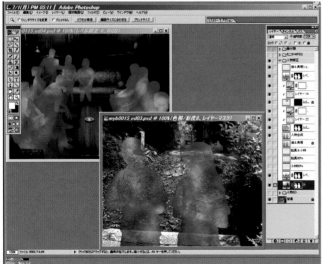
Maintaining a bluish color

The character's cloud pattern is added after the processing stage. At this point, a different brightness level is provided for and applied to each character to create depth in the screen, rather than simply filtering over the whole screen. Also, in order to maintain a bluish color for the characters, each silhouette is made into a gray scale and combined.

Each silhouette was created by CG, but sometimes also from a live-action scene. For example, in the scene with the wrist, the hand was photographed against a blue background using a digital camera, and the silhouette was created based on that image. Without adhering to CG, the production approach was determined by the individual expression.

Representing water using both live-action scenes and CG

Stabilizing live-action material

Complete loop movie

One of the remarkable visuals in this title is a loop movie. The loop of the water's edge was based on live-action scene filmed by DV. To make it look natural, a part of the wave was cut off and superimposed on a transformed element, then it was looped in fixed time. Since the color and the light could not be used directly from a live-action scene, the texture was also adjusted.

Pulling out the waves to be adjusted

Texture applied in Maya

The representation of water pouring into a fountain was created in Maya. After the texture and reflections were set, the waving surface animation was expressed by using the texture for a bump map. The fountain itself was created as a 3D object.

Rendering image

Texture for a bump

CHUNSOFT
Game director/designer
Shin-ya Ochiai

CHUNSOFT
Game designer
Hideaki Kondo

CHUNSOFT
Graphic designer
Megumi Muranaka

CHUNSOFT
Graphic designer
Mitsuhiko Auto

Will, Inc.
Representative
Haruhiko Syono

Lupin the 3rd:
Treasure of the Sorcerer King

Lupin the 3rd—the character of the popular Cartoon Network anime—now moves around in 3D in PlayStation 2. The voice artists for the game are the same people who helped create the animated cartoons, so one can enjoy the real Lupin the 3rd. Players can control Lupin, Jigen and Goemon, so that the charm of the thief family business can be relished to the fullest. Naturally, Fujiko and Zenigata also appear as the Lupin family gathers together. The thrilling story can be enjoyed enormously as a game.

platform	PS2	made by	®

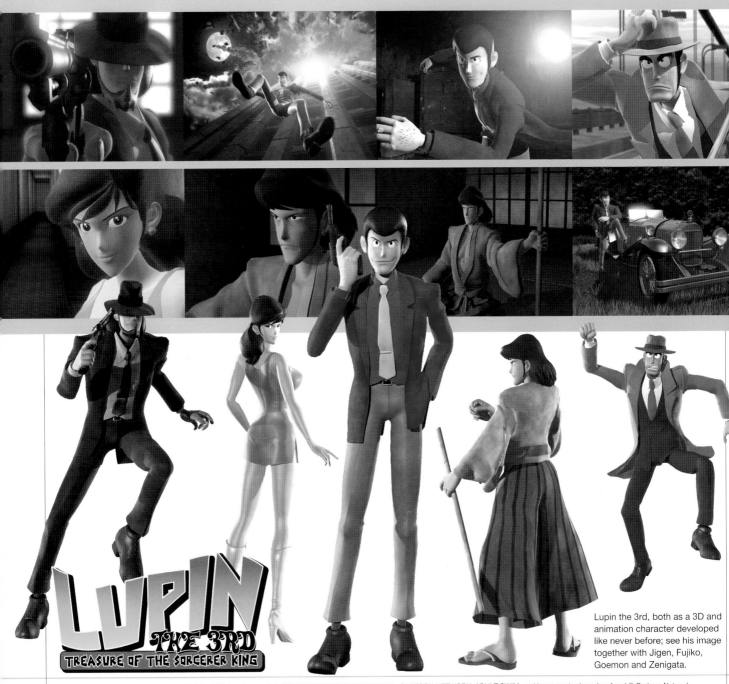

Lupin the 3rd, both as a 3D and animation character developed like never before; see his image together with Jigen, Fujiko, Goemon and Zenigata.

Overall picture of modeling Lupin; one of the characteristics of 3D is that his arms and legs look skinnier when the bones are moved, so the modeling body was shaped more thickly than the original animated image.

Bones embedded in the model as shown; the lower body is moved by Inward Kinematics (IK). The upper body is basically moved by Forward Kinematics (FK), but also uses IK for some cuts when necessary.

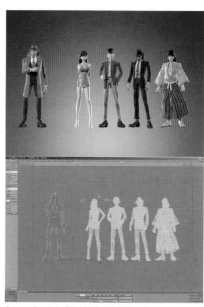

Approximately 50,000 to 80,000 polygons were used for each body. A rough model (with about 5,000 polygons) was used to create the animation. This was replaced by a high-polygon model for the final rendering.

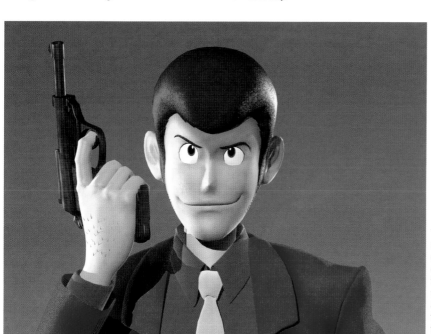

The texture of the characters was developed realistically with comparatively fine details for the clothing in particular. The texture of the hair was rendered in a style that was between a figure and an animation. Fresnel lens was applied to almost all of the surfaces to make them appear bright green, and the illustration style was also adopted.

Character modeling to help focus on the atmosphere

For the CG, Kiminori Okamoto and Toshiyuki Aoyama handled the opening movie, and Kenji Tsuchida and Uichi Uchida directed the game section.

With the aid of the project team that was organized by MOMO, the production began with the character modeling. "Lupin the 3rd" is based on the comics title by Monkey Punch, which later became a popular TV animation. In adapting these characters to 3D, the creators attempted to draw the images from various angles, although in the end certain elements were retained in 2D.

No one had ever seen the 3D characters for "Lupin the 3rd," who boast a 360-degree field of vision. Some characters were gathered as reference, but they were too far from the quality that the team wanted. Instead of creating 3D images, they performed character modeling in order to focus on the atmosphere. Even if the results of the character modeling, in terms of shape, were different from the character Lupin as he is drawn on paper, the staff proceeded with the modeling process by exploring his aura.

Although it was necessary to develop the character of Lupin with a vivid description like a biohazard, it was difficult to erase the animated image. Likewise, it was inappropriate to shape him into a human-

like model by blindly pursuing realism. What was required was a realistic 3D model developed from an animated Lupin.

Seventy percent of the modifications were done by asking the animation production staff for directions. In altering the models, many demands were raised, especially concerning Fujiko's figure; porno magazines and toy figures were used to indicate specific forms, such as the breast shape and the hip line.

Although the picture remains in 2D, the final model, which was developed through a combination of appearance and aura, eventually achieved a level that met the high demands of the creators. From here, the production of the opening title and game section proceeded.

One of the team member's friends who lived in New York was asked to photograph the scenery and accessories and send them through the Internet.

Night cityscape opening cut created from the images of New York; the trash can up front can be seen in closeup and was created using polygons instead of mapping.

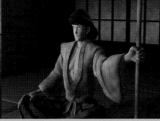

If a shadow color becomes achromatic, such as gray, the distinctive hardness and inorganic feeling of a 3D CG comes out. Hence, shadows need to contain blue or green colors to create brightness and the atmosphere of a celluloid animation. Also, the tatami mat was rounded off so it would not look like a board.

Cut of Jigen holding a magnum; the fine detail of the accessories and mechanisms was developed precisely as one of the characteristics of "Lupin the 3rd."

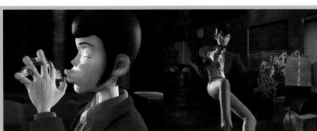

Cut of Lupin kissing a piece of jewelry; since the animation expressions (such as the lines of his face) change so rapidly, each cut and angle was provided for when it was converted to 3D. As long as the stance did not break down when viewed from the camera angle, the creators decided it should be fine.

When the 3D character was made to move exactly like the original celluloid animation, the motion was too light, and seemed like a moving piece of paper, so the weight and force of habit assigned to the motion were increased. This was different from a vivid movement in a motion capture, but one that could only work in 3D was also developed.

Cut of Jigen assembling a magnum; since the hand polygons were highly visible at closeup, a different model was used.

Screen shot of the hand model for the closeup; numerous polygons were required to smoothly represent this deformed shape.

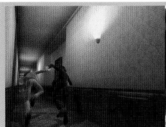

Adding motions by hand tends to lessen useless movements in a good sense as well as information volume, so lavish movements were added, such as this cut where two guys insensibly bump into each other.

Cut of Fujiko pulling up the zipper of her boots; the bright glowing part on the left was added later by digital fusion.

For the room interior, only the visible parts caught by a camera were developed, so the invisible parts were not shown.

The light source was colored and a sense of unity was given to the entire screen to avoid producing a desolate impression.

Opening movie that pursues Lupin's aura

The opening movie jauntily begins with the theme song entitled "Lupin the 3rd," which was composed by Yuji Ono. This song has the same position as the opening title of the TV broadcast.

In making the opening title within a short period, the creators developed the storyboard by emphasizing Lupin's coolness rather than by pursuing a narrative. In the brainstorming stage, the team continuously exchanged ideas about the things that Lupin would do, and sorted them out so a story could be added to the movie during the theme song.

Next, the staff of MOMO captured the scenes—from both the TV version of "Lupin the 3rd" and the animated theater version—that would be useful as reference and created a huge library. The opening movie was based on these scenes.

Since the title originated from an animation, the expressions and motions of the characters are different than that of live-action scenes and had to be manipulated. Therefore, all the motions were added manually. Also, some expressions and motions were embellished.

Lupin runs along the wall, avoiding a spotlight. This typical scene from "Lupin the 3rd" was arranged by 3D for reproduction. For a running motion, a different movement was added to each step instead of using a loop.

Lupin undoing a disguise of Zenigata; this scene was represented by intricately combining a morphing, bone and displacement. Since Lupin's head is bigger than Zenigata's, it required a design that would make it expand at the moment when the hat is taken off.

Cut of Lupin jumping off of a building; his jacket sways harshly with the wind, which strengthens the impression that he is leaping into the air. To create the effect of height, the camera angle was only moved parallel to the building without rotation. The speed was enhanced to emphasize the height.

Screen-shot of creating the building scene; in order to emphasize its height, the building in the scene was built up impossibly high. To avoid a gimbal lock in the camera, the building was laid down in the scene and filmed like it was falling to the side.

This dynamic cut created by 3D CG facilitated the view of the falling movement and the effects of an explosion, which hardly would have been represented by celluloid animation.

Mercedes Benz SSK driving away from the explosion; the explosion was created to focus mainly on the voluminous smoke. Both physical calculations and conspicuous motions with a celluloid animation were adopted by moving a clump of particles in keyframe. HyperVoxels 2.0 was applied for rendering.

The explosion scene shows many finely scattered fragments, although they are hardly seen in the actual movie because of the motion speed.

Test image of the Mercedes Benz SSK; all the details were made to pursue a sense of reality.

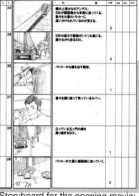

Lupin's expression from the animated cartoon moves quite dynamically. To achieve this, it was carefully created using left-right asymmetry.

Motion Designer was used for the clothing's cloth simulation. It created the feeling of a cloth dancing in the wind, with a mild thickness, yet not too thin, and does not look like it was soaked underwater.

Last cut of the movie; it includes the city image, and reminds one of the game section as the next objective. Some parts were created by copy and paste, but lighting was added to imbue a different look.

Storyboard for the opening movie; image boards were exchanged on the Internet and given to the staff to simultaneously share information with each other.

Since it had been decided early on that Lupin should be developed as vividly as a character from "Resident Evil Zero," Toshiyuki Aoyama, CG technical adviser for "Resident Evil CODE: Veronica," was appointed. As a result, this became the movie in which a 3D Lupin moves around the world with a detailed sense of reality.

LightWave 3D was used as a production tool. The cityscape in the early scene was created based on images of New York City. The trash can in front of the screen, a paper fluttering in the wind, fragments of broken glass from Lupin's 1928 Mercedes Benz SSK—every single piece was created with differently shaped polygons.

In addition, the difference of the level of the sidewalk and the heights of the streetlight and buildings were adjusted in accordance with the characters. This can be viewed as a live-action scene without doubt. What appears here is not simply an animation or a live-action image. Rather it is a new "Lupin the 3rd" in 3D.

Let's compare the scene making with the actual game screen. Lupin creeps on the roof of a train, and tries to overhear the conversation between Zenigata and Teresa and who are inside the train. When Zenigata and the other characters disappear from the compartment, Lupin opens the skylight and sneaks inside. Since the monologue was included from the beginning, the cut was switched along with the script to synchronize the motions. The scene showing the back shot of Zenigata was tricky to make, since it was impossible to request a CG model to illustrate this. Instead, the area of Zenigata's back that is seen in the screen was reduced by changing the angle. In the scene of Lupin peeking through the skylight, he was actually standing inside the compartment; if he had stayed on the train roof, his face would have been invisible.

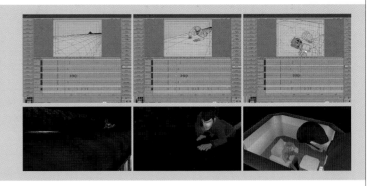

Unnecessary data was excluded from the frame to maximize the resources for rendering. Zenigata and Teresa were not sitting down face to face until Lupin peeked through the skylight.

144

Model image of the station where the game starts; one can see the finely created details.

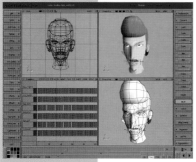

The game's original character, Theodore Hannevald; a motion-like animation was required when creating his expressions, widely deforming the polygons.

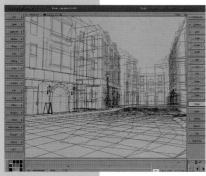

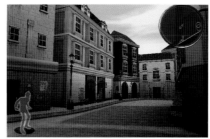

BANPRESTO CO., LTD.
Producer
Shintaro Miura

MOMO, Inc.
Kiminori Okamoto

Cityscape model used in the game; to pursue realism, it was created based on an existing European city.

Cityscape rendering as it appears in the game

Toshiyuki Aoyama

Scene making of the people walking through the city; since the number of containable people is limited, the camera angle was devised to create an atmosphere of a busy street by using few characters.

Scene making of people relaxing around a table in a café; the density was created from people passing in front of the screen. This casual everyday scene also helped to develop the worldview.

Air
Kenji Tsuchida

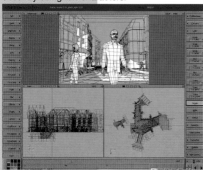

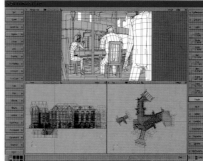

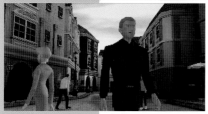

Uichi Uchida

Real-time rendered image in the game

Rendered image of a café; the street image of the crowd of people can be created by following the previous cityscape cut.

SD Gundam
G Generation Neo

A large number of mobile suits appear in the "Gundam" series. "SD Gundam G Generation Neo" is the latest release in the long-running and popular parody series that spoofs the serious drama of the Gundam saga proper. Despite the Superior Defenders (SD), the completed models and quality of the battle scenes are quite high. Gundam fans and machine lovers will be very satisfied with the game.

| platform | PS2 | made by | Bandai |

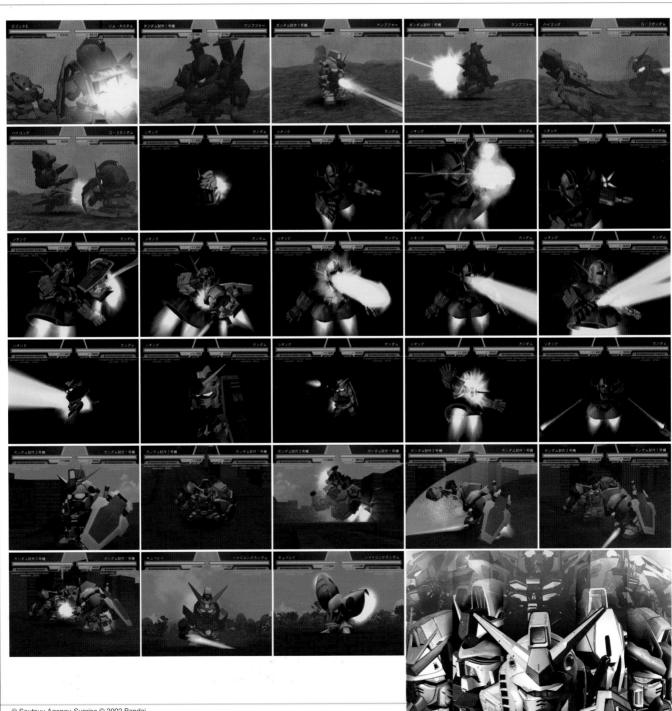

Creating a humorous appearance without cutting corners

Both the pre-rendered and real-time CG of "SD Gundam G Generation Neo," a Bandai game for PS2, were produced by Tom Create.

The major characteristics of the mobile suits that appear in "SD Gundam G Generation Neo" are extremely humorous-looking, deformed bodies. Usually comic cartoon characters are drawn as 3-heads tall, but in this title, they were widely deformed to almost 2-heads tall.

As for the modeling, LightWave 3D was used for creating the data. The design drawing that served as a draft was not used when developing the data.

Although building a deformed model without a legitimate draft seemed difficult at first, Tom Create produced more than ten games in the "SD Gundam" title series, but on different platforms. Therefore, when the modeling staff saw the proportion of the real type of mobile suit, it was able to sense which element should be deformed and how, in order to fit the proportion within the worldview of "SD Gundam."

As for the real Gundam type, many 3D products, such as toy figures, have been sold, so these were used as reference for modeling the one that was deformed in LightWave 3D. A supervising staff member would take a look at the model developed by each modeling staff member to maintain the overall balance and image.

Even though more than ten "SD Gundam" titles have been produced, the model data was re-created for each title and has never been used twice. It was the staff's intention to reflect the different interpretations of the entire Gundam in each period.

Gundam's texture expressions—such as surface texture, line of mold and weathering—changed in each period. In order to be attuned to the latest period, the staff performed the modeling of "SD Gundam G Generation Neo" with each interpretation. Naturally, since the same model data could not be used for different platforms, the creators always pursued the front line within the Gundam worldview. Unlike a humorous figure, the "SD Gundam G Generation Neo" model never cut corners in pursuing a sense of reality.

Modeling for real-time CG

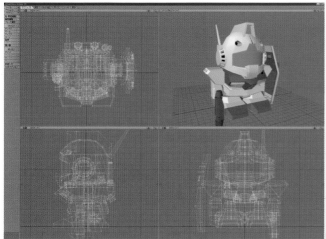

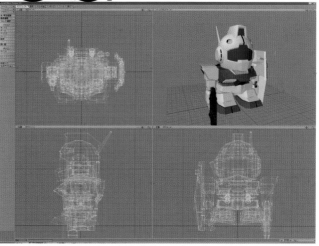

Early modeling image of Gim II that was made for real-time CG in the game; the limit for the number of polygons per body was unclear at first, so this image was created with 2,000 polygons. At 2-heads tall, it had pretty much the same proportions as the characters of the previous "G Generation" series. The surface color settings were not yet set at this stage.

Just before the final version of Gim II; the number of polygons was increased to 5,000. The proportion of the character became thinner and the face became smaller in order to increase its sharpness. Gundam maintained its overall balance by having small "eyes." In the final version, the hands became long enough so that they were easy to move. After manipulating the overall adjustments in relation to the screen, the creators completed the game model.

The unit that appears in "SD Gundam G Generation Neo" consists of about 250 bodies. To move them in real-time CG, a variety of animations responding to the game operation were required. Since more than a hundred different variations were provided for each body, the total number of animations was more than 25,000.

Battle animation

Aiming for the fusion of real-time and pre-rendered CG

The movie part in the pre-rendered "SD Gundam G Generation Neo" is about thirty minutes long, including the opening title and the introduction for each stage. The modeling staff took charge of the making of the movie.

The team consisted of three to four modeling staff members who worked on producing the movie based on its modeling. The production period covered six weeks for each title, and it took about a year to finish the entire movie part.

As opposed to real-time CG, which cannot provide free texture expression due to the limit of its memory capacity in PS2, pre-rendered CG has huge flexibility for representing texture. In "SD Gundam

G Generation Neo," a sense of reality was further increased through weathering and texture mapping.

Despite its realism, the body proportions were quite deformed. Compared to an ordinary model, the character has some motion restrictions, but with various devices and modeling techniques, a mobile suit moves without drastic deformation in the movie.

For example, the character's arm length is too short to pull out a beam saber from his back. However, if the arm was slightly lengthened, it would appear too long and not maintain its proportion with the body. To solve that problem, a slightly longer joint part was created and implanted. When it moves, a joint will extend instantaneously to make the hand reach the back.

The modeling for the movie was made by applying the same models that had

been used for the real-time CG, which were created by the in-house staff of the same company. Unlike with pre-rendered CG, the modeling that creates a proper look for a particular area within the camera's view is not available in real-time CG. Instead, it was performed after taking these things into consideration.

Since both the pre-rendered and real-time CG were created by in-house staff of the same company, they had the advantage of being able to coordinate the production and to improve the overall quality. As a result, both approaches inspired each other.

As a production, a game without a delineation between pre-rendered and real-time CG would be ideal. In order to achieve this, the game console would need to evolve, but in the meantime it is important to strive for that kind of quality.

Modeling for the movie

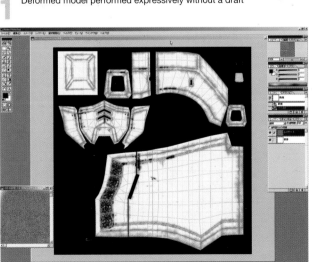

1 Deformed model performed expressively without a draft

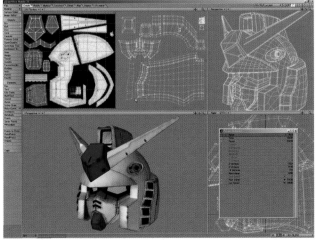

2 Shaded image that shows the best texture that real-time CG can create

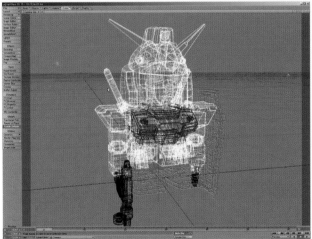

3 UV mapping texture created in Photoshop; the movie screen size was widened so the details could be finely created.

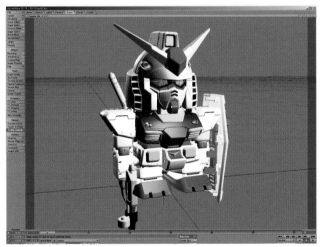

4 Head model and image mapping that have pursued a sense of realism, such as metal rust, scratches and gun smoke dirt.

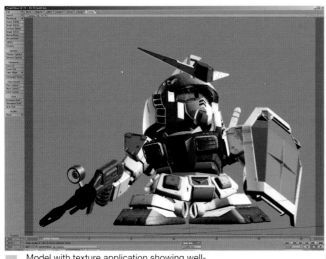

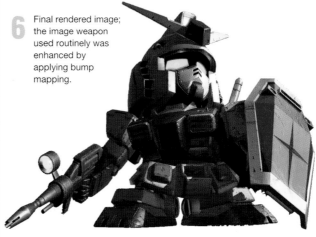

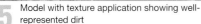

5 Model with texture application showing well-represented dirt

6 Final rendered image; the image weapon used routinely was enhanced by applying bump mapping.

Procedural texture like fractal noise was applied on the previous texture; this is the Gundam used for the movie of the previous title that looked like a plastic model.

1 Townscape in the movie background was created based on an actual town; the well-shaped building was used for modeling.

2 Shading without texture will not create a sense of reality.

3 Texture was created by using a live-action image, which was then mapped to the model.

4 Final rendered image; the finished quality is high enough to represent the background against the realistic mobile suits.

Opening movie

Townscape scene; in closeup, only the buildings appearing within the camera angle were retained because the data amount increases enormously when extra images are retained. The motion of the Gundam's hammer chain falling down was patiently created piece by piece by hand, instead of using plug-ins.

Cut wherein Zaku falls over and the building starts to collapse; the X-dof2 plug-in* was applied for the camera's depth of field.

Combining all types of effects

In "SD Gundam G Generation Neo," all the explosion and beam effects were rendered separately, and combined afterwards with After Effects. For some movies, the background, mobile suits (MS) and effects are rendered with the same approach.

Image rendered without effects

Image of a burnia blaze effect

Sparks image represented by particles

Smoke and blaze

Image after final combination with After Effects; the immensely deep movie was developed by using various effects.

Original image rendered without effects; later effects were added.

Smoke with an alpha channel used for its transparent expression to create depth

Rendered image of smoke

Sparks represented by particles

Explosion

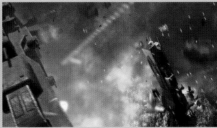

Final rendered image; the object's clarity was magnified by creating depth.

Image of combining elements using After Effects; in addition to making image composites and color adjustments, the staff was also able to exclude the cut from a slow-paced movie and reduce the time.

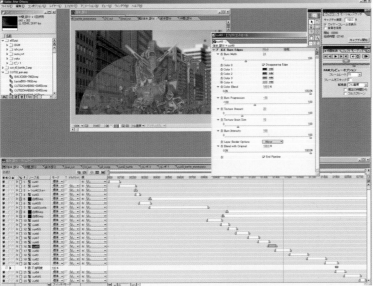

Tom Create, Inc.
Planning and development head
Noriyoshi Takagi

Tom Create, Inc.
Battle animation chief
Kouichi Fujikawa

Tom Create, Inc.
Movie director
Yuji Yokoyama

Tom Create, Inc.
Art director
Hiroyuki Morino

Real-time CG effects

About 2,200 different kinds of real-time CG effects were used. Those rendered with the PS2 machine had a relatively fixed form and were expressed by digitalization. The computer required that the rendering be confirmed several times. Also, the images of Gundam and the background came from the initial development phase, which were not used in the game.

Saber effect

Bubble effect

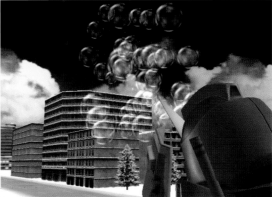

"Apsalus" military model effect

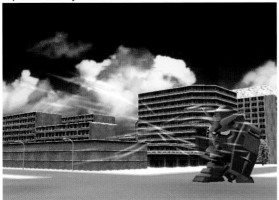

Explosion effect

Dead or Alive:
Xtreme Beach Volleyball

The women of the "Dead or Alive" series are back and better than ever. The game is based on a two-week vacation, with different activity options morning, afternoon and evening. Users spend their days playing volleyball, gambling in the casino and lounging around on the island. The female characters of "Dead or Alive: Xtreme Beach Volleyball" appear in sexy swimsuits, of which more than 100 different kinds can be chosen. After choosing the perfect swimsuit, players can dress up the character with cute accessories—and enjoy the activities of the island.

platform	Xbox	made by	TECMO

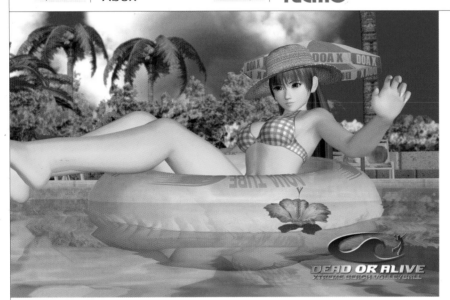

Creating not with quantity but with a first-class objective

First of all, what was the reason for producing this sports game? The most demanding requests obtained from past "Dead or Alive" (DOA) series questionnaires were to develop a supplementary game. However, producer, Tomonobu Itagaki is not the type of man who would sell a game by fawning in such a manner, so it was a tall order.

"If you go to a steak house, you don't want to eat sashimi (Japanese raw fish)—even if it's on the house. If I would do it, I would make the sashimi bar serve me the very best kind that they had available. Similarly, I planned the project this way,"

Itagaki said laughing, but with a completely serious look. Itagaki asserts that he has been producing videos by establishing what he wants to express as a game. He handles everything from programming to direction, and he is the kind of person who indulges in object creation.

In fact, he planned the sports game out of the field in a certain sense, but on the other hand, it helped to clear up something he had been wondering about. "In regular sports games, every character is uniform in size and motion. To make up for that, the characters are subliminally and differently embedded in the user's memory by bringing each of their faces close up. Since we are Team NINJA and have confidence in interactive CG, we wanted to overhaul the project," Itagaki remarked.

True significance of choosing beach volleyball

Then, what does the title have to do with beach volleyball? "It's because [as of August 2002] there has been no interesting beach volleyball game," Itagaki explained. But apart from that, various thoughts were involved. For example, if one sees this change as relatively easy, one thinks the title is characterized as a girly stimulation game that features the female CG characters' sex appeal, like breasts shaking and sexy swimsuits. When in fact, the swimsuits are hidden while swimming, but can be seen from various angles when they are playing beach volleyball. However, thinking of this title as a product does not only involve those elements. In a volleyball game, one needs to control six characters for one team, but for beach volleyball, one can only control two.

This does not imply that the easy course was taken. Itagaki said that ultimately he desired to make maximum use of the hardware by mobilizing the characters without diminishing the expression of the women's charms as the interactive CG.

"I've been saying for a long time that software technology has been progressing more rapidly than hardware," Itagaki explained. "Hardware technology is supposed to be parallel with it but its

performance has not improved. Xbox finally came out and helped us to express the female charm as an interactive CG. We couldn't have done this project with the other consoles."

It is not as though he was flattering Microsoft. Perhaps his real intention as a creator is to be oppressed by the slow pace of hardware evolution while he pursues the quality he desires.

Female charm represented as interactive CG

Why does Itagaki strive to express female charms as an interactive CG? "Part of the reason is because I like it," he explained, "but I also think that the expression of attractive female characters is necessary for entertainment, such as movies, novels, comics and everything else. This is common sense. However, the real question is why video games do not respond to that. It's because people are afraid to end up with a farce when the product is not accompanied by both technology and quality." [Laughs]

The main focus of this game is beach volleyball, as stated in the title. However, the purpose of the game is to enjoy two weeks of vacation; whether one plays beach volleyball or not is up to the user. That signifies in a certain sense that one is expected to experience the charm of one's favorite character by hanging out with her.

Naturally, careful attention was paid to expressing women's charms during a beach volleyball game. For example, before performing a program, the team figured out what kind of picture would look appealing in a certain situation, such as a brilliantly shining sun or a sunset, and which angle to use to make this possible. Therefore, the time spent creating character motion and detail patterns was able to be increased dramatically. As a result, the proportion of character and data, which was two to one in "DOA3," was reversed to one to two in this title. As for the characters' movements, they were developed by trying different methods, including motion capture, until a satisfactory level was reached.

Producing a simple system with creative picture and sound

In conclusion, Itagaki was asked what he thought of the game system. "A simple system is the best," he responded. "People jump to say the word 'profound,' but is there any existing video game in this world that goes beyond the 'profundity' of old games like backgammon, chess and mah-jong? What is needed now is impartial profundity and easiness that everyone can play with. Therefore, a picture and sound representation can be considered as creative work, but a game system is just intellectual work that can be carried out by anyone who has a certain intellectual capability." He also stated that this is the necessary condition for developing a project that can be accepted by people of different cultural backgrounds.

Moreover, there are some swimsuits that were designed by a user, but that is not what public participation on a large scale was invited for. Designs were adopted and sent to Tecmo as candidates. This professes Itagaki's belief of game production—it is a form of passion that drives him to actualize what he wants to create without profit and loss calculations.

The game is based on a setting during a two-week vacation. The concept is how to enjoy oneself in a resort island, thus, one does not have to play beach volleyball.

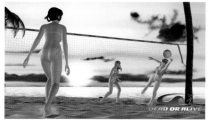

Bottom right: the lighting effect similar to a sunset was carefully created. While there are not that many games that extend consideration to this kind of manipulation, this title adheres to visual quality.

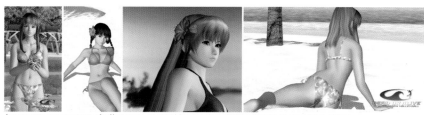

An enormous amount of effort was exerted in creating all the visuals in real time. Some pre-rendered movies are included in a certain part of the game. The production team comprised about one hundred people in total: about 30 in-house staff members, including programmers, and 70 external staff. (All pictures above are from the development stage.)

Unlike a battle game, this title consists of immense broad actions. Although the motion capture was performed, various measures were experimented on during the programming stage.

Producer
Tomonobu Itagaki

Rygar:
The Legendary Adventure

"Rygar: The Legendary Adventure," the arcade masterpiece that appeared in 1986 and won a reputation for breakthroughs in graphics and exhilarating action, has now been released on PlayStation 2. This powerful title was developed as a remake, and resurrected to allow one to experience the world of Argos, which imbues the flavor of ancient Greece and the Roman Empire, along with the overwhelming graphics and impressive music. This is a title whose graphics, game and exciting action can be enjoyed to the fullest.

platform | PS2 made by | **TECMO**

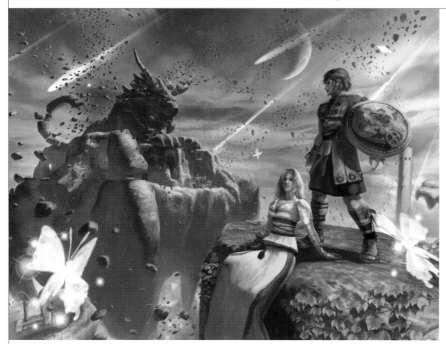

© 2002 TECMO, LTD.

Storyboards were drafted for the movie and the game. They must be have been large volumes, although only two people were involved in drawing them. These became the framework for "Rygar: The Legendary Adventure."

A colorful world based on images of ancient Greece

"Rygar: The Legendary Adventure" originally derived from Tecmo's arcade game, which was a big hit in 1986. This title aimed to see what it would look like if the images from that popular game were reproduced for the current game console with current technology. As opposed to the old game, which was an action game in horizontal scrolling, this one was represented in 3D.

Since the stage was based on a worldview that is reminiscent of ancient Greece and the Roman Empire, actual remains from those time periods were used as reference. When the game project was confirmed, the in-house staff members of Tecmo conducted an expedition to Greece "at their own expense." CG designer Tadafumi Kubo participated in this trip and photographed a number of materials for texture use.

After considering the production time restrictions, Tecmo's in-house game section team, which consisted mainly of

Kubo and CG designer Hirohisa Kaneko, and the external staff's movie team created the CG for the game. Tecmo's in-house staff also provided the character and stage design, and the storyboards for the game section and the movie. The storyboards were drawn by a staff member whose father was a professor of archaeology; some authentic elements were included.

The stage design was developed in 3ds max by Kubo because, as he said, it was faster to form an image using familiar software than drawing it by hand. Naturally, another reason was that the data

Game stage modeling performed in
3ds max

Adjusting the camera to determine
the proper angle

Rendered image in 3ds max; the shading is
different from the actual game screen.

Modeling in 3ds max; the sky was
mapped to a semi-globular dome.

Vertex point color applied to the representation
of the created model

Shaded image from an object color
process

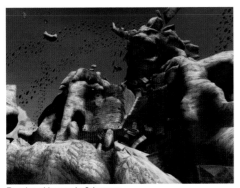

Rendered image in 3ds max

Modeling data for the map in the game showing the
area where the hero moves around

Game stage created in 3ds max

The colosseum galleria's modeling image

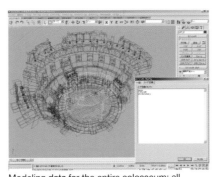

Modeling data for the entire colosseum; all
the data—including the camera, light and
sound effects—were developed together.

Shaded image in 3ds max

developed by the software could be
applied to the actual game.

A number of photo materials and design
drawings for the character and stage were
developed in this way, and the huge
collection of these images was shared with

the production staff. Also, the movie scene
image and fantasy pictures were all
brought together.

From these, the scene wherein a wave
changes into a horse was created.
However, an epic fantasy movie that

contained a very similar scene was
released during the game's production, so
that scene was quickly changed to a
sandstorm changing into a lion. Such
episodes provide evidence of a worldwide
contemporaneous large-scale game.

Character making

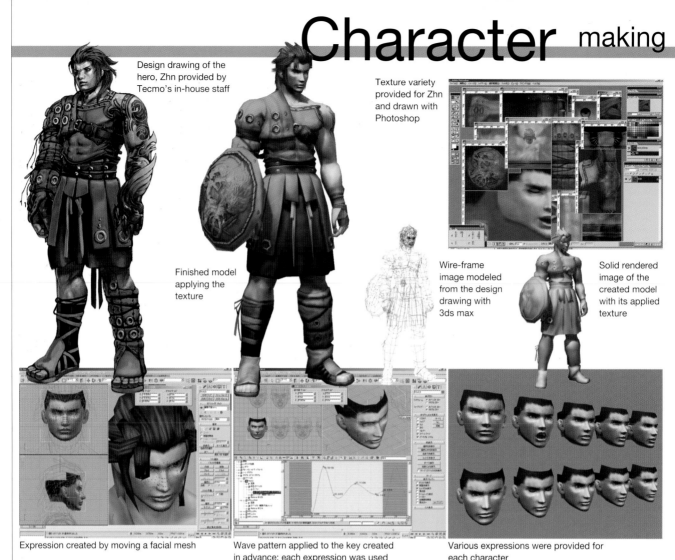

Design drawing of the hero, Zhn provided by Tecmo's in-house staff

Texture variety provided for Zhn and drawn with Photoshop

Finished model applying the texture

Wire-frame image modeled from the design drawing with 3ds max

Solid rendered image of the created model with its applied texture

Expression created by moving a facial mesh

Wave pattern applied to the key created in advance; each expression was used and mixed on a PS2 machine.

Various expressions were provided for each character

Opening scene developed in advance of the game section

The opening movie was drawn on an unusually grand scale and produced by Masaru Mayama of Polygon Magic, while Visual Science Labo (VSL) handled the actual production.

The production offering date was for February 2002. At that point, the opening movie part was already scheduled for release at the world's biggest game show, the Electronic Entertaiment Expo (E3), which was held in United States the following May.

The request made by Satoshi Kanematsu, Tecmo executive producer, was to develop a "movie that will make people at E3 stand and watch with their mouths agape." Further, the purpose of the

opening movie was to represent the worldview of Argos. This serves to provide information about the weapon, called a diskarmor, and the enemy, called Titan.

The opening movie production began when VSL appointed a director to create a new image-based storyboard inspired by a storyboard created by Tecmo, which took about a month to complete. The production time for developing the actual 3D was reduced to about two months.

The hero and several other characters were provided by Tecmo, but since the movie was created in advance of the game section, Harmonia and the bossy character riding on the tank pulled by a horse were modeled by VSL. Incidentally, this bossy character does not appear in the game due to the specification changes in the game section. He is a precious character who you can only see in the movie.

Since the time devoted to the production was limited, efficient operation was required. Therefore, the storyboard was filmed by video to develop a draft movie. It was later replaced with the precisely rendered image.

Softimage 3D and 3ds max were used for the effects. Maya was used for particle processing. Each software application had its own element. In the actual production, each cut was handled by a single staff member, which means that each software application was used for each cut.

The movie rendered with those softwares was adjusted for color tone maintenance during the final combination stage. What the movie required was an element that had a feeling of dignity rather than photorealism, that set the redness quite strongly and whose color tone was easy to maintain.

Motion making

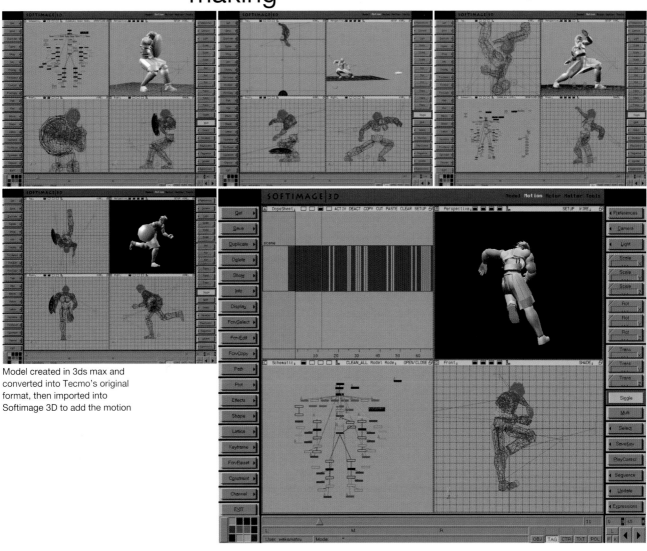

Model created in 3ds max and converted into Tecmo's original format, then imported into Softimage 3D to add the motion

Model and motion previewed on PS2 for confirmation; on the viewer, one can check the effects together.

After confirming the motions and effects, the data was reproduced in the PS2 machine. These pictures are screen shots of the actual game.

Opening movie

Behind-the-scenes highlights from the opening
movie of "Rygar: The Legendary Adventure"

Scene of the running crowd
mobilizes about 240 people. It
was difficult to render
everything at once, so the
scene was divided into three
layers. For the motions,
variations in the running
motion capture were provided
and applied to each character.

1

 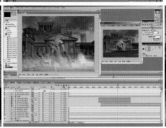 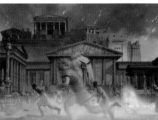

Background of the crowd
created separately

Scenes combined in After Effects
and adjusted in detail; in addition to
the crowd and background layers,
more than ten other layers, including
a smoke layer of each crowd,
shadow layer, three background
layers and four volcanic bomb
layers were combined in this image.

Image of the completed movie;
the scene of many people running
to escape is quite powerful.

Background scene created in
Softimage 3D

Princess Harmonia created in
Softimage 3D; the cloth
simulation was used heavily for
her hair and clothes. Using
Softimage XSI's Hair for the
hair was an option, but its
possibilities were doubted at
that time, so NURBS object
was used instead.

2

Instead of using VSL's software
that was similar to Cloth to
calculate the clothes' movements,
the product version was
implemented because it was easier
to use. In other projects, Softimage
XSI was used only for cloth
simulation, and XSI's Cloth was
also partly applied in Argos. XSI is
able to open Softimage 3D scenes
with animation, so it became useful
for the scene's "hit check" function
(although some functions, such as
Deformation, will not open directly).
XSI's Cloth is highly flexibile and
easier to control than Softimage 3D.

Background and character
separately rendered and
combined in After Effects

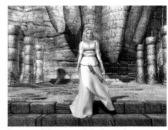

Image of the completed movie;
the clothes swaying in the
wind are beautifully done.

3

In the scene where
the hero, Zhn swings
the diskarmor,
Softbody was
applied for the hair
effects. For the
dynamics calculation,
XSI's Softbody Cloth,
ClothExtreme and
Cloth were used
accordingly,
depending on their
license and
conditions.

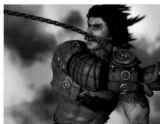

Completed image showing Zhn's
well-represented manliness

Zhn and an aurora in the scene where the sand that Zhn threw gathered and converted into a lion; this scene was created using Softimage 3D.

Lion created with Maya; the lower body turns into sand, so it was not modeled.

Sand particles also created with Maya

4

Completed image after combining with After Effects; the motion was synchronized by sharing the camera's animation data with an in-house plug-in after adjusting the camera angle of Maya and Softimage 3D. This camera work was difficult to approve.

Music
video for Princess
Harmonia

Cut showing the glittery ball rising from Princess Harmonia's feet to the water surface; since the character was created in Softimage 3D and the background in 3ds max, the camera data was transferred to 3ds max after fixing the camera work in Softimage 3D, and both were rendered and combined in After Effects.

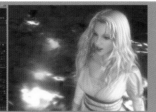

Princess Harmonia created in Softimage 3D; Cloth was applied to her hair, skirt and cuffs for dynamics calculation

Water surface created with 3ds max; the surface, specular image, reflection and mask materials were rendered separately in 3ds max by using the render element function of 3ds max, and combined in After Effects to create the final surface image.

Completed image after combination; to reproduce the glittery ball on the surface, the rendering was performed twice with a projection map.

Cut showing Princess Harmonia singing and being covered by light in the last scene of the movie

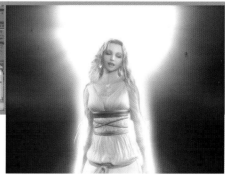

Character created in Softimage 3D; four or five staff members were needed to create the simulation for each part such as the hair, clothes and ribbon.

Background surface created in 3ds max; the huge amount of work was difficult for a single staff member to do.

Image combined with After Effects; the light covering Princess Harmonia was reproduced with After Effects. Most parts consisted of nested compositions to represent Princess Harmonia being covered by a halo. More than ten layers were combined.

Completed image; because it was the last cut, creating Princess Harmonia's expression was very difficult.

Tecmo Inc.
Executive producer
Satoshi Kanematsu

Tecmo, Inc.
Real-time CG designer
Hirohisa Kaneko

Tecmo, Inc.
Real-time CG designer
Tadafumi Kubo

Polygon Magic, Inc.
Movie producer
Masaru Mayama

Visual Science Labo, Inc.
Chief designer
Eiji Sumida

Visual Science Labo, Inc.
Maya software head
Jun Satake

Visual Science Labo, Inc.
3ds max software head
Jun Nakamura

Visual Science Labo, Inc.
Motion capture specialist
Yoko Sano

One Piece:
The Adventure in Grandline

Luffy, Zoro, Sanji and Chopper all make spectacular appearances in this CG animation. This very powerful 3D movie brings the viewer a number of special effects—such as a seat that moves along with the movie, laser beams and an aroma system that heightens one's experience of the movie.

| platform | Ride Attraction | made by | **TOEI ANIMATION** |

A ride to get into the worldview

Often motion ride movies are quite one-sided. The audience is engaged in the story, but suddenly an accident occurs and they are dragged by a navigator character; the seat shakes as the character moves this way and that, and eventually the plot ends with all troubles settled. The story often flows ambitiously but does not satisfy the viewer most of the time.

However, "One Piece: The Adventure in Grandline" is different. One can get totally caught up in its worldview. Audiences will sneak into the world of the hero, Luffy, and follow him closely in a miniature vehicle that is invisible from their side. It is like chasing something closely for observation. The movie runs within a very enjoyable seven-minute, speedy scenario; the ride moves in perfect timing, and the movie, which is created with full CG effects, achieves a very high level of celluloid animation.

Director of TOEI ANIMATION, Daisuke Nishio, who took charge of the production, animation director, Naoki Miyahara, and CG producer, Takeshi Himi, discussed how they produced this title.

Draft of the plot right before it became the storyboard; in order to capture the viewers' interest within the short span of seven minutes, the staff developed several pre-productions, instead of drawing the storyboard first (from left to right):

Daisuke Nishio wrote the overall plot from a two-page project outline. After having received the plot, a scriptwriter wrote the scenario. Naoki Miyahara created the characters and roughly drew the reference images in discussion with Nishio. Then, the storyboard was developed.

Seven-minute adventure

Each title of this attraction, which is called a "time dream machine," has played in theaters for two years. This time, the screening opportunity came from Sanrio, who was looking for a project to replace "Digimon." Although "Digimon" was also produced by TOEI, "One Piece" was adopted as a strong project, not just as another project. It was not that a specific slot was determined, but rather that Sanrio was searching for something fun for both boys and girls. Sanrio Puroland was already attracting girls, but it needed an element to entice more boys. "One Piece" fit right into this concept, hence, the project was begun.

The first problem was how to emanate the world of "One Piece." It was difficult not only creating a motion ride but also a stereoscopic vision. Subjective contents might be suitable for a motion ride movie, but then they conflict with presenting the story objectively. On the other hand, they might also be difficult to bring about in a stereoscopic vision.

"We discussed with Sanrio how to depict a drama while considering the way the audience becomes immersed in it," explained Nishio, who is known for creating interesting objects without compromises. "The attraction was originally based on the idea of going back to a certain situation in the past in a time machine capsule, but after working for a while we started to forget about the basics. After we remembered these ideas, we thought about developing the world of 'One Piece,' which conformed to the original ideas." This is how the story evolved.

The next problem that arose was the length of the time for the movie, because the screen system was limited to seven minutes. "Actually we wanted at least fifteen minutes. Even an ordinary animation runs for thirty minutes. When movies run in less than fifteen minutes, the stories end right before the climax. Hence, the movies don't really explain much about it. The pre-show explains it all. However, the contents still have to be rushed in a whoosh. It's difficult to convince the audience that this is just a rush movie," Nishio remarked, although this construction actually became the factor for producing the all-encompassing movie.

Although the story rushes in the beginning, the preliminary part, which is supposed to be explained naturally during the movie, is mentioned in a display in the waiting room, so the audience can read it before entering the attraction. And the pre-show, which announces "you are entering this movie world in a time machine," explains the basic settings reasonably. Explanations are well done during the entire attraction, but somehow supreme efforts were also exerted.

Since the modeling could not be executed at the last minute, focus was placed on the motions instead. Nishio checked the monitor to direct the performances—such as the timing for the cut where Chopper's jaw stretches out, for example. Since each motion was well developed, the completed movie does not provide any difference from the world of the animation "One Piece." "It doesn't really matter how similar the characters appear; the important thing is to create an animated character," Nishio said.

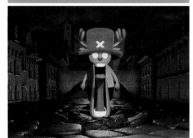

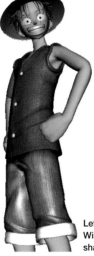

Dinner scene; the art concept was written on the background and accessories and was developed through external production.

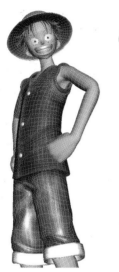

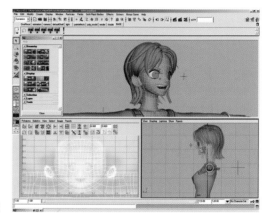

Left:
Wire-frame and shading for Luffy

Right:
Model and face texture for Nami

Two staff members from "Dragon Ball"

The most difficult part of the production of this title was preparing of the story as a 3D movie. "We had a basic plot outlined in a two-page manuscript wherein the hero goes on a journey and comes back," explained Nishio. "However, those two pages did not fit within seven minutes. Therefore, we drafted a simpler plot and had the scenario writer rewrite the scenario, and the project began from there." In addition, a scene that the team wanted to include was extracted from this scenario.

CG was chosen and used for this title, instead of celluloid animation. This is because the team thought that CG was probably suitable for representing beauty and depth in a 3D movie.

Yet, the method for producing a celluloid animation is different than producing a 3D movie. Because a celluloid animation structure is drawn by hand based on an image that uses a radical perspective, it cannot be made into 3D. Also, 3D gives importance to depth and should include only the elements that it can represent. Therefore, Nishio and Miyahara discussed the kind of picture that would be created. Nishio gave a specific image for the cut, then Miyahara developed a rough picture based on it.

Actually, even though Miyahara was a CG staff member, he used to be an animator; because of his background he was able to act as the intermediary between the 2D and 3D images. He was the director of animation for "Dragon Ball." Both Miyahara and Nishio were former staff members of the animated series, thus, the process was executed in perfect harmony.

"We wanted to make the video comfortable for the viewer who has already seen the TV animation," Miyahara said. "We thought about making it first with Celshader but we decided not to focus on its appearance. Instead we focused on creating an animation style or atmosphere by including cuts that disregard the standard perspective."

In this way, the scene's rough images that were to be included were gathered and narrowed down for the final story.

Movie created by each element

The CG production for this title was executed by several different companies. OMNIBUS JAPAN created the scenic effects for the sea, water and the ride; Links DigiWorks created the background and artistic effects. For character creation, which was the main job, the staff members at Polygon Pictures who were adept at making key frame animation by hand joined the production team's twenty staff members organized by TOEI.

Himi, who had worked with Shinji Shinohara in coordinating with Sanrio and other productions, explained the reason for taking this approach. "TOEI's task was to illustrate a CG drama, not to create the effects or the ride; it also handled the character animation. We aimed to draw a livelier character than the still image whether they are alike or not. Therefore, we specialized in creating the characters for this production."

With this concept, the team considered performing the specialized character modeling in the beginning of the cut, because it was almost impossible to mold a 2D manga character directly into a universally applicable 3D model. However, since there was not enough time, the team created a model that would not look odd in any scene. Naturally, despite their efforts some cuts looked odd, thus, custom parts had to be re-created.

"It became an animation style," Nishio said. "Thus, I guess motion timing is important. If it works properly, it looks just as expected."

"I think one of the reasons for this was because the direction that Nishio gave to the staff was accurate," Miyahara added. "For example, he actually gave a performance direction by using gestures in front of a monitor. He would say, 'this should be more like this.' That's how this animation was developed."

For the software, TOEI used Maya, OMNIBUS JAPAN used Maya and 3ds max, and Links DigiWorks used Softimage 3D and 3ds max. Since each company used a different software program, a rough draft was given first to each company to quickly confirm the structural outline. Anything that needed to be done was provided in advance.

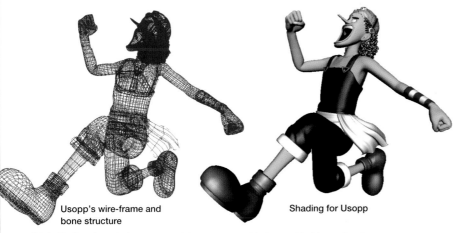

Usopp's wire-frame and bone structure

Shading for Usopp

Combining the background and characters with After Effects to complete the scenes took quite some time for the right and left sides.

Originally, the character's proper model was supposed to be provided for each cut. However, due to time restrictions, the settings were adjusted to serve and be used as a base for each cut. "There was no image with perfect symmetry, so even if we produced the proper image from a specific angle, it came out misaligned, such as eyes askew on one side and the mouth on the other side. Yet, we first planned to create a face pattern facing the right and left, then tackled the expression," Nishio says.

Scene roughly built based on the original image; the background was created by the external team, and the character by the in-house team. Eventually both were combined to become one picture.

Then, TOEI produced the rough model and camera work. Each production created the background or the effects based on the camera manipulation, and each element was ultimately combined in After Effects.

Elements to be weighed on the machine

The dream time machine used 70mm film, which is equivalent to what is used for IMAX productions. For this reason, the CG production was manipulated in 1,280 x 720 and 24p HD. (Since there was no laboratory that could develop 70mm film, the film was produced in 35mm, then converted to 70mm.)

Another important element of the movie was the chair in the ride. This involved motion timing. In this seven-minute movie, the ride could only move for six minutes, and the length seemed half-timed on the production side. The team debated about whether to move right from the beginning, or delay the timing to the end. Finally, the team chose to create the effect of entering the story world by moving the chair during the "arrival time" in the early scene. Detailed settings for this motion used Sanrio's suggestions, which were based on the movie attraction. (The director's intention, which was different, was revised.) However, the motion was quite surprising when one first took the ride.

In the end, the animators, CG specialists and Sanrio staff worked well with one another to create a very successful motion-ride movie. Whether you are a fan of "One Piece" or not, you will enjoy experiencing this ride.

1 Basic scene storyboard

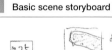

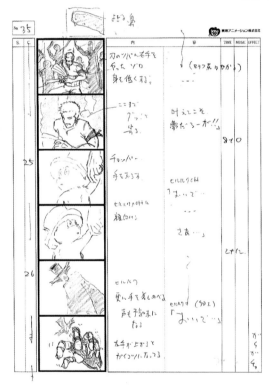

Chopper was the most difficult character to create in CG because of the representation of the hair. Maya Fur was used in the end, but it was difficult to make adjustments and avoid creating the realistic hair. Actually, the model was completed a week before the delivery of the movie.

2 The rough cut's original image from which the screen was created

3 Chopper's setup image; one can see each expression and the Fur setup.

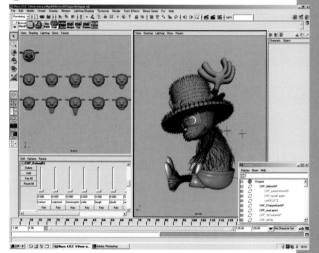

4 Scene modeling image; only Chopper used the final model and the background consisted only of temporary data because it was created in a different production.

1 Screen image for the left side

2 Screen image for the right side

3 Parallax errors

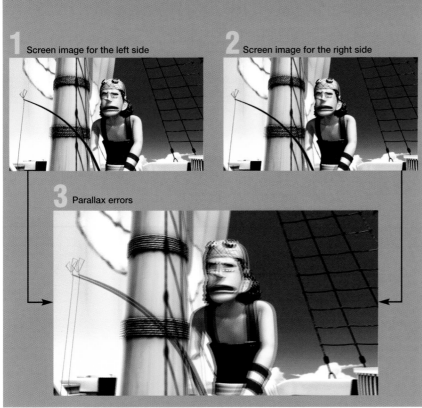

TOEI ANIMATION
Producer/director
Daisuke Nishio

TOEI ANIMATION
Animation director
Naoki Miyahara

TOEI ANIMATION
CG Producer
Takeshi Himi

Due to stereoscopic vision, parallax errors occurred. Two cameras were set up during production and two rendered objects were produced. The camera distance was adjusted properly for each cut. These fine adjustments were confirmed on the actual movie after the material was transferred to 70mm film. The rough grid was checked first and confirmed in the nearly final edited image, then fine adjustments were conducted using a simple tool like a liquid crystal screen.

5 Chopper without Maya Fur looks a little scary.

6 Application of a flat Fur, but not completed yet at this stage

7 After adding the shading

8 Background created by Links DigiWorks

9 Background and character combined to perform a color adjustment, and later completed

Resources

Game Manufacturers:

Bandai
www.bandai.com

Banpresto
www.banpresto.co.jp

Capcom
www.capcom.com

Chunsoft
www.chunsoft.co.jp

From Software
www.fromsoftware.co.jp

Irem
www.irem.co.jp

Konami
www.konami.com

Namco
www.namco.com

Sega
www.sega.com

Sony Computer Entertainment
www.scea.com

Square Enix
www.squaresoft.com

Taito
www.taito.co.jp

Tecmo
www.tecmogames.com

Toei Animation
www.toei-anim.co.jp

Platform Manufacturers:

Dreamcast
www.sega.com

Game Cube
www.nintendogamecube.com

PlayStation 2
www.playstation.com

Xbox
www.xbox.com

Software Manufacturers:

After Effects
www.adobe.com

Deep Paint 3D
www.righthemisphere.com

Digital Fusion
www.eyeonline.com

FiLMBOX
www.kaydara.com

finalRender
www.finalrender.com

LightWave 3D
www.newtek.com

Maya
www.aliaswavefront.com

Photoshop
www.adobe.com

Softimage 3D
www.softimage.com

Softimage XSI
www.softimage.com

3ds max
www.discreet.com

Game Sites:

Contra: Shattered Soldier
www.konami.com/shatteredsoldier

Dark Cloud 2
www.us.playstation.com/games/scus-97213

Dead or Alive: Xtreme Beach Volleyball
www.tecmoinc.com/doax

Final Fantasy X-2
www.square-enix-usa.com/games/FF2-X

JoJo's Bizarre Adventure
www.jojo-ova.com

Lupin the 3rd: Lupin in the 3rd Dimension
www.lupinthethird.com

Onimusha 2: Samurai's Destiny
www.capcom.com/oni2/oni2_teaser.htm

Panzer Dragoon: Orta
www.panzer-dragoon.com

Resident Evil Zero
www.residentevil.com

Robot Alchemic Drive
www.enix.com/rad

Rygar: The Legendary Adventure
www.tecmoinc.com/games/rygar.asp

Sakura Taisen 4: Koi seyo Otome
www.o-works.co.jp/owshp/english/main0102_etc_sakura.html

Soul Calibur II
www.soulcalibur2.com

Unlimited Saga
www.u-saga.com

Virtual-On Marz
www.vo-marz.com/site_e/index.html

Zone of the Enders: The 2nd Runner
www.konamijpn.com/products/zoe2/english

Other:

Official U.S. Web Site for PlayStation 2
www.gamers.com

Credits

Some of the games included in this book were originally launched under different titles in Japan. The names might have been adapted for the convenience and/or preferences of the game lovers abroad. Here is a comparison list of the original Japanese titles and the titles that were used for the American market.

Unlimited: Saga	Unlimited Saga
Final Fantasy X-2	Final Fantasy X-2
Gigantic Drive	Robot Alchemic Drive
Tekki	Steel Battalion
Biohazard 0	Resident Evil Zero
Jojo's Bizarre Adventure	Jojo's Bizarre Adventure
Oni Musha 2	Onimusha 2: Samurai's Destiny
Panzer Dragoon Orta	Panzer Dragoon: Orta
Sakura Taisen4: Koi seyo Otome	Sakura Taisen 4: Koi seyo Otome
Cyber Troopers Virtual-On Marz	Virtual-on Marz
Soulcalibur2	Soul Calibur II
Venus & Braves	Venus & Braves
Contra	Contra: Shattered Soldier
Anubis: Zone of the Enders	Zone of the Enders: The 2nd Runner
Dark Chronicle	Dark Cloud 2
Popolocrois III	Popolocrois: Hajimari no Bouken
Energy Airforce	Energy Airforce
Space Raiders	Space Raiders
Armored Core 3	Armored Core 3: Silent Line
Zettai Zetsumei Toshi	Disaster Report
Kamaitachi no Yoru 2	Kamaitachi no Yoru 2
Lupin the 3rd The Legacy of the Magic King	Lupin the 3rd: Treasure of the Sorcerer King
Ggeneration Neo	SD Gundam: G Generation Neo
Dead or Alive Extreme Beach Volleyball	Dead or Alive: Xtreme Beach Vollyball
Rygar: The Legendary Adventure	Rygar: The Legendary Adventure
One Piece the Adventure in Grandline	One Piece: The Adventure in Grandline

The original texts for the following interior pages were written by the contributing writers mentioned below for the Japanese edition:

P.32–39: Steel Battalion, p.76–79 Soul Calibur II, p.104–109 Popolocrois: Harimari no Bouken by Masamichi Yoshihiro
P.86–91: Contra; Shattered Soldier by Kazutomo Tatsuko
P.152–153: Dead or Alive: Xtreme Beach Volleyball by Yoshikazu Saitoh

Index

ACKNOWLEDGMENTS

We would like to express our sincerest gratitude to all those who have contributed so graciously to the production of this book:

To Marta Schooler, Associate Publisher of Harper Design International (HDI), for her strong belief and confidence in the possibility of publishing an English edition of "Making of Game Graphics" and for her superb editorial direction;
to Ilana Anger and Gyda Arber, also of HDI, for their smooth collaboration with the Japanese chief producer of the book;
to all the game makers and creators who contributed to this book, for their continuous support in confirming all the information about their works that transpired from the Japanese to the English edition;
to Shinichi and Yuko Ikuta and Tomoya Yoshida of Far, Inc., for their incredible editing and production work, which survived many sleepless nights;
to Atsushi Takeda, for his wonderful talent and art direction in creating a different design approach for this book;
to Toyoshi Nagata, chief editor of the Japanese edition, for his precious time and patience in sincerely accepting the interview and for his efforts in developing the game theories;
to Junko Tozaki, for her generous translation work from Japanese to English;
to Alma Reyes-Umemoto, for her utmost patience in the English editing and proofreading of the material;
and to Alison Hagge, likewise, for her extreme cooperation in bringing out accuracy and detail in the English copy editing.

To everyone, thank you very much.

Finally, we should not forget to thank all the game characters featured in this book. Because of their undying appeal, this book of game graphics was born. We hope that through this book, all readers and audiences worldwide will continue to anxiously support and love Japanese game graphics.

Works Corporation
November 2003